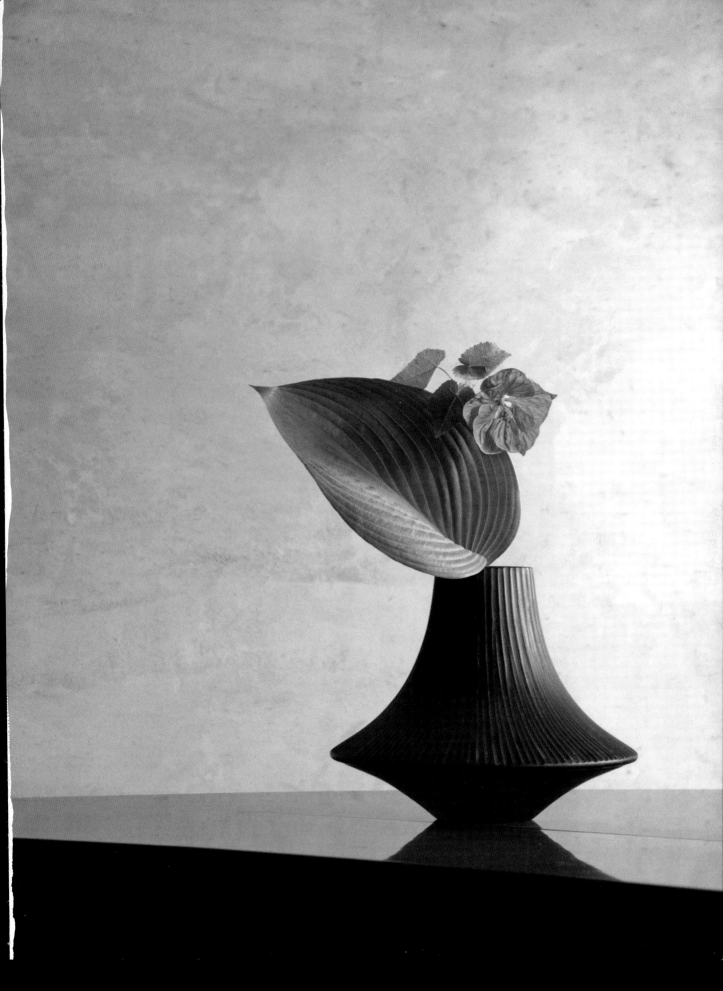

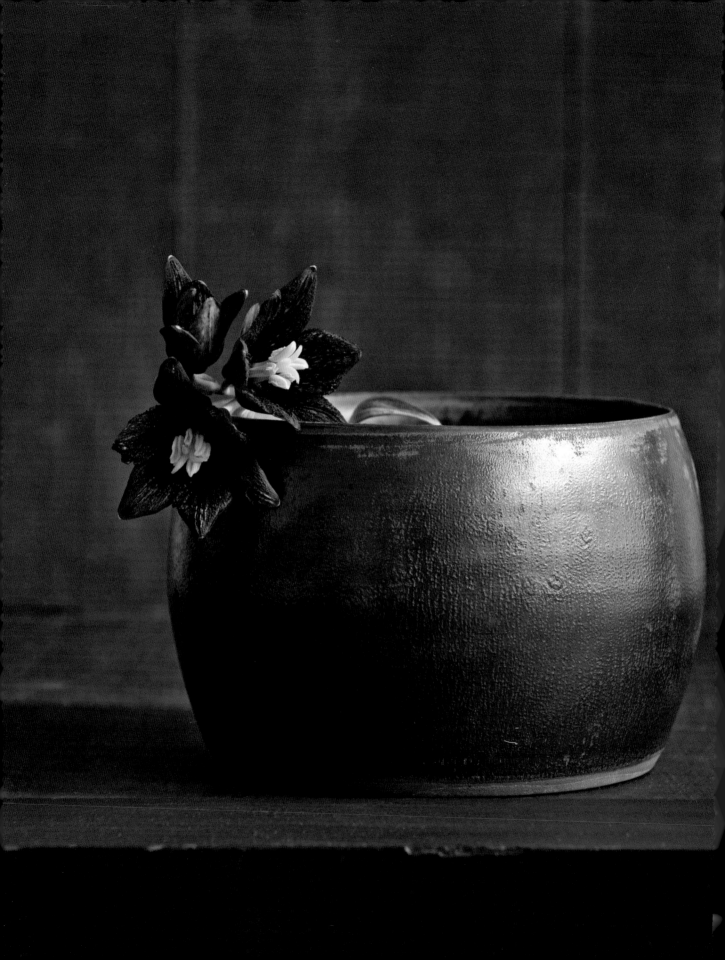

japanese
ikebana
for every season

Rie Imai **and** Yuji Ueno
Photography by **Noboru Murata**

TUTTLE Publishing
Tokyo | Rutland, Vermont | Singapore

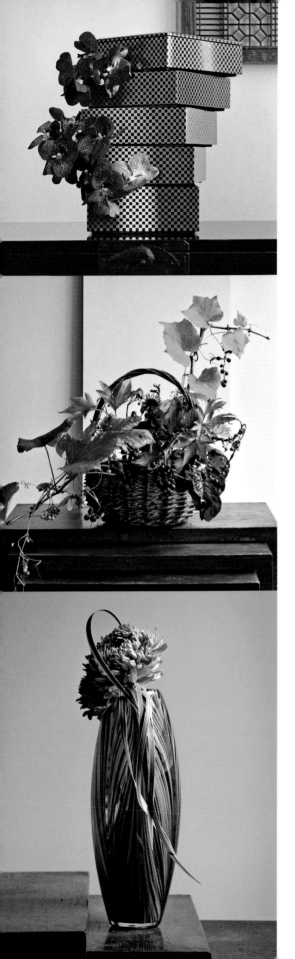

CONTENTS

spring

summer

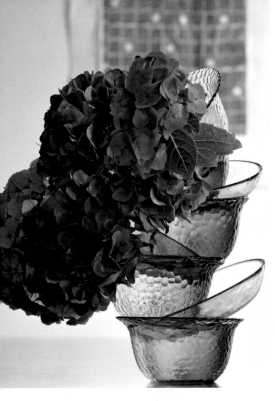

autumn

winter

the new ikebana

RIE IMAI

Raised and educated in Tokyo, Japan, I received an interior coordinator's license and then moved to the United States. I lived in New York and San Francisco where I studied horticulture, including Western flower arrangement styles and Japanese ikebana. During my studies, I became aware that there was a new wave of expression developing in all the floral arts. I was also able to view the art of Japanese ikebana impartially, from outside the formality and lifetime commitment it requires.

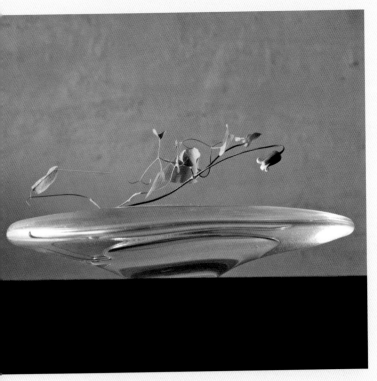

Above and opposite Yuji Ueno's arrangements.

After returning to Tokyo, ten years later, I continued to research horticulture design and became interested in current flower arranging trends. This led me to encounter an ikebana arrangement by Yuji Ueno. Seeing his work for the first time, I realized that contemporary Japanese ikebana was indeed moving in new directions. I was very excited and heartened to see this development.

Yuji Ueno's arrangements are a new kind of ikebana to me. Although his work is simple, it embodies a special type of beauty. It also precisely expresses the arranger's artistic intention without using complicated techniques. Yuji Ueno is a true seeker of creative expression in floral art. He has raised the caliber of Japanese flower arranging, taking it to a new level, one not bound by convention. He is one of the top practitioners of new, innovative trends and, fortunately, is happy for people to adopt his ideas and techniques.

Yuji Ueno and I share the same view about the need to introduce this current trend of pushing Japanese ikebana in new directions. It is my great honor to introduce to readers, along with Yuji Ueno, contemporary Japanese flower arrangements that go beyond the traditional concept of ikebana.

The main purpose of this book is to introduce the beauty of flower arranging with a Japanese sensibility to a wider audience and to encourage readers to create such arrangements by themselves. But we would like also to make the basic mastery of Japanese-style flower arrangements accessible to anyone who is interested in this wonderful art.

The basis of arranging ikebana originally evolved from observing nature, and this practice is one of the main themes of this book. I believe that dialogue with the natural environment is the starting point of a Japanese flower arrangement. True beauty resides in nature and we need to capture it for ourselves.

All the arrangements shown here have been made with floral materials and containers that are widely available anywhere in the world. We selected flowers that can be purchased in most flower shops. We used ordinary containers that can be found in daily life and were not specifically made for ikebana. Basic techniques are used over and over again to help readers develop familiarity.

In the book, we go directly to the essence of beauty as found in ikebana. I attempt to explain the aspects of universal beauty that are inherent in ikebana. I not only discuss the shape, design and techniques of an arrangement but also introduce methods of coordination and ideas about adding and subtracting materials and colors. In each arrangement in the pages that follow, I will introduce what constitutes a sense of beauty in Japan, which is the key to a successful arrangement.

A unique approach taken in this book is the emphasis on the importance of the relationship between every aspect of a Japanese-style flower arrangement. In Japan,

arranging flowers means producing an artwork by paying attention to the total contribution and coordination of various elements, such as the floral material, container, season, water, setting, space, light and purpose. Ikebana is an integrated art of space and time, where all the elements conjoin at one point. My aim is to present this kind of awareness to the reader.

In Japan, a European-based lifestyle has penetrated all aspects of urban society and many people have become "Westernized". There are now many houses that lack the traditional *tatami* mat room and the *tokonoma* alcove for displaying seasonal art objects. At the same time, Western society is beginning to understand Eastern culture and be influenced by it. "East meets West" prevails in many ways in modern Japanese society and we increasingly see a fusion of the two spheres.

Japanese-style arrangements can also be appreciated during Western festivities and on special occasions. Certain celebrations, such as Easter or Thanksgiving, are not widely observed in Japan, but even so flower arrangements with a Japanese touch may provide a different but memorable touch to your special occasion.

Although ikebana has traditionally been placed in a special alcove in a Japanese-style room, my intention is for the arrangements to decorate a contemporary living space. All of the arrangements in this book are therefore designed to suit a Western environment. Simple ikebana set in any room in the home can add a great deal of pleasure and enjoyment to your life.

A certain level of technique is required to make an arrangement that fully realizes your creative intention. However, the real goal of an arrangement is to express your creativity, not to show off techniques. In this book, all the important and essential techniques used in the arrangements are covered in a separate section. My explanation for each work focuses more on the concept and key factors for the success of the arrangement.

Additional photographs are included to illustrate details of the techniques and arranging tips. I encourage readers to try to apply such techniques in their own arrangements. Beyond just a mass of flowers in a vase, creative and pleasing ikebana can be accomplished with the simple techniques presented in this book. Although "practice makes perfect", it can also lead to creative thinking and originality.

I like to keep my eyes and mind open to discovering beauty and spontaneity in any encounter I experience, whether it be with seasonal flowers, a peaceful sunset or a nice glass of wine. I urge you to keep your eyes and mind open to the message of the beauty and feeling within the Japanese-style arrangements presented here. Although this book may seem to be filled with rules, they are really only guidelines born of my interaction with the art of Japanese ikebana. Sometimes breaking the rules

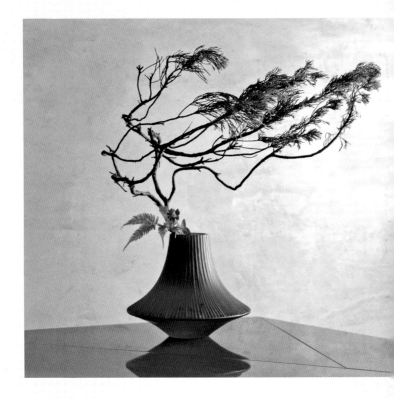

can lead to new ideas that will set you on an exciting journey of your own.

I do hope that this book encourages you, through the floral arrangements skillfully created by Yuji Ueno, to look closely at flowers, to communicate with flowers, to even sometimes to struggle with flowers, and to discover your own style of arranging, one that matches your lifestyle. Let this book accompany you in finding your own personal sense of beauty and potential through interaction with nature and your own self-expression through flower arranging.

basic ikebana techniques

The basic ikebana techniques that are essential in making Japanese-style arrangements are presented in this section. They include techniques related to water absorption, cutting, stabilizing, bending and shaping, trimming and maintenance.

It is important to decide what kind of impression you want to make with an arrangement. Inspiration and a will to create are very important, but very often your ideas will only be accomplished with the help of certain of the techniques. While you should not let mastering these techniques be your sole purpose, it is a fact that having a good grasp of them will enable you to have a greater understanding of what is possible in an arrangement and this will allow your imagination to reach its potential.

WATER ABSORPTION TECHNIQUES

Water intake is one of the most fundamental techniques for a flower arrangement. Water is essential for cut plants to stay fresh and beautiful as long as possible. It is important to know the characteristics of the plants and apply the appropriate method for treating each type of cut material.

1 CUTTING UNDER WATER (*MIZUKIRI*)

Among the various methods of ensuring water intake, this is the most commonly used technique. This easy method involves cutting the stem under water without exposing the cut end to air. Water pressure to the cut end forces more water into the stem. This also improves the floral material's strength to draw up water. Every flower must be cut this way before being treated by any subsequent method.

Fill a bowl or small bucket with ample water. Place the stem under water and cut the bottom end diagonally, rather than straight across, to open a wide surface for water intake. After cutting, keep the stem in the water and do not remove until ready to arrange. Cutting under water prevents floral material from absorbing air through the cut end. Air in the stem blocks full water absorption up to the neck of the flowers and to the tips of leaves and branches, causing them to wilt. To revive wilted flowers and facilitate water absorption, re-cut the end of each stem under water.

The key for successful cutting lies in the scissors. If the scissors are not clean, bacteria may invade the cutting edge. Dull scissors will cause the stem to collapse. Always use clean and well-sharpened scissors.

Cutting under water

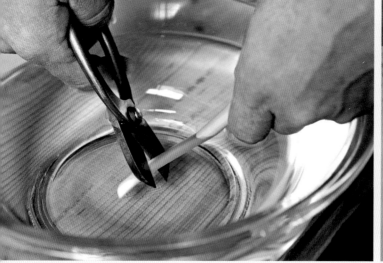

Pounding and crushing

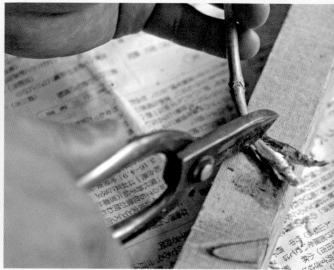

The *mizukiri* technique can be used on almost all types of flower materials, especially flowers from bulbs (tulip and hyacinth) and stems that contain water (gerbera, poppy, anemone), or stems that are thin and which twist (blue lace flowers, scabiosa).

2 POUNDING AND CRUSHING ENDS

This method is applied to hard and fibrous branches and stems, such as maple, dogwood, spiraea, clematis and balloon cotton bush. With a hammer or the handle of a pair of scissors, pound the end of a branch or stem for about 5 cm (2 in) to open up a large area to be exposed to water. The cut end of a thick branch can also be split and torn away or shaved off to expose more of the inside fiber.

This treatment enlarges the surface area of water absorption. For a branch with fresh green leaves which does not draw up water well, peel off the bark after pounding the cut end to make a large water absorption area and set it in deep water. You can get the same results by splitting the end, or making a cross cut.

3 BOILING THE STEMS

Dip the cut end of a stem into hot water for 5–10 seconds, depending on the thickness, and then immediately put it into cold water and leave it for about 2 hours in a cool place. When the stem is in hot water, the air inside the duct expands and is expelled, leaving a vacuum. The stem then contracts in cold water and pressure develops for taking up water. The temperature difference accelerates water absorption.

When dipping stems into hot water, be careful that flowers and leaves are not exposed to the steam. Wrap floral materials in newspaper and expose the stems only. Boiling water is most effective but hot water also works. A higher temperature helps kill bacteria.

This technique is effective for almost any kind of floral material, especially flowers that tend to wither easily as well as field flowers, including margaret, patrinia, hollyhock, amaranthus, dahlia, peony and rose. This method is not suitable for stems that contain water, as listed on page 8 in the section on cutting under water.

4 BURNING THE STEMS

Burn the bottom of a stem with fire to facilitate water absorption as well as kill bacteria. Wrap the blossoms and leaves in wet newspaper and char the cut ends over a flame. Burn them for 1–2 minutes until the ends glow red, then put them immediately into cold water.

This is a more effective method than the boiling because it produces a much higher temperature. It is important to char the end of the stem about 1–3 cm (1½ in) up, without damaging the flowers and leaves. If too much time is spent on burning stems, the heat reaches the flowers and makes them weak. Burn stems quickly over a kitchen gas burner or use a flame torch to char them efficiently.

An additional merit of this method is that carbonated stems function like charcoal and act as a purifier for the water in an arrangement.

This method is good for materials with hard stems, including roses, miniature roses, spray mums, poinsettias and peonies, but not effective for thick stems which contain a lot of moisture.

Splitting

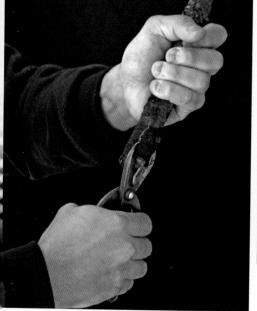

Boiling

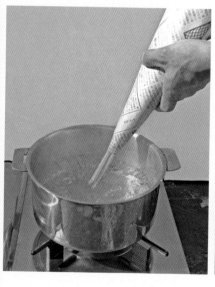

Burning

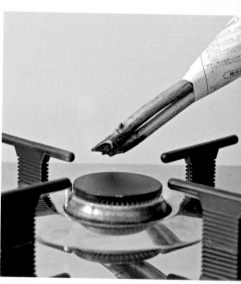

BASIC IKEBANA TECHNIQUES 9

5 POURING WATER ON THE UNDERSIDE

Spraying water on the reverse side of leaves prevents loss of moisture and keeps flowers fresh. For this method, hold the materials upside down and dampen the backs of the leaves with a watering pot.

This method is mainly used for materials whose stems and leaves are perishable or become too weak to apply other water absorption techniques. It is also effective for spray mums, spray roses and herbs that have many small leaves on the stems.

6 IMMERSING IN DEEP WATER

By immersing the materials in deep water, the water pressure facilitates water absorption. Water always evaporates from the surface of the cut flowers. Floral materials with many leaves or those with weak water absorption capability cannot maintain the water balance only from water uptake at the end of the stem.

Prevent as much water evaporation as possible by wrapping the floral materials in newspaper and bending or curving the stems at the same time. After wrapping, spray water on the newspaper to prevent the water from evaporating. Leave the wrapped materials in deep water for at least an hour, preferably half a day, in a cool and dark place.

This method provides materials with effective water absorption. The deeper the water level, the easier it is for the water to go upward. However, be careful about the depth because flower petals touching the water are likely to be damaged.

This immersion technique is suitable for almost all materials except ones that have tiny flowers and leaves and are low in moisture. This method is effective for materials which naturally grow in damp soil, such as ranunculus, or stems that tend to bend due to large and heavy flower heads, such as roses and sunflowers.

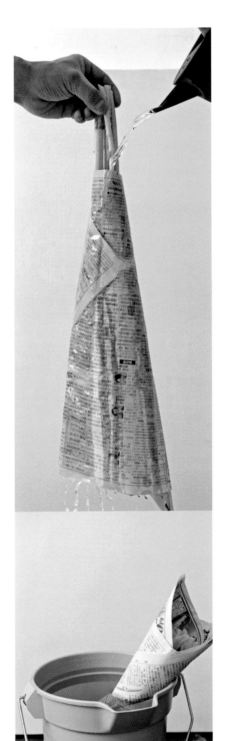

7 USING NATURAL SUBSTANCES

In ikebana, people often use traditional substances to aid in water absorption, among them alum, vinegar, salt and alcohol. With some cut floral materials where it is very difficult to boost the amount of water absorption, special additives are needed. The methods below are effective for specific materials.

Burnt alum is effective for hydrangea, peony, hellebore (Christmas rose) and smoke tree. Put a pounded stem in water for about 10 seconds and then rub its pounded portion with burnt alum powder. Place the stem in deep water.

Vinegar is used for bamboo and bamboo grass as it prevents the leaves from drying out. Put the cut end of the stem in vinegar for about 20–30 seconds and then immerse it in water. This method is also effective for rice plant, reed grass and foxtail millet.

For plants such as allium, hyacinth, and lilac which contain mucus or milky sap, alcohol is used to enhance water absorption. Plant fluid at the end of a stem not only covers the absorption duct and prevents water intake but also makes the water in the container murky and causes the growth of bacteria. Alcohol neutralizes the fluids and cleanses the cut end. Dip the end of each stem in alcohol for about 5 minutes, then rub the end with your fingers to wash away the milky fluid. Leave it in deep water for at least 2 hours.

Above left Pouring water.

Left Immersing in deep water.

Opposite left Ikebana equipment.

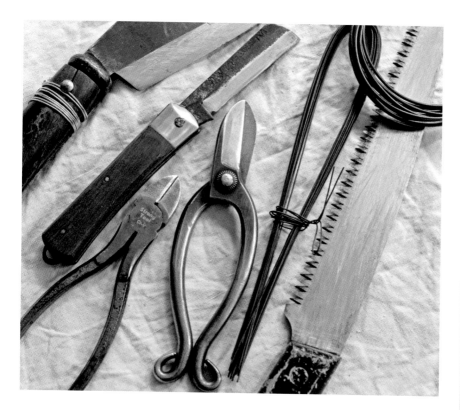

scissor handles wide, put the branch well inside the blades at an angle and cut.

When the branch is too thick to cut with a single motion of the scissors, place it well inside the blades and cut as deeply as you can. Remove the scissors and repeat the same motion until completely cut through. Another way of cutting a thick branch is to rotate the scissors down as you cut the outside, then breaking it off with both hands. A saw can be also used to cut a very thick branch.

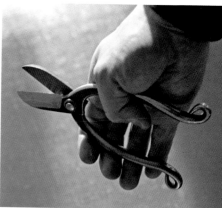

HOW TO USE SCISSORS—HOLDING AND CUTTING
When the upper handle is gripped by the thumb and forefinger, the lower handle will fall down by gravity and open up the cutting blades of the scissors. Grasp the lower handle with all your fingers and squeeze to cut the stems and branches as you like. Handle scissors with care to avoid injuries, as the edges are sharp and the handles are hard and heavy.

Residue from plants causes the blades to rust. Wipe the blades with a cloth every time you use scissors. It is advisable to wash scissors to remove sticky residue after using and to dry them well and store in a case. Proper maintenance of scissors not only keeps them in good condition for a long time but also helps to increase the life of cut flowers.

CUTTING TECHNIQUES

Scissors are probably the single most essential tool for creating a flower arrangement. For a Japanese flower arrangement, Japanese-style scissors or *hasami* are used. *Hasami* scissors are now relatively easy to find outside of Japan. If they are not available, you can substitute them with Western floral scissors or multipurpose scissors available in hardware shops.

Use scissors for cutting most of the floral material. If you wish to cut very thick branches, use any type of blade, saw or hatchet, as appropriate.

Before sawing off tree branches outdoors, think about your final arrangement in order to avoid cutting off too much and wasting materials. Try not to damage the natural ecosystem by cutting more than you need.

SCISSORS (*HASAMI*) This type of scissor is called *warabite-basami*, meaning "fiddlehead fern-handled scissors" because the handles resemble young bracken shoots. These scissors serve various cutting purposes and can cut both slim stems and thick branches. They can also be purchased from shops that carry gardening products.

SAW AND HAMMER These tools are best used when cutting thick branches and for pounding the ends.

CUTTING A FLOWER STEM Cut a stem diagonally to make a wide area for effective water intake. When cutting, insert stems fully into the blades of the scissors. Thin stems can be neatly cut using the tips of the blades. It is easier to cut a thick stem by placing it deeper down into the scissor blades. When cutting a hollow stalk such as calla lily, place the stalk between the blades and rotate the stalk as you cut. Too much direct pressure from the blades will damage the soft tissue inside the stem.

CUTTING A BRANCH Cut a branch diagonally at the appropriate angle in order for the cut edge to rest flush against the inner wall of the container. Open the

STABILIZING TECHNIQUES

These techniques are used to set and support the flowers in a container. They are fundamental to making a long-lasting arrangement with a firm structure. Although many stabilizing techniques have been developed, two of the most common are a horizontal support (*ichimonji-dome*) and a cross support (*jumonji-dome*). Short stubs of branches are used for these stabilizing techniques.

When materials are inserted in a container without the use of these techniques, the stems are held in place by a corner or an edge of the container. Arranging in this manner causes materials to face outward and leaves an empty space in the center. Stabilizing techniques enable a stem to stand apart from the edge of the container or at a desired angle. They are highly recommended to allow you to express your imagination using few flower materials.

These techniques are often called "backstage" because they are normally not visible to viewers. A support should be placed deep inside the vase below the mouth. A cover-up technique, such as a naturally arranged leaf, can be used to disguise a stabilizing device.

1 DIRECT STAY (*JIKA-DOME*) This is the most basic technique. Many times stems can be fixed in place without using a support by cutting them diagonally. Place a flower inside the container with the diagonally cut end resting against the inside wall surface. The branch touches only two points of the vase: the rim and the inside wall of the vase. Cut the angle of the stem to fit flat against the inside wall of the vase to prevent slipping or rolling of the floral material.

Use this method in combination with other stabilizing techniques, such as a horizontal support or cross support.

Direct stay

Horizontal support

Cross support

Forked support

Connected support

2 HORIZONTAL SUPPORT (*ICHIMONJI-DOME*) This is one of the most basic stabilizing techniques. Cut a twig or stem slightly longer than the diameter of the mouth of the container and push it down horizontally to press against both sides and rest suspended in the middle of the container by its own tension. Materials can be placed to rest against this stay.

Rather than use a dried twig that will loosen, a young and flexible one is easier to handle and has more strength. As long as the twig or stem is firm enough to stay suspended against the inside wall of the vase, any kind of material works. You can pick it from your garden or you can use a part of your flower arrangement materials. Do not force the twig

too hard into the container as this may damage it. This method (and the following two methods) requires force and should not be applied to vases of great value or old and fragile containers.

This technique is particularly suitable for a narrow and tall vase or for an arrangement with all the flowers placed facing one direction.

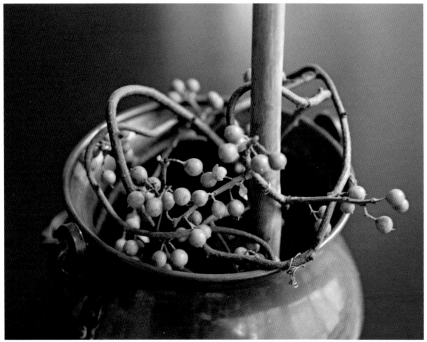

Natural coiled materials

Wire coil

3 CROSS SUPPORT (*JUMONJI-DOME*)
This technique basically uses the same method as the above-mentioned horizontal support. All you need to do is to add another horizontal stay, crosswise, above the first horizontal stay. Crossed double stays are stronger than single stays and can thus support the floral materials better.

Apply this technique if you want to place the flower materials firmly in exactly the spot you desire inside the container.

In the arrangement, you need not fill all four quarter sections created by this cross support. For instance, by placing materials into only two open sections of the cross-support, the arrangement should be stable enough and the base of the arrangement will look neat.

4 FORKED SUPPORT (*MATAGI-DOME*)
A two-pronged stay supports materials in the same way as the horizontal stay but by using a single V-shaped or Y-shaped branch. If such a jointed branch cannot be cut, the same result

can be achieved by combining two twigs or stems. With this method, when the arrangement is seen from the front, it looks as though all the materials are rising from the same point.

5 CONNECTED SUPPORT (*SOEGI-DOME*)
This method is useful when you want to make an arrangement with short-stemmed materials in a deep vessel. Select a sturdy branch and cut it shorter than the depth of the container. Slit the top of the branch and insert the flower into the slit. Place the flower connected to the supporting branch into the container. The entire arrangement is further stabilized if the ends of the flower stems are resting flat against the inside of the container.

When arranging branches, a stronger or thicker branch should be used as the supporting extension. Slit the ends of both branches and insert one end into the other. Adjust the branch for the arrangement at the angle you want. Make sure the cut ends of supported materials are touching the water.

6 NATURAL COILED MATERIALS Natural materials like twisted vines or branches can also be used for the same effect as wire. Bind a vine to create a sphere and insert the flowers into the small spaces between the branches. A support made of natural materials can be a part of the arrangement, and thus need not be hidden. Since the device is placed in the water, choose strong and non-perishable materials such as ivy, jasmine, clematis, honeysuckle and grapevine.

7 WIRE COIL Coiled wire can act as a stabilizing device inside a container. Loosely wind or twist into a sphere and place inside a container to hold plant materials. Choose wire that is strong enough to hold the materials but flexible enough to form into a ball with adequate spaces to insert flowers. This is an easy method and wire is available in most hardware stores. Apply this technique for a container with some depth so the wire can be hidden inside the container. Use non-rusting wire in colors that are close to the flower materials or the containers.

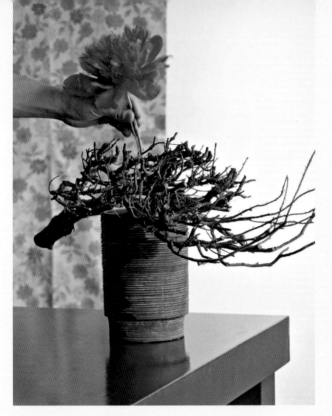

Dried branch as a stabilizer

Hydrangea flower as a stabilizer

Inner container for water

8 USING FLOWERS/LEAVES Even without specific tools, you can stabilize an arrangement using the materials themselves. For example, a stem's own tension can support itself. Some materials placed first in a container can act as the stabilizer for other flower materials added later. Vines or branches that constitute the basic structure of the arrangement can also function as a stabilizer.

9 INNER CONTAINER FOR WATER (*OTOSHI*) For a wide-mouthed container, a common stabilizing technique is to put another separate container, usually a small bottle or cup, inside called *otoshi*. This inner container is used when the main container is a basket, a vase with a hole or a clay pot that cannot hold water. This method is also useful when a container is too big to completely fill with water or when there is a problem with the container leaking.

Floral water tube

10 FLORAL WATER TUBE A capped water tube is one of the implements often used to keep flowers fresh. The water tubes can provide water to fresh flowers when other means for providing water to the cut material are not practical. Using this convenient water holder, you can create a dramatic arrangement by showing a flower from an unexpected place.

Use only one flower per tube, and check it frequently to make sure that it contains enough water for the duration of the display.

11 ALTERNATIVE MATERIALS In addition to the stabilizing techniques mentioned above, certain organic materials can be used to support flowers in arrangements.

One of the biggest challenges in arranging is how to stabilize floral materials in a container with a wide opening. Standard flower stabilizing techniques, such as the *kenzan* pin holder, are in most cases too mechanical and are not meant to be seen. In order to complete the arrangement, artificial support devices need to be hidden.

Here are some examples of natural stabilizing materials/techniques that need not be hidden in an arrangement and can actually enhance it.

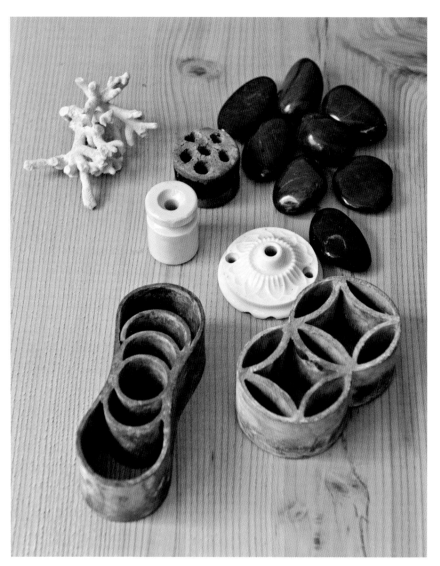

Alternative materials

• **STONES** Use a stone to hold stems upright. The stone must have enough weight to support the flowers. Be careful with the shape of the stone, as sharp edges may damage the container. A stone should harmonize with the container, so stock several kinds in different colors and sizes to enable you to have a good selection from which to choose. Stones can also be used to weigh down a container.

Even a hole or a crack in a stone can hold a stem. Using pieces or chunks of smoothed glass in a glass container is a similar approach.

• **DRIFTWOOD OR DRIED BRANCHES** These items are often used for ikebana. Set a piece of driftwood or other branch on or across a container and set flower stems against it. The wood can act as a part of the arrangement and add some movement and flow or dramatic accent. People who arrange ikebana favor branches with interesting curves and unusual shapes. Driftwood, obtained naturally from the ocean or beaches, contains sea salt. Soak it in water overnight and then dry it thoroughly in sunlight to prevent salt residue from damaging the flowers.

BENDING AND SHAPING TECHNIQUES

In ikebana, the technique known as *tame* is used to make an artificial curved line by physically bending the branches and stems into desired shapes. In order to make the most of the natural beauty of plant materials, this technique is recommended only for minor adjustments, especially in cases where the shape of the flower is slightly odd, or to allow materials to fit better into a container.

Most branches can be bent using both hands. Wrap your hands around a branch and hold it horizontally. Strongly support the bottom and top sides of the branch with the palm and fingers of one hand, while gently bending the branch with your other hand.

Some long leaves can be curved quite easily because the top surface stretches. Place the leaf between your thumb and other fingers and stretch the leaf. Apply pressure on the top and bottom at the same time.

The leaves of aspidistra, iris ochroleuca, calla lily, tulip and Dutch iris, as well as the branches of acacia and willow, are among the materials that are easiest to bend. When working with iris and many other leaves that have a center rib vein, place your fingers underneath the place where you wish to form a bend or curve. Tulips and Dutch irises are plants that have very soft inner stems and hold a great deal of liquid. Such stems can be both bent and straightened.

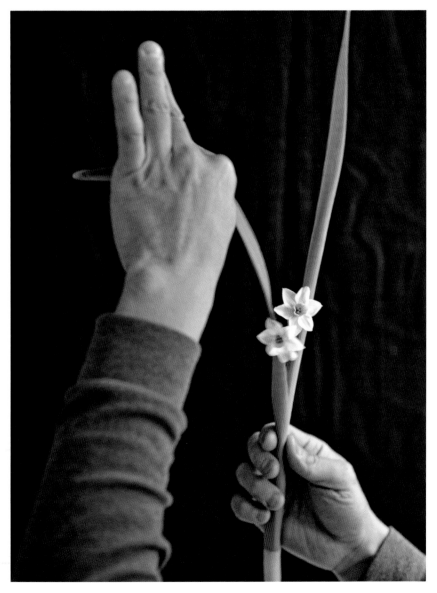

TECHNIQUES FOR BENDING AND SHAPING INCLUDE THE FOLLOWING:

BENDING A BRANCH (*TAME*) You can bend soft stems by lightly crushing them with your fingers. For hard stems, use the handles of the scissors to pound them.

BREAKING A BRANCH (*ORI-DAME*) This technique is used for harder branches. Bend the branch by slightly breaking it. Use scissors first to make a shallow cut in a branch about one-third of the diameter at the spot to be bent. Then, with your hands, bend the branch gradually on the opposite side from the incision.

TWISTING A LEAF (*NEJIRI-DAME*) Leaves that turn back or look unnatural can be gently twisted into the desired direction.

STROKING (*SHIGOKI-DAME*) This is a technique of bending and shaping by rubbing the leaves and stems to correct the curve direction. Place both hands on the area to be bent, and gently adjust the shape. If necessary, make the same action repeatedly to achieve the desired shape. Be careful not to damage the surface of the leaves. When this technique is applied to narcissus leaves and calla lily stems, gently pull or stretch them at the same time to achieve a graceful shape.

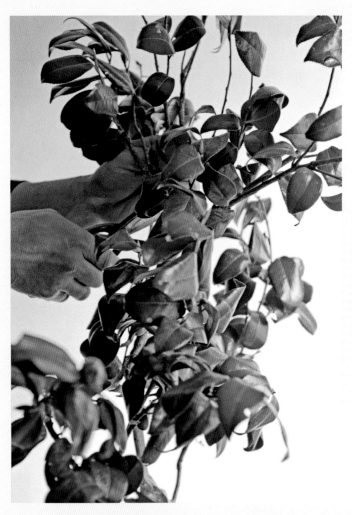

TRIMMING TECHNIQUES

In ikebana, the aesthetic appeal of a plant can be maximized by selective cutting. The way floral material is cut for an arrangement also provides an insight into the person who makes the selection and arranges it.

If many branches are used together in an arrangement, the character of the individual branches is diminished while the overall impression of the materials is accentuated. On the other hand, if only a single material is used, either a branch or a flower, the material speaks for itself with its shape or color. It is fun and interesting to discover your own preference for shapes among the many floral materials available and to make the most of their qualities in an arrangement.

The trimming technique described below is designed to help you identify and make the most beautiful part of a branch stand out.

Hold a branch and study its overall shape. Carefully look at how the branch naturally grows and in which direction it is facing.

When the branch has too many leaves and sub-branches, select the portions you want to retain and the parts you want to eliminate in order to bring out its beauty. Cut and trim the leaves and sub-branches, little by little, until the branch becomes more attractive to your eyes.

Notice the neat and attractive final form.

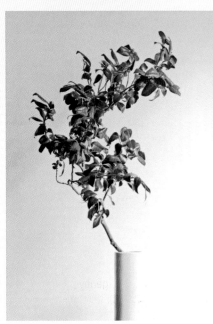
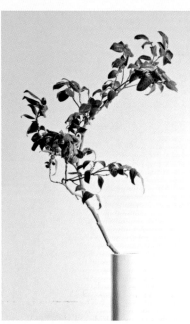
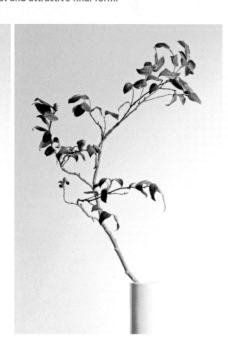

MAINTENANCE TECHNIQUES

A desirable environment for a flower is low temperature (2–6° C/36–43° F, except for tropical flowers) and high humidity (80–90%). In such an environment, flowers maintain slower respiration, lower perspiration and less energy consumption. These conditions prolong the life of flowers. Although it is not always possible to provide such an ideal environment at home, you should try to put the flowers in an optimal environment to allow them to rest, at least at night or while you are away from home.

To keep cut flowers healthy, it is important to balance the water evaporating from the leaves and that being absorbed by the stems. High temperatures, dry air and direct sunlight all upset the balance. Keep flowers away from places where water tends to evaporate, such as a windowsill that receives direct sunlight and wind, or near the air current of an air conditioner. In addition, keep flowers away from ripe fruit and cigarette smoke because ethylene generated from these things make flowers wither quickly. Paying attention to the environment around the placement affects the condition of the floral arrangement and makes all the difference to its lifespan.

In order to enjoy an arrangement for as long as possible, and thereby witness the evolution of the flowers' life whose intrinsic beauty changes with each day, you need to take care of the arrangement every single day. Organic matter, which is constantly secreted from the cut ends of the stems, is transferred to the water in the container and causes bacteria to propagate. Such bacteria clogs up the ducts and hastens the demise of the flowers.

To protect cut flowers from bacteria, two treatments are essential—water change and stem trimming, both on a daily basis. Through these treatments, fresh water and nutrients are transferred to all parts of the flowers and their life is extended amazingly.

Glass tableware

WASHING THE STEMS When the surface of a flower stem is slimy, it is because the stem has started to decay and is growing bacteria. Decay causes the stem's duct to clog. Wash the stems thoroughly each time the water is changed in an arrangement to get rid of the bacteria.

TRIMMING THE STEMS Apply the *mizukiri* technique (pages 8–9) for this treatment. Cut the end of the stem by 1–2 cm (3/8 –3/4 in) under clean water. By cutting the part of the duct filled with bacteria and scum to create a fresh cut end, the stem's water absorption capability will rejuvenate.

Naturally, trimmed stems become shorter and shorter. The shorter the stem gets, the easier it absorbs water. You can enjoy flowers for a long time by removing finished flowers and redoing the arrangement, although you must regard it as almost a new arrangement. Because of the constant trimming, the total balance of the arrangement will gradually change and become different from the original.

WASHING THE CONTAINER A container that is not clean will make the water cloudy. Some invisible grime, such as scum from a prior arrangement, is often attached to the surface of a container that has not been used for a while. Such a container, if used as it is, may promote the growth of bacteria.

Wash the container with detergent and soak it well in clean water before using it for an arrangement. Also, at the time of arranging, add some drops of bleach to the water to prevent bacteria from growing. Wash the inside bottom of a container with extra care, since residue tends to remain in this area. After washing the container, let it drip dry naturally rather than use a towel that may add dust to the clean container.

finding the right containers

It is important that your choice of container suits the kind of floral arrangement you want to create. Think about the texture, volume and size of the arrangement, depending on the season you are in, as well as its placement, and the situation and occasion, whether festive or everyday.

Some containers automatically go well with a particular season. Here are a few examples.

In the warm spring sunlight, pastel colors or bright colored containers bring cheer to interiors.

In the summer, glass vases, baskets and metallic or shiny-surfaced containers look cool and soothing.

Ceramics or pottery and thick woven baskets provide an arrangement with a warm earthy feeling in the autumn.

Formal porcelain china may be used for some holiday celebrations, such as Christmas and New Year in winter.

Above are only some examples of moods that can be set by the choice of containers. Of course, glass containers can be used in all seasons, depending on the content or atmosphere of the arrangement. Hand-made ceramic containers, both classic and modern designs, can be used all year. Although some traditional ikebana schools have a set rule that a basket can only be used for a summer arrangement, such a convention need not apply in creating modern ikebana.

In making an arrangement, it is essential to pay attention to the color, the shape and the structure of the flowers and branches you are using. At the same time, it is also fun to consider the size, color, shape, style and texture of the containers for coordination with selected floral material. See "Harmony of Elements" on page 27.

When selecting combinations, the pairing of decorative containers and

Various containers

simple flowers should generally be harmonious. Sometimes, however, a clashing of the characteristics of the containers and flowers may generate unexpectedly exciting results.

Although flowers and a container may be perfectly matched and well coordinated in an arrangement, this does not automatically spell success. The relationship with the entire space or, more precisely, the reason for the existence of

an arrangement in a particular place, should also be considered.

In order to express the thought you put into an arrangement more effectively, you should consider the place where the arrangement will be positioned and how it will be observed. The best position may not necessarily be the center of the table but, instead, at the end or edge of the table. In some cases, the best position does not have to be on

Ceramic containers

the table at all but, rather, on the floor, or even hung on the wall. Depending on the circumstances, it might be best to view the arrangement from a high or low angle, or slightly from the side. Thus, it is very important to decide the height of an arrangement in relation to the viewers. Harmony between the arrangement and the space itself is the key. Once the coordination of the arrangement to the space is established, it may be necessary to make more adjustments to ensure the arrangement will be seen from the best angle. An interesting technique to change the angle of an arrangement on a flat surface is to place a small stone or wood chip under the edge of the container to intentionally tilt it. Such subtle tilting of the container can create movement or fortify the direction and add accent.

As mentioned above, containers hung on the wall are interesting devices. Besides standard hanging containers, some types of vessels, such as bottles, tubes and pipes, or even ordinary vases can be hooked onto a wall. Containers affixed to the wall allow for unusual height and angle and have a dynamic and dramatic effect.

Vases for a single flower are useful for making quick and easy arrangements to decorate your room. When you pick a small flower in your yard or in a field, you can bring a sense of nature into your living space by quickly arranging without any planning. Flowers have the power to enrich our senses and provide comfort when we pause to look at them in our hectic lives. Try collecting various shapes of single-flower vases for adding a simple touch of nature to any space without a lot of fuss. Even a small flower matched with a suitable container gives a very positive impact to a space. The size does not matter; the coordination of the right elements is what counts.

ASSORTED CONTAINERS

There are many types of ikebana containers available in different shapes, colors, sizes and textures, but the most practical is a round, square or triangular wide-mouthed cylinder about 30–40 cm (12–15 in) high.

For beginners, it is a good idea to have a basic cylinder-type vase, since it is useful for practicing the stabilizing techniques described earlier, such as a horizontal support. In some cases, vases with smaller openings are easy to use for arranging because a complicated stabilizing technique is not required.

1 CERAMIC CONTAINERS A ceramic container is frequently used for ikebana because it has the texture associated with the earth, necessary for most flowers to grow. It also has a warm feeling even if the design is modern. A ceramic container goes well with a naturalistic arrangement.

2 GLASS VASES The most obvious characteristic of a clear glass vase is its transparency. Because of this, the flowers and the container are united and the whole shape of the arrangement is visible. Glass containers glimmer in the light. A pure, clear and cool sensation is unique to glass and is quite different from the feeling of earthenware.

As water can be seen through even translucent glass, an arrangement includes the form of the water as well. For that reason, the amount of water and the maintenance of it are also important.

The clarity of glassware creates a refreshing mood of its own not only for summer but for any season, in either traditional or modern styles. Deliberately exposing the water in an arrangement as a distinct component is an artistic choice, and therefore special attention should be paid to the cut ends of the stems visible in the vase.

Glass vases

3 METALLIC CONTAINERS Containers made of metal, such as iron, pewter or copper, have hard surfaces and thus impart a cool feeling. The cold nature of metallic containers makes them suitable for summer arrangements. The dull luster of pewter also fits nicely with winter arrangements. Gleaming metallic containers are often used for arrangements at festivities. The sheen and texture of metal contrasts with flowers and other organic materials and this can give additional impact to an arrangement.

In Japan, there is an extensive tradition of metal craft, and metallic containers have long been used for ikebana. Copper containers, in particular, are regarded as being noble and are used for classical *rikka* arrangements even today.

Metallic containers are relatively easy to use because their heavy weight can support big arrangements. Very firm stabilizing techniques such as a horizontal or cross support that cannot be applied to fragile containers may be used in metal containers because of their durability.

4 REPURPOSED VESSELS—*MITATE*
In Japan, there is a concept known as *mitate*, of discovering another value and finding a new appreciation for objects of daily use, such as dishes and tools. In ikebana, the notion is that old or common things can be seen with new eyes and therefore everyday objects

WHERE TO BUY CONTAINERS Often expensive pottery and antique vessels are used in ikebana. However, you can find good and useful yet inexpensive containers at retail shops specializing in home accessories or interior goods. You may also use receptacles for daily use or other mass-produced items and devices as containers. Western-style vases are often used in Japanese ikebana.

can be used as alternative containers. This is a concept borrowed from the Japanese tea ceremony of not relying on stereotypical ideas but seeking your own sense of beauty for yourself. It may be an interesting adventure for you to explore the objects around you and create an original arrangement with the treasures you find.

5 WOVEN BASKETS Baskets and trays match well with floral materials because both are made of plants. Arrangements in woven containers create a warm and generous impression. A shallow basket complements wild flowers picked in your garden or a meadow. Be sure the separate inner container for water is stable in the basket.

Below Metallic containers
Middle Woven bamboo baskets
Bottom Repurposed vessels

FINDING THE RIGHT CONTAINERS

principles of japanese floral design

Japanese-style flower arrangements should have, more or less, the characteristics discussed below. Understanding these characteristics is the key to creating an arrangement that is based on the concepts behind the work of Yuji Ueno. A grasp of these concepts will guide you in making simple Japanese ikebana and this is more important initially than mastering detailed techniques.

NATURE

It is important to always observe nature and learn from what you see. Ikebana is a process of developing a communication with the natural environment, and ikebana is the expression of the arranger's condensed feelings or perception through that dialogue.

It should be sufficient to use technique only to the extent that it allows you to express a feeling or sensation in your arrangement. We often encounter flower arrangements that are overly artificial and highly artistic. However, an approach to floral materials that considers them merely as materials is incompatible with the concept of this book. In some cases, an excessively skillful arrangement does not engage a viewer. It is up to the arranger to try to give the flowers a comfortable environment in which to express themselves freely.

It is also important to keep in mind that Japanese ikebana is not simply nature transplanted into a vase. Ikebana is, in essence, flowers picked from nature that are restructured, combined with a vase and presented as another form of nature displayed indoors. Therefore, the arrangement is no longer nature itself, but the crystallized form of the arranger's persona, the person who has interpreted nature with his or her own sensitivity.

In creating an arrangement, try to find and make the most of the alluring facets or expression of the floral material in your hand. Each flower has its own individual character, or face, just as it has had a unique life. Before cutting, carefully examine the flower and pinpoint its most beautiful aspect. You should discover beauty not only in the blooms but also in the shape of the branches, leaves, stems, and even the roots.

WATER AWARENESS

Fresh water is essential for ikebana to maintain the life of the floral material and make an arrangement last. It is often an integral part of ikebana and is viewed as a component along with the floral material. Water seen in an arrangement should be clean, and careful consideration should be given to the amount. Water should be "arranged" just like other materials to express the intentions of the creator and convey the purpose.

SIMPLICITY

The basic concept is to let ikebana be simple yet strong and to express a notion eloquently with minimal use of materials.

An overly complicated arrangement often projects something unreasonable, and, in itself, goes against the grain of

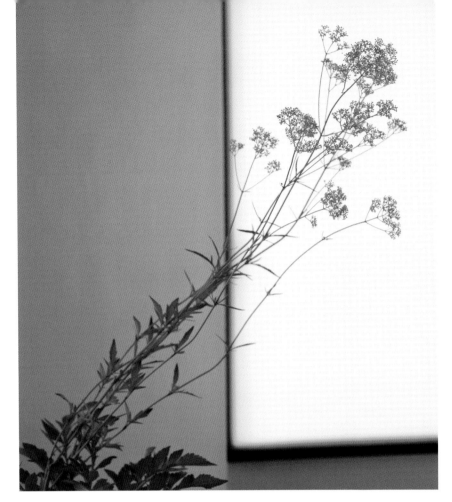

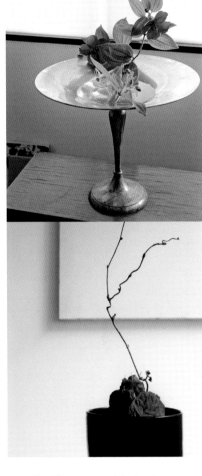

the nature-oriented philosophy mentioned above. How to express more with fewer materials is Yuji Ueno's aim in his arrangements. Not only in ikebana, but also in the demonstration of beauty in general in Japan, it is often characterized as "the beauty of subtraction". Zen philosophy describes profound truth by not mentioning it, nor explaining it. Zen also embodies the idea that we should save nature and not waste life, including the lives of plants.

With few materials to contemplate in an arrangement, viewers tend to look more carefully at the lines of the branches and stems and the shapes of the flowers, by which more meaning will be gained from the arrangement. Sometimes the simplest of Japanese ikebana arrangements seem more gorgeous than a typical Western-style arrangement with an abundance of blooms and foliage.

SEASONALITY

Flowers convey to us a sense of the seasons. Traditionally, the Japanese lifestyle always seeks harmony with the seasons. Japanese people learn from a young age to notice and appreciate even subtle, transient signs of each season and express them in daily life.

When the Japanese compose a letter, it is common to begin with expressive remarks on the season, and set phrases are used to convey such feelings. In *haiku*, a succinct form of poetry in Japan, a poem must include a *kigo* or formalized word expressing the season. Although the Japanese are sensitive and appreciate seasons in many ways, they also accept the fact that situations constantly change. This acceptance of instability and flux is known as *mono-no-aware* and holds much the same meaning as "here today, gone tomorrow" in English. Destiny and mortality

Opposite Observe materials closely.

Above left, top and above Arranging only a few seasonal materials in a simple manner makes impressive ikebana.

must be accepted because it is the rule of nature. This is all the more reason to enjoy a dialogue with nature in ikebana as profoundly as possible.

Similarly, there is the concept of *ichi-go ichi-e* or "treasure every encounter for it will never recur". The flow of a season is a chain of moments. In a particular moment, through the will of the arranger, flowers are coordinated with a suitable container, the arrangement is placed in a space, and people get together to see the arrangement. Ikebana is an art that fully manifests all its elements. Recognizing the transient nuances in each season and capturing fleeting moments in simple ikebana will enrich your life.

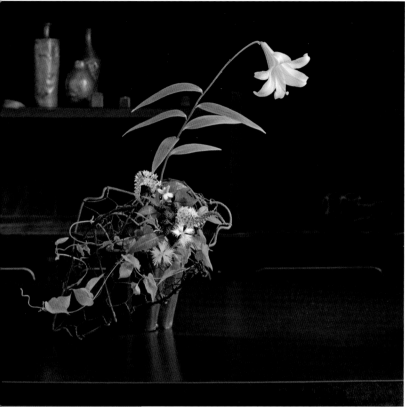

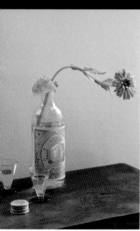

Top left White flowers stand out in a dark space.

Top right Feel the materials for a deeper understanding of their nature.

Above A flower Is arranged to face the natural light.

LIGHT AND SHADOW

As a rule of nature, plants grow and extend toward the sun. Trees and flowers that face the sun appear vigorous and exude a will to live. Without sunlight on earth, all life would perish.

Light also plays an important role in ikebana. An arrangement will become more natural looking and robust by taking into account the direction of incoming sunlight on the flowers.

Shadows or darkness are as important as the light. The balance of brightness and darkness or light and shadow is one of the keys to a successful Japanese-style flower arrangement. Known as "yin and yang" in English, this ancient Chinese philosophy of dualities was introduced into Japan long ago and permeated the culture. The belief that complementary forces interact to form a greater whole still resides to some extent in the Japanese psyche.

In the days before the advent of electricity, when candles and lanterns were the norm, there were strong contrasts in brightness between the inside and the outside of a house. The parlor room (*zashiki*) for receiving guests in a home was invariably dark and sparsely furnished. The Japanese room reserved for the tea ceremony, called *chashitsu*, was intentionally designed to be rustic and somber. Seasonal ikebana was placed in a raised alcove (*tokonoma*) of the room and arrangements were placed to highlight the flowers by receiving even the smallest amount of light. For that purpose, some color strategy, such as strong contrast and gradation, was applied to enhance the presence of the arrangement. It is always thrilling to see a tiny white lily gleaming alone in a dark space.

SENSORY PERCEPTIONS

Do not make an arrangement by only relying on your eyes. Try to appreciate floral material by utilizing the five senses to detect the fragrance of the flowers, the feel and texture of the materials and containers and even the sound of snipping flowers or the taste of sipping tea while in the company of flowers. Ikebana in Japan has long been associated with the tea ceremony and the occasion to enjoy refreshment and take refuge from the stress of everyday life. Ikebana is an art of the total experience of human life.

practical design tips

Here are some ideas for understanding core concepts in ikebana that help bring about successful arrangements. If you keep these points in mind, it will lead you to a deeper appreciation of ikebana.

1 VERTICALITY

One of the basic concepts in Japanese-style flower arrangement is that, in many cases, the arrangement has one vertical line moving upward. When a plant is growing straight up against gravity, it looks resilient and vigorous. Conversely, plants that bend over present a weak or depressed image. It is the same with our own posture as human beings. An upright form is one of the most essential aspects of all living plants.

Because of the perception of vertical strength, people receive positive energy and encouragement from upright plants.

In order to replicate this vertical energy in an arrangement, we need to use some flower stabilizing techniques (pages 12–15) but such techniques should be naturally hidden from view.

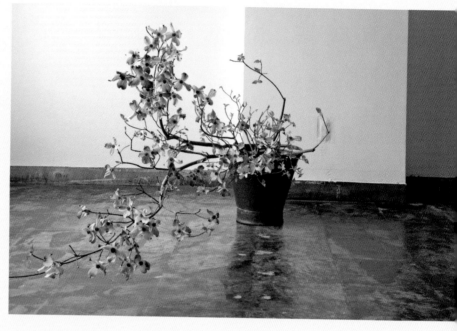

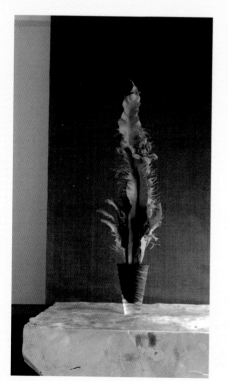

2 ASYMMETRICAL AND UNBALANCED BALANCE

An asymmetrical structure gives a viewer the impression that an arrangement is bigger than it actually is. In some cases, an asymmetrical arrangement makes the viewer feel movement or experience an awareness of direction.

The notion of "imperfect beauty" is an inherent part of the Japanese sense of beauty. An asymmetrical structure and unbalanced form in an arrangement that is pleasant to look at despite being uneven are at the heart of "imperfect beauty"—and successful ikebana.

A well-proportioned, symmetrical arrangement successfully conveys the perfection of beauty in a straightforward manner when you look at it. But extreme perfectionism soon loses its ability to intrigue us. Unbalanced in parts yet balanced overall attracts our attention and gives us something to ponder.

Left Verticality

Above Asymmetrical balance

Below Unbalanced balance

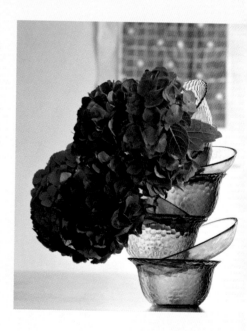

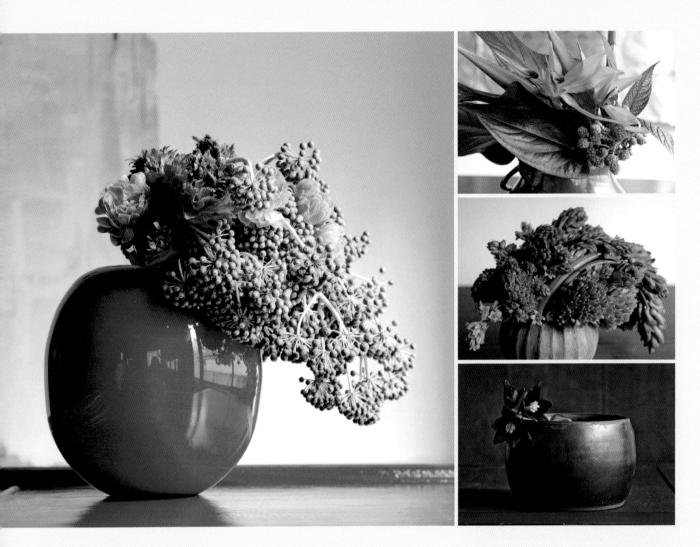

It takes time and practice to feel confident in creating an arrangement that is not symmetrically balanced. Unbalanced balance is a prevailing element in ikebana and many arrangements in this book are good examples that will help you grasp the idea. Let plant materials guide you with their natural growth and experiment with balancing the weight and showing the visual attractiveness of both mass and line. Soon you will discover a new sense of balance that encompasses both beauty and excitement.

3 COLOR

In putting together an ikebana arrangement, we must take into consideration two essential factors regarding the combination of colors: gradation and contrast.

Gradation is a layer of similar colors in the color scheme. Such a set of colors gives a comfortable and steady feeling to the viewer. You can develop gradation by selecting one color to start with and then move to cooler or warmer tones; for example, start with red, then red-orange, then orange, then yellow-orange, and finally yellow.

On the other hand, contrast consists of opposing or complementary colors that set up a feeling of tension and bestow strong impact on an arrangement. For example, red and green, violet and yellow and blue and orange are complementary or opposite colors. We can create a similar complementary color

Above left Complementary colors
Top Triad color scheme
Middle Gradation
Above Color contrast

scheme by using three colors, such as violet-green-orange as a triad. If you have a round color scheme chart (such as Color Wheel by THE COLOR WHEEL COMPANY™), you can easily find the relationship between all colors. Color wheels are available in large stationary stores or art supply shops.

In both gradation and contrast combinations, the color coordination stirs emotions in the creator when the arrangement is being made. It also leaves an impression on the viewer, generating an afterglow.

4 HARMONY OF ELEMENTS

The harmony of the flowers with the containers is one of the most important elements in ikebana.

Carefully study the details of flowers and branches, such as their colors, shapes and texture. Match your findings with a suitable container in order to express your feelings and intention properly.

Even if a container is not very attractive at first glance, once flowers are coordinated with it, it may take on a different air and become more appealing. When the union of the materials and the container is successful, you may be surprised and delighted beyond your expectations and be inspired to create other successful combinations.

Below Strong textural harmony
Bottom Fine textural harmony

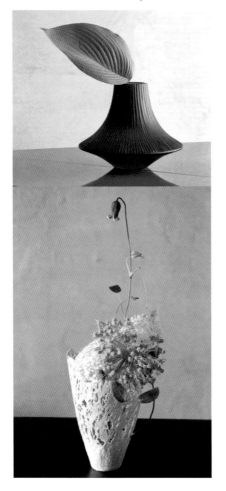

Above A frontal arrangement in which all the leaves face forward.

5 FACING TOWARD THE VIEWER

The flowers in Japanese ikebana are arranged primarily for viewing from the front. This means that a direct encounter between the arrangement and the viewer is anticipated.

Various messages may be contained in a Japanese-style arrangement that the arranger wishes to convey. When such messages are properly transmitted and received, the arrangement draws out the viewer's feelings, adding a subjective dimension to the encounter. Standing square in front of the viewers, the floral materials begin a dialogue and even a serious engagement with them.

Due to a long historical tradition as well as deep cultural influence from the tea ceremony, it is still a basic concept of Japanese ikebana that flowers are set in front of a simple background and seen from a face forward position, even though times have changed and people enjoy a modern lifestyle. As such, in Japan it is unusual that an arrangement is designed for viewing from different angles, or seen from 360 degrees. In contrast, Western-style arrangements that are often centrally positioned in spacious settings are designed to be viewed from all directions.

Even in living spaces without specific Japanese interiors, you can create display areas in your environment where the beauty of flowers can be emphasized and appreciated, by decorating such places with wall hangings, a screen, scrolls or works of art.

An arrangement is never completely perfect at the time it is finished. Aided by the background, the light and the person arranging it, the flower arrangement is about to approach its perfection. Such an arrangement finally becomes perfect when the arrangement is finished, the arranger steps aside and people view it. People must ultimately partake in the viewing and appreciation of the ikebana.

Naturally entwined vine acts as a support and as a part of the arrangement.

6 NATURAL SUPPORTS

The most common support device used in contemporary ikebana is a metal needle pin holder called *kenzan*. Interlocking rings of heavy metal called *shippo* is another device used to hold flowers in traditional ikebana. In the simple and modern arrangements in this book, use of such artificial means for supporting the floral materials has been avoided. Instead, different natural materials are used as the stabilizers and supports in the arrangements. It will thus not be necessary to struggle with concealing the *kenzan* pin holder and your arrangement can look natural and delicate rather than artificially formed.

Using such natural materials does not merely mean a way of treating flowers with gentleness. By not relying on man-made support devices, arrangers are exposed to the organic nature of plants and forced to be sensitive to the fundamental shape and structure of floral materials. This experience will eventually lead to discovering the beauty and an understanding of the qualities of plants.

Moreover, it is essential to respect the life of flowers, all the while manipulating them into a satisfying arrangement.

my flowers, my approach

YUJI UENO

I am always looking for the meaning of "arranging" flowers in a vase, even though flowers are beautiful as they are, alive and growing in fields and gardens. I am always thinking of how I can touch the hearts and minds of people with my ikebana in a striking and brilliant way using those flowers whose lives are surrendered once they are cut.

All creatures and plants have their own lives on this earth. Arranging floral materials means to shorten the natural life of plants and regenerate them in a container of water with added meaning; to realize the arranger's creative will with the help of those cut flowers. I think this is a very radical action by a human being.

Nature has its own inherent beauty and rationale. In the natural world, all living beings, as well as the colors we perceive from light, possess their own wavelengths and cast them into the atmosphere. In a flower arrangement, the stems and flowers may be artistically arranged to produce rhythm and tempo, the shape of a branch may create movement or a wave, or the entire structure of the arrangement may provide the invisible feeling of a larger universe. I get a feeling like a wave or a pulse from plants. I define this energy as a "vibration"; it could be called an aura.

Guided by the vibration I detect in nature, a spiritual power, I try to extract the aura that the flowers are giving out, and to resonate and sympathize with it. It is very important for me to carefully observe the floral materials when I am arranging them to interpret the beauty and vigor they possess in nature and to react accordingly.

Renowned traditional ikebana schools often focus on the conventions of arranging that are formalized by rules. This approach may be useful and meaningful for someone who wishes

Yuji Ueno arranging flowers.

to learn and master ikebana through its historical context. Personally, I feel it is not essential to rely too much on structure, even if following a fixed scheme is an easy way to study. I also think that blindly following set formulae is dangerous because, by doing so, you may not develop the intuition needed to bring out the true beauty of the flowers you wish to arrange. Rules and customs hold us back from experiencing the essence of ikebana.

The art of ikebana is one method of self-realization or self-expression, just like other liberal arts, including painting, photography, music, dance, film, literature, and even animation. Touching something as alluring as flowers, making beautiful arrangements and placing them in our living spaces is very emotionally satisfying. It has the same meaning as enjoying one's life.

Plants are living things. Naturally, they grow, blossom, wither and die. But handling and arranging flowers after taking their lives and then trying to give back life is a deep responsibility. Ikebana allows them to live with us for a short

time longer. This fact creates an encounter between the flowers and ourselves and conveys a strong message to us.

Basically, the life force of a plant is the same as that of a human being. Through the arrangement of flowers, we synchronize and sympathize with them. We begin communicating with nature. I see myself as a person who has a dialogue with a flower as another individual.

My goal in arranging floral materials is to make what everyone, even someone who does not have any interest in flowers, feels is simply beautiful. I believe that beauty is a universal concept, or the truth, and no explanation is required. No questions need be asked. I wish to make arrangements that express a universal beauty that can be appreciated anywhere in the world. It would be my great pleasure if many people could experience a Japanese-style flower arrangement for themselves, and understand it, and eventually decorate a corner of their homes or public spaces with flowers. I encourage people to make themselves happier and enrich their lives with simple ikebana.

spring

Under the gentle rays of sunshine, fledgling lives are stirring. The plant world begins to come alive and whisper its rebirth. All the grasses, flowers and branches are shooting straight upward. Young, shiny, green leaves peep out and then unfold slowly with each day's warm light. Bamboo quickly extends from the hard ground, growing taller with each passing day.

Arrangements suitable for this season can be described as gentle and discreetly bright while capturing the nuances of a warming season full of new growth. At the beginning of spring, opaque vases of warm colors as well as pure white ones match well with spring flowers and branches.

The approaching steps of spring are so quiet that we sometimes overlook them in our busy daily routine. As the ground is still cold in early spring, it is not time yet to make an arrangement that shows water. Porcelain containers in delicate shades and textures are often used to create the feeling of a season that is slowly getting warmer.

Spring is also the season of new green leaves and the fresh transparent beauty of such leaves moves us. Appreciation of seasonal beauty should be expressed in a spring arrangement by careful selection of young floral material, like blossoming trees in the garden, such as cherry, dogwood and forsythia.

Another characteristic of spring is the gentle colors: the sunlight is soft and the flowers have various subtle tones in the petals. The slight change of the light affects the colors and we feel an airiness that lifts our spirits. We can express such subtleness with the gradation of colors in flower arrangements. It is important to understand the sense of expectation of the season so that you may fully express such delicate nuances in modern simple ikebana.

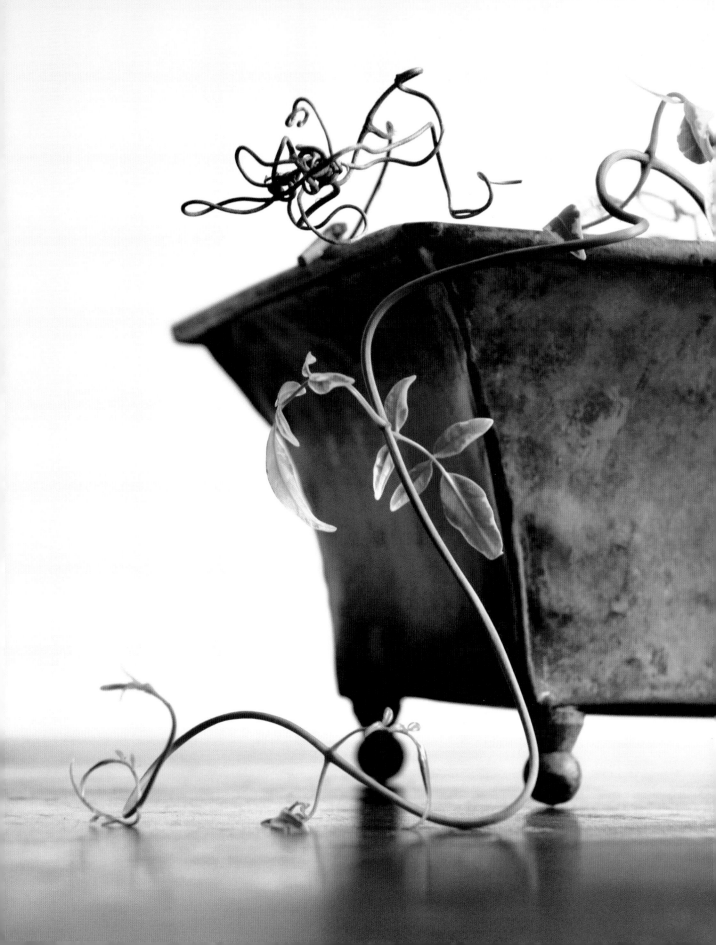

stacked boxes of orchids
a new year's greeting

In Japan, New Year is considered the start of spring. A set of finely decorated stacked lacquer boxes for storing special foods eaten at the start of the year is called *jubako*. These splendid boxes are filled with a colorful array of prepared foods that dazzles the eyes before delighting the palate.

Each tier of the *jubako* is aligned with the next and serves as a lid for the box below. The top box has a separate lid. To utilize the set as an interesting container for flowers, each box has been offset and small shot glasses for holding water are placed inside. The offset placement of each box can be varied to create an interesting structure, like a formative artwork. In many other countries we can find similar decorated boxes that can be set one atop the other to resemble *jubako*.

Floral materials for New Year should be more gorgeous than daily flowers in order to communicate the wish for happiness and prosperity expressed in greetings. Strong upright branches such as pine and plum are used as well as splendid flowers such as roses, lilies, bird-of-paradise and many varieties of orchids, like cymbidium and cattleya.

Short stems of vanda orchids are inserted into three of the boxes to make the most of their beautiful modern shape and pattern. The deep violet hue is a complementary color of the gold lacquer and creates a vivid contrast. The tiny white spots on the orchid petals synchronize with the rhythm of the neat check pattern. The interesting contrast of color and texture is energetic and expresses the joy of starting out a new year.

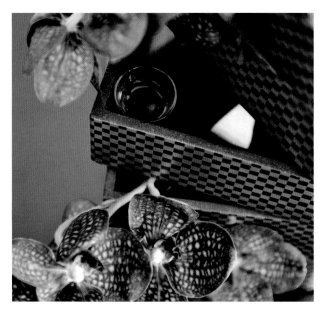

MATERIAL
VANDA ORCHID

CONTAINER
LACQUER BOXES

CHARACTERISTICS
UNBALANCED BALANCE, COMPLE-MENTARY COLORS

TECHNIQUE, KNOW-HOW AND METHOD

An interesting aspect of this arrangement is its architectural quality, which is achieved by stacking. Piling up objects of the same shape is innately exciting. Make sure that the stacking method is stable, and do not use too many heavy flowers that may topple the structure.

Objects stacked up in an orderly manner are beautiful and invoke a comfortable impression of stability or a sense of excitement, depending on the number of items. As piling things up is an activity against gravity, it also creates a sense of tension. Especially in this arrangement, each box is slightly offset in a clockwise direction making the entire shape look like an inverted pyramid. This helps to make the arrangement more thrilling. The sensational form shows off the beauty of the flowers.

Stacked lacquer boxes can be substituted with other separate boxes of a similar size made of lacquer or sturdy material. When you make this type of arrangement with smaller boxes, reduce the number of colors you use. For example, a monotone arrangement with only black and white colors will give you a simple yet modern impression with great impact.

Left Each box is set out of line and small glasses are placed in the boxes, as *otoshi*.

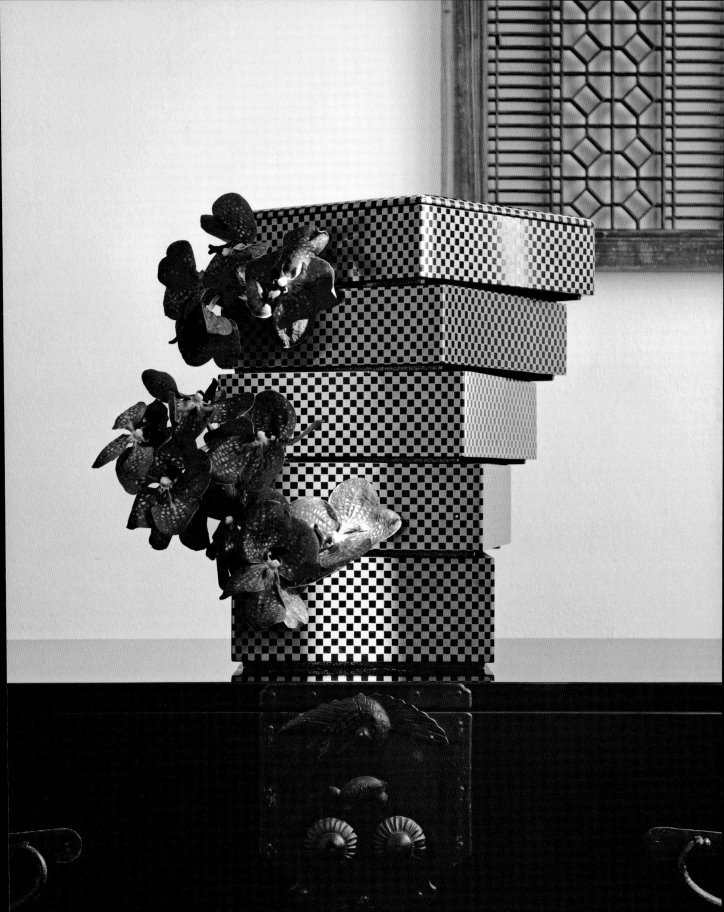

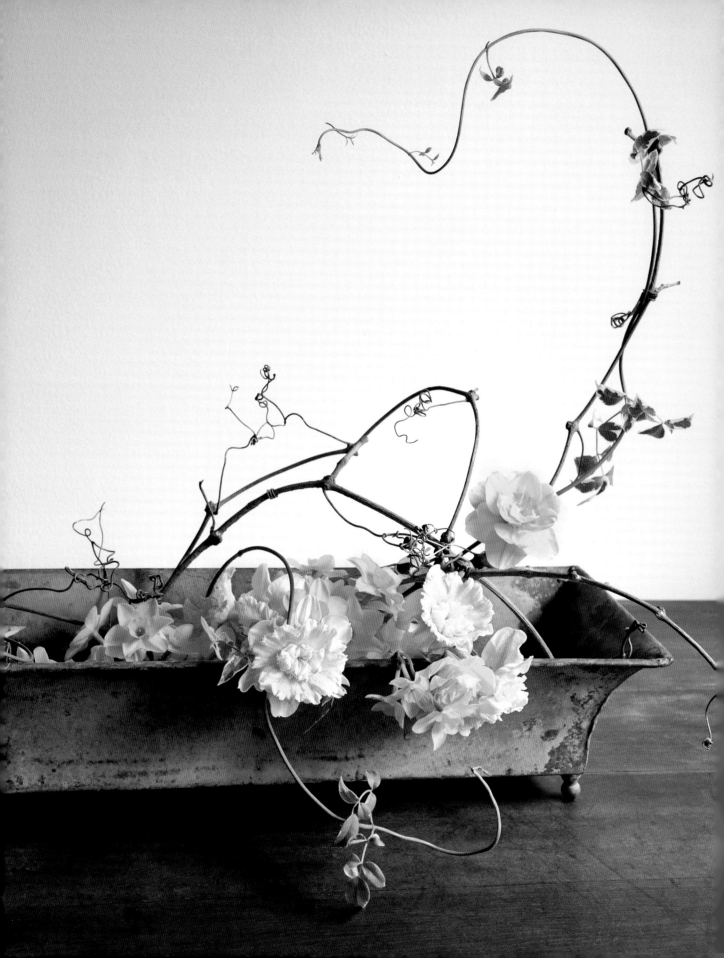

daffodils and vines
the early spring arrivals

In early spring, the plant world wakes up from winter stillness and slowly unfurls. The bitter cold lessens, yet we can still feel winter's breath in the air. Spirited daffodils brave the chill and bloom first to announce the impending arrival of spring.

This arrangement tells a story of the intermingled emotions of two seasons: spring flowers bloom while the touch of winter remains. Dried grapevine, with its association with winter, is used as a support for the gently curved line of jasmine awakening with the energy of spring. Daffodil blooms are arranged low and at varying heights to emphasize the activity of the creeping vines. The dried grapevine also supports small bunches of flowers spaciously placed near the center of the arrangement that become the starting point for the creeping jasmine. The design feels full yet airy.

Coming closer and looking into the arrangement, you can see many flowers in it, as if they were hiding from the front view. In order to make a neat and beautiful arrangement, it is important to be mindful of the distinct features of the plants and pay attention to small details.

Wild grapevine works not merely as a floral support technique but as an important element to suggest the remnants of the passing winter. Starting with a barren branch and then adding sprouting jasmine, represents the vitality of spring. The moment when a fresh jasmine tendril is climbing up from the soil is captured.

When arranging, pay attention to the direction in which the vines are pointing. As a horizontally wide container is used here, the main vertical vine is arranged so that the tip of the vine points inward. The entire volume is restrained within the width of the container, as if to suggest the daffodils are supporting and protecting the young vine.

An important point is the combination of materials with different seasonal qualities. You must carefully select the materials; not every spring material fits well with dried grapevine. This arrangement achieves a synchrony of jasmine and grape vine because neither overpowers the other. Other thin dried vines used for Christmas wreaths would also be suitable if they are not too brittle or ragged. Some clues to such harmonious combinations may occur naturally in your spring garden.

Right Dried wild grapevine is used as a support in the arrangement. Although this container is a large Western planter box, a simple and natural Japanese-style arrangement can be created without using floral foam or a *kenzan* pin holder. The point is to create large, open spaces with the twisting vine that will define the size of the entire arrangement. Tie together several bundles of daffodil flowers with wire. Be conscious of the amount of space inside the container and the volume of the bunches. Do not fill the space completely.

Right Notice the movement of the tip of jasmine vine.

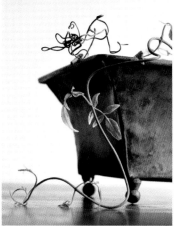

MATERIAL
DAFFODIL, WILD GRAPEVINE (DRIED), JASMINE

CONTAINER
ANTIQUE-FINISHED PLANTER

CHARACTERISTICS
SEASONALITY, SPACING

the elegant narcissus
fragrant flowers and slender leaves

This neat arrangement is formed of narcissus with lovely fragrant flowers and slender leaves. The tip of the leaf stretching past the top of the background poster brings to mind the serenity of an elegant dancer.

In general, narcissus flowers bloom higher than their leaves, but by making the arrangement with the flowers in a lower position, you can create a steady and graceful atmosphere.

This arrangement symbolizes the beauty of simple Japanese ikebana, where the natural shape of the flowers is improved by a gentle human touch.

Below left First, look for the flower's inherent beauty.

Below right Using your fingers, gently rub the leaves to create natural movement and expression (page 16).

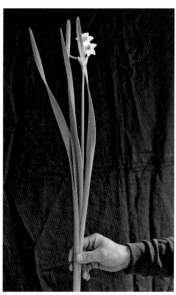 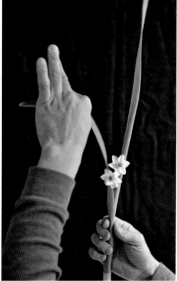

MATERIAL
NARCISSUS

CONTAINER
OPAQUE GLASS VASE

CHARACTERISTICS
SIMPLICITY, VERTICALITY

TECHNIQUE, KNOW-HOW AND METHOD

Look carefully to understand the flower's natural beauty and movement. To reshape the narcissus flower, soak the bottom of the stem in water for a few minutes and then grasp the end of the stem and gently pull out the center flower stalk from the white sheath that holds the flowers and leaves together. Then remove the leaves one by one, taking care to save the sheath without tearing it.

Reassemble the separated stem and two leaves in the appropriate balance. Adjust the lengths and slowly push the sheath back on. Trim the bottom of the stem. Using your thumb and index finger, gently rub the leaves upward to enhance the twisting and curving of the leaves. Be careful not to handle the leaves too roughly or for too long or they will wilt.

The essence of this arrangement is the balance created by the two lines of leaves and the flowers set just below the center point that link the lines together and also to the container. You can substitute other similar materials, such as small daffodils and freesias or New Zealand flax for leaves, accompanied by a separate flower. When using separate materials, select a simple container and flowers that match it well for the best results.

A narcissus flower faces in a specific direction. When you want to make an impressive arrangement with only a few materials, choose flowers that face in a clear direction, such as narcissus, clematis or lily. To create and enjoy a simple Japanese ikebana style, use only one flower or just a few, depending on the size and length of the leaves.

Thin and long leaves take the lead in showing the direction of the entire shape. In this arrangement, vertical movement is emphasized. Placed in a container with a small mouth, the leaves straighten up to express strong will. The arrangement gives the impression of a dignified person.

tulip mania
the joy of spring

Shouting the joy of spring's arrival, every tulip from my garden is unique in shape and color. Flower bulbs convey the vital energy of rebirth. The powerful unrolling tulip leaves show the uplifting feeling of spring.

By simply putting tulips with their bulbs and roots still attached into a common wine glass is to make a pretty arrangement and a picturesque tableau of spring. The arrangement reveals the natural power and unique shapes of the flower bulbs.

In order to express each flower's individual character, it is very important to examine the flowers one by one. Wine glasses may be lined up or intentionally set unevenly in order to create an interesting rhythm. The random placement of glasses creates a sense of unbalance, so flowers should be placed with careful consideration to achieve overall balance of the arrangement.

Pay close attention to the total distribution of height, direction and the amount of space each flower occupies. Careful consideration of both the setting of the glasses and the placement of the flowers determines the rhythm, movement and balance of the entire arrangement.

This is a really enjoyable arrangement because you will establish a dialogue with each flower during its creation.

TECHNIQUE, KNOW-HOW AND METHOD

Tulips are among the most popular and accessible flowers. If you observe them carefully, you will find that each tulip is unique in terms of the size of its flower, the length and curve of its stem and the shape of its leaves. Make full use of such distinctive characteristics in your arrangement to generate harmony between different types of tulips. In arranging, consider the timing of the opening of the flowers and the coordination of various types and colors of tulip.

In this arrangement, wine glasses are used as containers. Notice that the shape of the glasses resembles the form of the tulip blooms and bulbs. This pleasant shape, when utilized repeatedly, acts as the design motif running through the arrangement.

Other flowers sprouted from bulbs, such as crocuses and hyacinths, can also be arranged in this way. Clean off all dirt before arranging. Select glasses that suit the size and height of the flowers you use. As you can see here, even ordinary daily tableware can be a suitable container for an arrangement. Just as the different shapes of tableware are best suited to various foods and drinks, so too they can be the inspiration for coordinating with flowers.

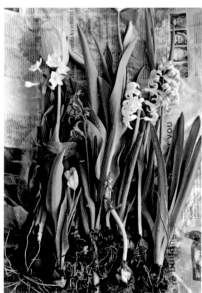

Above left Spring flower bulbs, such as tulip and hyacinth, directly from the garden.

Above right Crocus bulbs.

MATERIALS
TULIP

CONTAINER
WINE GLASSES

CHARACTERISTICS
SEASONALITY, UNBALANCED BALANCE, RHYTHM

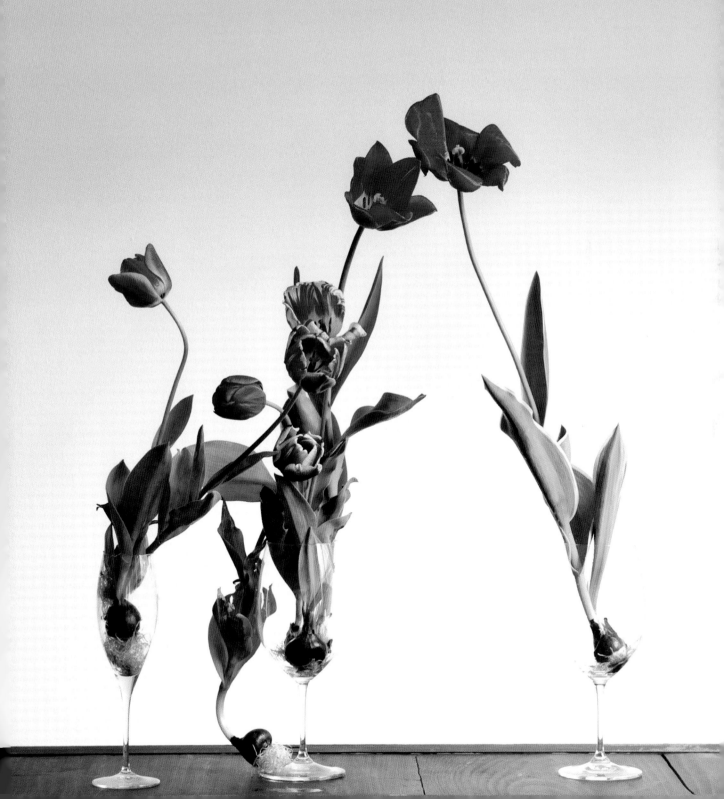

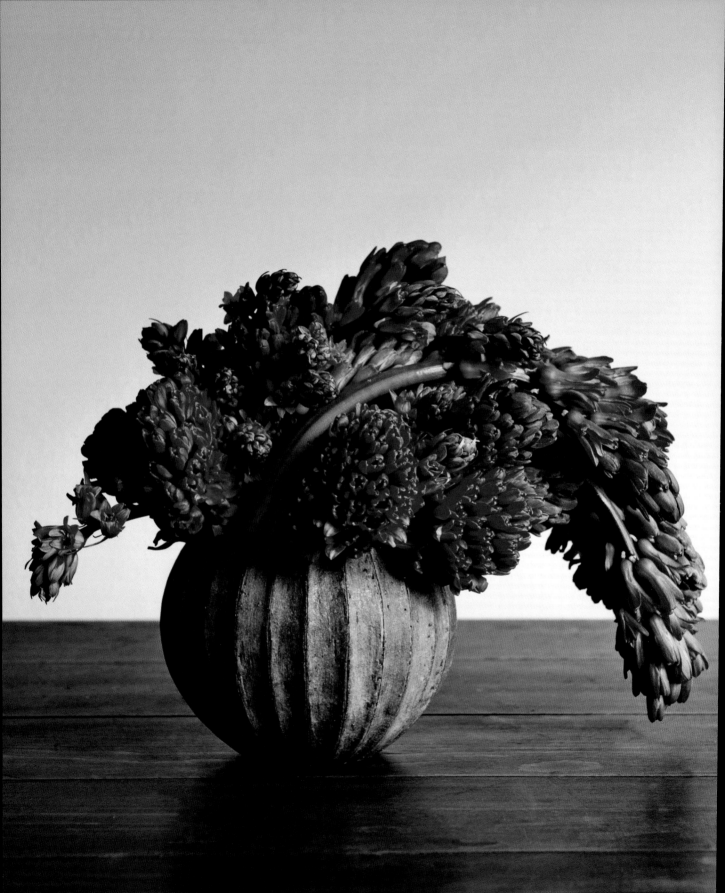

blue on blue
overflowing hyacinths

Spring quickens after long winter hibernation. How dramatic the blue of these hyacinths seems in early spring! The flower is named after Hyacinthus, a young handsome Spartan prince who was adored and accidentally killed by Apollo. The myth says his spilled blood gave life to the flower, and therefore fragrant hyacinths are often associated with rebirth.

In the traditional coordination of kimono that developed in ancient Japan and continues to epitomize the essence of style today, there is a custom of layering garments that results in rich hues and color tones. Layering dark blue flowers imbued with the lingering winter twilight creates an arrangement of subtle color gradations. Placed in light, the color gradations stand out and the arrangement is dramatic.

Only tight, not fully opened blooms of hyacinth are used in this arrangement to enhance the feeling of density overall. Although it is an arrangement of only one kind of floral material, each flower has a unique shape and color shade. The individual characteristics of each flower should be considered as you arrange one stalk at a time to achieve the desired form.

In this season, a ceramic container that suggests an image of the earth adds a touch of gentleness to the arrangement. Notice how the strong molded lines of the container harmonize with the bending stems and volume of the hyacinths. The whole arrangement, including the flowers and the vase, is united in one pleasing form. Yuji Ueno defines this perfect union of elements as a "vibration between the vase and the flower".

TECHNIQUE, KNOW-HOW AND METHOD

The essential points of this arrangement are to decide on the directional movement and to coordinate the shapes of the container and the flowers so that they look unified.

This is a voluminous arrangement with a combination of deep colors. The clusters of flowers, larger than the container and overflowing from it, generate a momentum that would impress any viewer. The round vase, along with the shape of the flowers, contributes to the spherical shape of the whole arrangement. Although it looks like one cluster, five kinds of hyacinths with different flower types, colors and volume are, in fact, used. These differences generate the dark blue gradations in the arrangement.

In place of hyacinths, you can use plants such as muscari (grape hyacinths) or lilacs, as long as they can be arranged into a mass with the same effect.

MATERIAL
HYACINTH

CONTAINER
CERAMIC VASE

CHARACTERISTICS
COLOR GRADATION, HARMONY OF ELEMENTS

Above left First, examine each flower's color and shape.

Above right Make the arrangement, considering the pattern of the vase, with its molded lines, and the stem flow of the hyacinth.

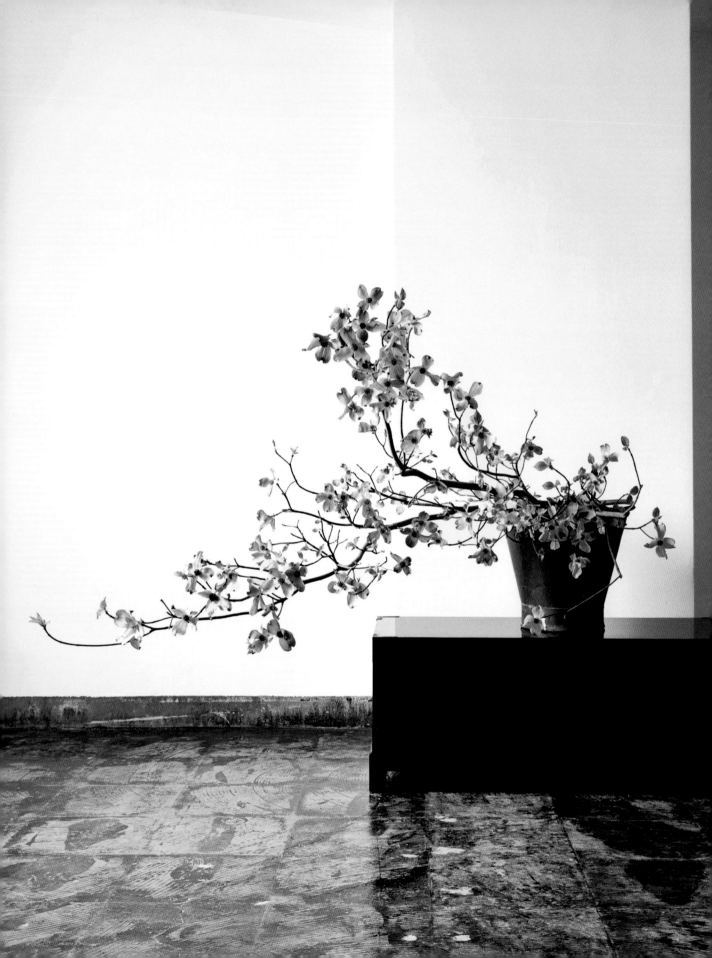

dogwood blossoms
spring is in the air

It looks here as if spring is being invited with open arms. Charming dogwood blossoms can be seen in gardens or along well-tended streets in urban areas. Dogwood branches can be arranged in wide-mouthed containers or buckets that harmonize with the modest flowers.

Simply arranging only one kind of branch with blossoms can result in a refined arrangement. Quite often it is not necessary to add multiple materials when flowering branches themselves are so attractive.

In this single floral material arrangement, the use of the space—an important characteristic of modern Japanese ikebana—is well considered. This modest arrangement uses the whole space as one big stage without the focus being solely on the work itself.

As the blossoms are perched on the tips of tiny branches, it is easy to see the playful lines of the whole branch. A short upward branch and a longer one flowing dramatically from the side of a sturdy bucket allow the arrangement to appear stable yet unstable at the same time: this is unbalanced balance.

The important points of this arrangement are the natural upward direction of both branches and the tension created by the longer branch not reaching all the way down to the floor. The longer branch, which hovers above the floor, conveys a feeling of strength to the viewers that would be lost if it touched the ground.

TECHNIQUE, KNOW-HOW AND METHOD

Flowering trees, such as apricot, peach, and cherry, are traditional symbols of spring in Japan. Small dogwood trees with white or pink blossoms are also recently appreciated as a cultivar.

First, look at the whole branch carefully to establish the particular line you want to emphasize and then cut away the excess (page 17). Trim any branches, leaves and flowers that detract from the main movement of the arrangement.

Dogwood usually grows horizontally. To utilize this feature of natural growth and balance of the plant, I made an arrangement in an ordinary bucket. The arrangement extends horizontally and is set on a low chest to create some space below the longer branch. If the branches were arranged more vertically, the arrangement could be placed directly on the floor. When arranging branches, carefully consider the patterns of growth of trees and shrubs in their natural environment.

The longer branch was arranged first and set the tone for the movement of the entire arrangement. The remaining branches were added to give support to the main branch and to balance the arrangement. The shorter branch flows in the same direction as the main branch but also visually lifts it up from the strong downward movement to one side.

MATERIAL
DOGWOOD

CONTAINER
TIN BUCKET

CHARACTERISTICS
ASYMMETRICAL BALANCE

Above To stabilize a large arrangement like this, the technique of a cross support that is wound with wire at the cross point is used (page 13). For the support, it is essential to choose strong twigs that are fairly straight.

lilies for two
for saint valentine's day

The romance of lovers on Saint Valentine's Day is celebrated with two kinds of lilies embracing each other in a modern pink container that sets the warm mood of the arrangement. The petals of the pink and white lilies are arranged to appear sensually entangled. Full blooms overflowing from the vase represent a profusion of love.

To express a simple and strong love, this arrangement moves in one direction. Traditionally, ikebana is viewed from one perspective, but placed in the center of a table this passionate arrangement can be enjoyed from all sides. A large space around the arrangement will show off the classic beauty of the lilies and allow the fragrance to fill the room. The flowers are arranged to look attractive from all angles but not to look exactly the same. Buds about to open imbue the arrangement with movement and vitality.

Opposite The flower maintains lively tension because it almost touches the table.

Below Bronze-colored wire is loosely twisted and placed in the container. Wire should be strong enough to support the flowers.

MATERIAL
LILY

CONTAINER
CERAMIC VASE

CHARACTERISTICS
COLOR COORDINATION, FOUR-SIDED VIEW

TECHNIQUE, KNOW-HOW AND METHOD

Cut stems in varying short lengths. Trim the leaves except the uppermost small ones to emphasize the bold shape of the flowers. Do not pile the flowers up in a single mass. Although the flowers are placed close to each other, attention should be paid to how each bloom is placed individually so as to look natural and not be crushed.

Wire placed inside the vase as a stabilization technique (page 13) holds a small number of materials firmly, yet allows some space between the blooms as they open up to make the arrangement look relaxed. Without the use of wire, the flowers will fall into the vase on top of each other and the arrangement will look tight and cramped.

Lilies have prominent stamens topped with abundant pollen. Florists usually remove the pollen tips as soon as the flowers bloom. But the pollen-laden stamens are a beautiful natural part of the flower and many people prefer to keep them intact. Decide which is better for your arrangement based on the circumstances.

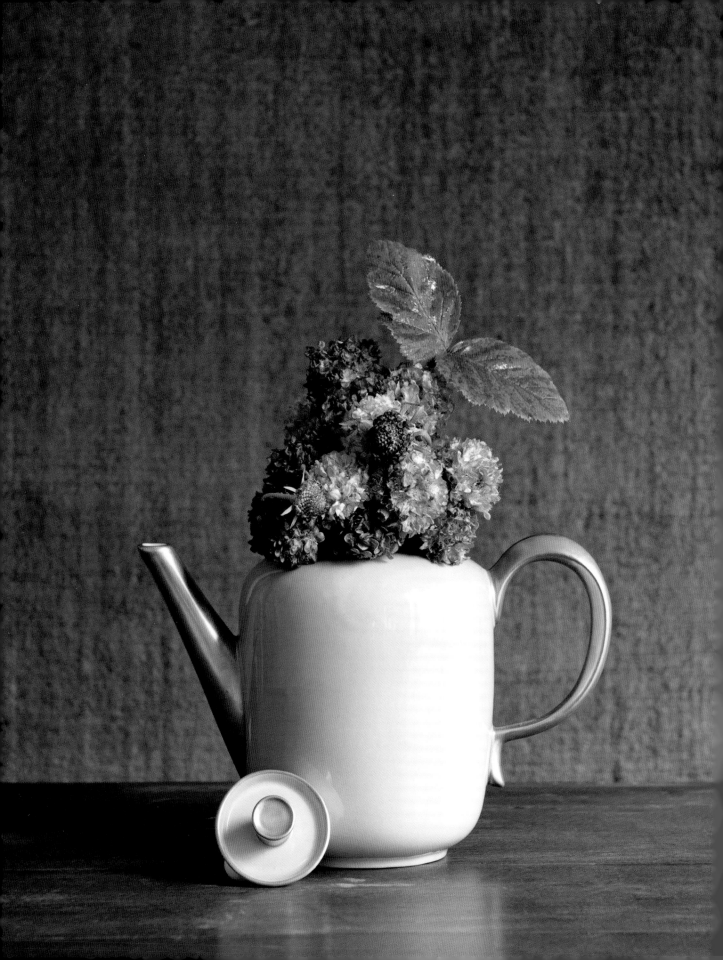

an antique teapot
with candytufts and mint

This pale blue teapot was found in an antique shop in San Francisco. Although not meant to hold flowers, the shape and color make it an unusual but very appealing container for simple ikebana. There is a concept originating from the art of Japanese tea ceremony, known as *mitate*, a way of looking anew at an object and using it for a purpose other than what was originally intended.

Utensils or common tools in daily use can be looked at with new interpretations of utility and converted into tea bowls or flower vases. Tea masters have attached a high value to the experience of *mitate* and finding true beauty in such utensils, without prejudice based on their price tags. This concept extends the boundaries for creating simple ikebana and is explored in several places in this book.

Here, an antique European teapot has been reinterpreted as a flower container. The delicate blue tint, like a robin's egg, and gold adornment of the teapot complement the tight mass of magenta-colored flowers. The smooth roundness of the teapot harmonizes with the cluster of flowers and provides a comfortable balance. The crisp green mint leaves are as light as a butterfly and add a sense of playfulness to this joyous arrangement.

The placement of the lid is an important accent that repeats the rounded form of the teapot and the flowers and provides continuity. The gold spout and handle hold the arrangement steady.

With the introduction of the idea of *mitate*, you may discover a fun way of enriching your daily life by taking a fresh look at ordinary objects around you and assigning them new uses.

TECHNIQUE, KNOW-HOW AND METHOD

This arrangement is inspired by the charm of the teapot. Its cute yet elegant round shape is brought out in this arrangement. As the colors of the teapot are light turquoise blue and gold, purplish-pink flowers were selected as a triad color scheme. The teapot's round shape is emphasized and continued by the similar shape of the round candytufts. Mint leaves on the top were chosen as a symbol of tea.

Create your own arrangement using your favorite teapot or vessel by matching it with flowers that bring out the beauty of the container. To highlight the shape of a pot, the volume of flowers should not exceed that of the pot. Avoid a design that conceals the outline of the vessel.

MATERIAL
CANDYTUFT, SCABIOSA BUDS, MINT LEAVES

CONTAINER
ANTIQUE TEAPOT

CHARACTERISTICS
MITATE, COLOR COORDINATION, FORM

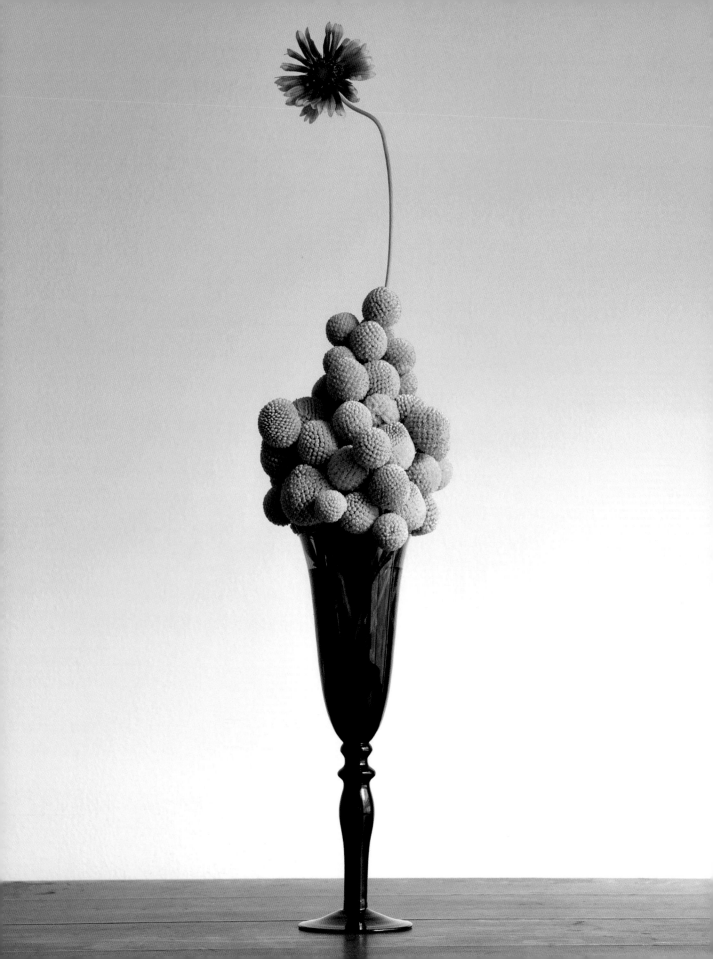

an easter sundae
billy buttons in a glass

Western style flower designs for Easter often consist of yellow or pink flowers sprouted from bulbs, colored eggs, and sometimes rabbit dolls on the side to re-create the impression of a spring garden.

Easter, with all its symbols, is not a well-known holiday in Japan. Here, craspedia or billy buttons, which resemble fluffy baby chicks, are piled up using a simple arranging technique to express in a sophisticated way this special celebration of rebirth.

It is fun to see the round balls of billy buttons mounting up in a rhythmical manner and topped with a single robust rudbeckia (coneflower). This is a carefully constructed arrangement full of the playful charm of pop art, composed of simple materials in an ordinary wine glass. The brown color of the wine glass not only matches well with the bright yellow of the flowers but hides the stems from view.

From left to right Place one stem in a wine glass. Add stems one by one to gently create the form you have in mind and to express the movement of continuity up to the top. The stems become interconnected and naturally support the whole mass. The final single stem of rudbeckia is added last and gracefully extends upward.

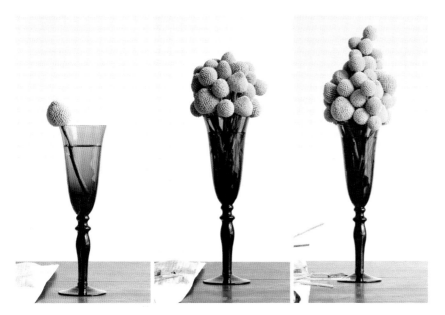

TECHNIQUE, KNOW-HOW AND METHOD

This ascending design with bulging volume near the center expresses a growing upward movement. The single rudbeckia (coneflower) floating above provides relief from the mass of mounting billy buttons and repeats the line motif of the stem of the glass. Such a pure and delightful arrangement is the perfect decoration on Easter Sunday. The balance of the height and volume of the container and the flowers is also important. The mass of the flowers is only slightly larger than the container. Too much massing of the continuous round shapes would take attention away from the beautiful silhouette of the wine glass. The top flower should be cut long enough to make it appear to float above the arrangement.

MATERIAL
CRASPEDIA (BILLY BUTTONS), RUDBECKIA (CONEFLOWER)

CONTAINER
WINE GLASS

CHARACTERISTICS
RHYTHM (REPETITION), VERTICALITY

mother's day memories
the warmth of soft poppies

A single red carnation is symbolic of Mother's Day in Japan, but it is an image taken from the West and promoted only in the last forty years by florists. In some cultures, a pink carnation is a symbol of a mother's undying love. A contemporary interpretation is expressed in a simple arrangement of colorful poppies that make us feel the kindness and warmth of motherhood. A table decorated with this modern arrangement in pastel colors will make any mother smile.

Poppies in various pastel tones are arranged as if overflowing from the container. Poppy petals have a silky crepe texture and come in several shades. The colors may stand for different ideas depending on the arranger; passionate red may stand for a mother's love, pink may mean mercifulness and orange may be the color of joy. Poppies in full bloom may express happiness and laughter. Partially opened flowers and buds are full of boundless possibilities and fill us with anticipation. Each stage of the poppy bloom reminds us of the times and scenes we have spent and shared with our mothers.

The fresh lime green of the felt vase cover is a solid base from which the poppies burst and hover. The shapes make us feel happy and the color combinations confirm that we are in the middle of spring. This unforgettable arrangement is the focus of a memorable day for expressing thanks to our mothers.

TECHNIQUE, KNOW-HOW AND METHOD

What kind of message do you intend to convey with your arrangement? How can you best express yourself and your ideas in an arrangement? These are important issues to consider before starting. Observe each flower's color, shape and texture carefully to determine the flower's expressive power. The feeling you get from a single flower and that from many flowers massed together are different. Consider these questions and find answers that you can translate sensitively into your own creation.

In this arrangement, special attention is paid to maintaining each flower's uniqueness. Although the blooms look massed together, there is actually some distance between them and their heights also differ to reveal the stems. The flowers are positioned to one side. The asymmetrical design represents the spontaneous nature of the poppy stems.

Left A single poppy in a glass flask is a complete contrast to the arrangement opposite, full of blooms. Here, you see the interesting curving movement of a single poppy stem. With its downward-looking direction, lonely appearance and thin, curving stem, this poppy displays its individual qualities of delicate sensitivity that should be expressed even in a bunch of the same flowers.

MATERIAL
POPPY

CONTAINER
CERAMIC VASE, FELT VASE COVER

CHARACTERISTICS
ASYMMETRICAL BALANCE, COLOR COORDINATION

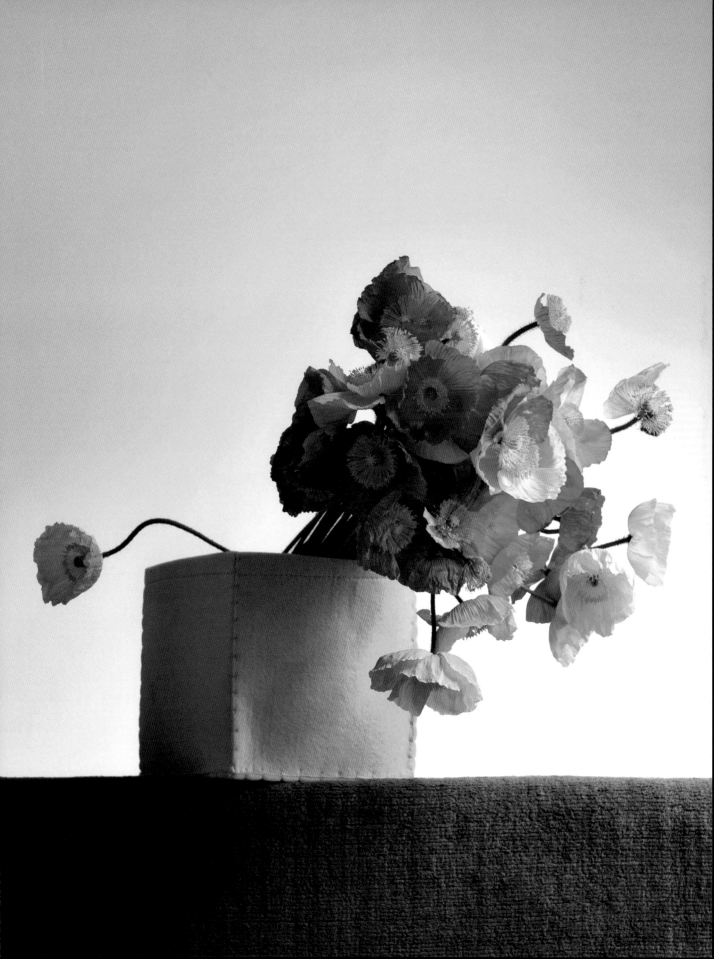

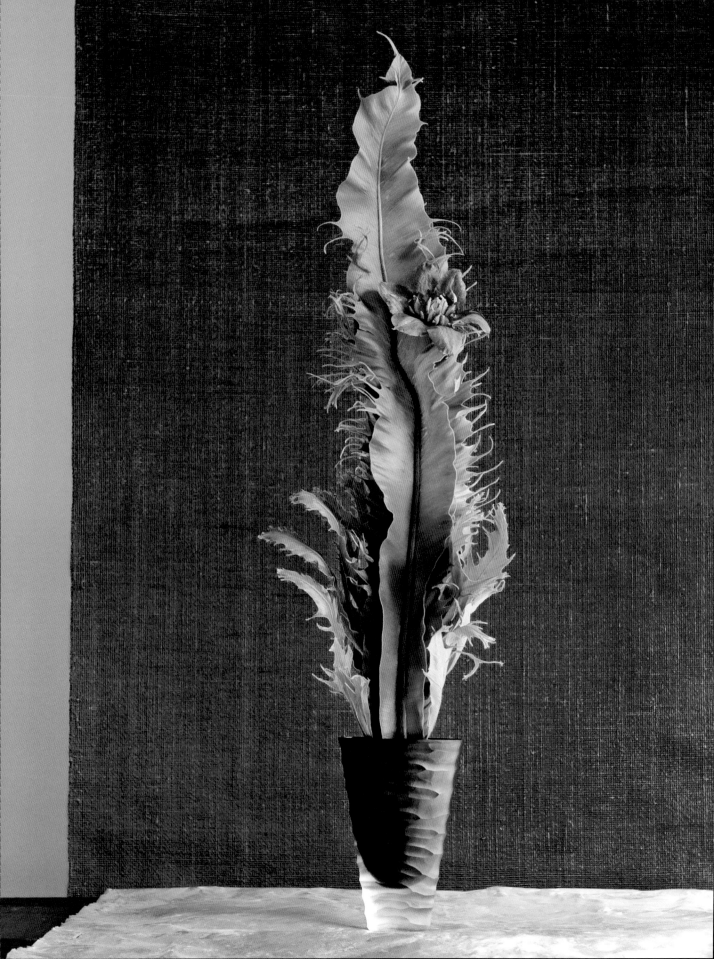

dignity and energy
for father's day

Fathers, or men in general, may be too shy to accept a flashy flower arrangement. This is a quiet, thoughtful and simple arrangement with controlled colors. The fern, which grows upright, represents dignity. A composed vertical line is characteristic of traditional Japanese ikebana developed nearly 500 years ago. There is a long history of enjoying vertical ikebana, known as *tatebana* or *rikka*, especially on formal occasions. This impressive vertical arrangement represents the strength and energy of standing up as humans or rising grandly from the ground like trees.

TECHNIQUE, KNOW-HOW AND METHOD

The bird's nest fern plays the role of a support for other flowers. First, leaves with an interesting shape and movement are selected. Two or three leaves are lined up straight with one leaf extending higher than the others to set the tone for the arrangement's distinct vertical direction. The flower is not put in the exact center, but arranged slightly toward the right. To master a Japanese sense of beauty, avoid symmetry and try to create overall balance of your arrangements with some components of unevenness within. A black glass container with rough cuts adds a masculine touch to the arrangement.

MATERIAL
BIRD'S NEST FERN, CLEMATIS

CONTAINER
GLASS VASE

CHARACTERISTICS
VERTICALITY, ASYM-METRICAL BALANCE

Above Select one leaf with an interesting formation. It also acts as a support.

magnolia and ivy
cascades from a hanging bucket

The Japanese tea ceremony takes place in a traditional room called *chashitsu*. The room is painstakingly prepared and decorated with simple ikebana to welcome guests for the congenial gathering. Arranging a few seasonal floral materials naturally and effortlessly for the tea ceremony is the art of *chabana*. An unpretentious flower arrangement is placed in the special *tokonoma* alcove, either on the floor, hung from the ceiling by a chain or hung by a peg on the wall or side post.

The tea ceremony is a chance to enjoy fine arts, nature and the poetry of life in a leisurely setting. The appreciation for simple ikebana that brings a hint of the season to a particular spot in your home can be enjoyed as poetic expression. In your daily life, make it a custom to select flowers and coordinate containers to be enjoyed in a designated place throughout the year.

A hanging flower arrangement, known as *kakebana*, offers a different approach to the standard arrangement of flowers placed in a vase on a table. Flowers and leaves picked in the fields and arranged indoors as decoration is, in itself, a stage for creative expression and skill. However, because a hanging arrangement quickly attracts our attention, there is much impact in such an artful action. Sometimes hanging arrangements provide the viewer with the impression that plants are popping out from the wall.

This is an unusual arrangement of floral materials in a bucket hanging on a wall. Here, a basic implement such as a bucket is converted into a container for the arrangement and hung high to focus attention on it. The plain white wall suddenly changes into an inviting stage for creative expression. When the arranger uses a discerning eye to convert an ordinary item like an old bucket into something aesthetic, it is regarded as *mitate* in the world of Japanese arts and aesthetics.

TECHNIQUE, KNOW-HOW AND METHOD

In hanging arrangements, the position of the container is important. Hang it higher than the viewing point but not so high as to go unnoticed. Keep in mind that the arrangement is made so that the floral materials in the container appear to be approaching the viewer from a high position. A view of only the undersides of flowers and leaves is undesirable and should be adjusted.

Filling such a large hanging bucket with water would be impractical, so a smaller container is strategically placed inside the bucket (page 14). This method of using an inner container is suitable for large-mouthed deep containers and eliminates the need for a lot of water and its heavy weight.

Other low vines, such as grapevine and various climbers and creepers, are suitable for a hanging style arrangement. Neatly trimmed cascading plants like bougainvillea and weeping trees are also good. A single flower or flowering branch may create an interesting hanging arrangement. But take care to place the material so that flowers are facing the viewer from overhead. Decide what kind of expression you want to convey to the viewers in your arrangement.

MATERIAL
IVY, MAGNOLIA

CONTAINER
METAL BUCKET

CHARACTERISTICS
MITATE, ASYMMETRI-CAL BALANCE

Right A large empty can is placed inside inside the bucket, as *otoshi* (page 14), a suitable method when using large containers.

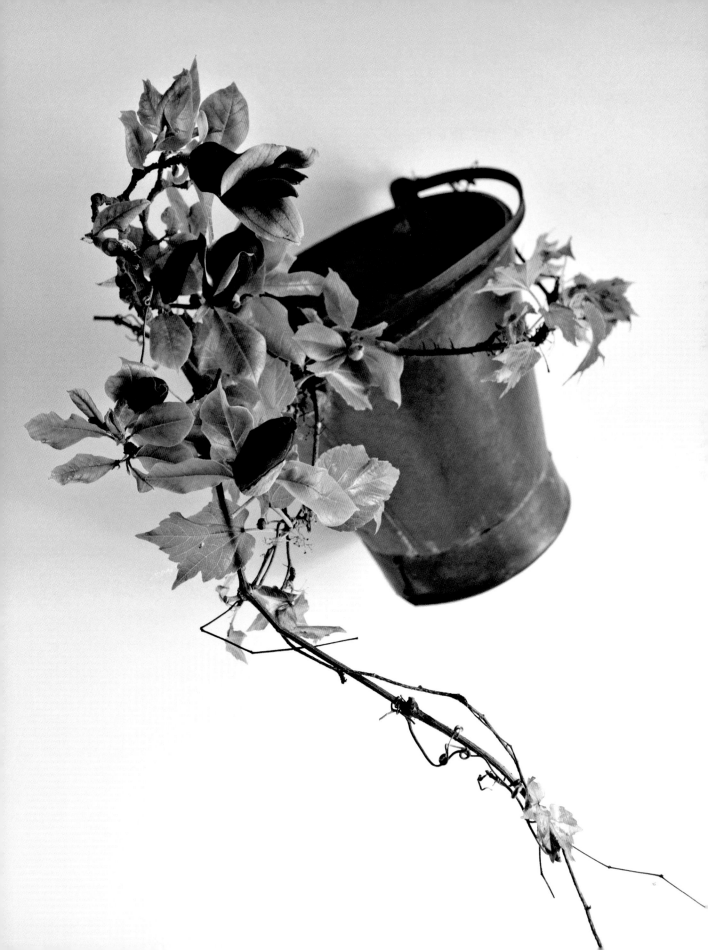

berries bubbling over
a cheerful birthday celebration

Each fatsia berry looks like a bubble.
This stunning arrangement reminds us
of overflowing champagne bubbles
immediately after the bottle is opened at
a birthday party. The sensually round and
red glass vase is brimming over with small
green fatsia berries and red ranunculus
arranged in a mass. The strong asymmetri-
cal balance produces a lively and vigorous
atmosphere in the entire space.

The vibrancy of the arrangement and
the reflected light make it appear to be
moving. A dramatic moment has been
captured in this arrangement created for
a memorable occasion.

TECHNIQUE, KNOW-HOW AND METHOD

The concept for this arrangement is based
on the image of the vase. To match the color
of the vase, red flowers in a similar tone are
selected. Then, to complement the red, thick
clusters of green fatsia berries are incorpo-
rated. As the vase has a spherical form, the
round berries successfully continue the circular
motif. The difference in the size of the vase
and the berries creates contrast. The contrast
of colors and texture puts the vase and floral
materials in contention and, at the same
time, provides of focus for the viewer. If the
objective is a beautiful arrangement, the
viewer will not forget it.

To make this arrangement, fatsia berries are
first bundled to form a mass. This bundle acts
as the support for the double petal ranuncu-
lus. Each ranunculus stem is inserted into the
tiny gaps between the berries to create a
single united form.

MATERIAL
FATSIA JAPONICA BERRIES,
DOUBLE PETAL RANUNCULUS

CONTAINER
GLASS VASE

CHARACTERISTICS
COLOR CONTRAST, HARMONY OF
ELEMENTS, ASYMMETRICAL BALANCE

Right Fatsia berries are used as the support for
the flowers. This arrangement is made by first
putting the fatsia berries in the vase and then
inserting the ranunculus in the gaps between the
berries. You can enjoy this dynamic arrangement
either from a distance or up close. Illuminated by
candlelight at a party, the vase glows like an ember.

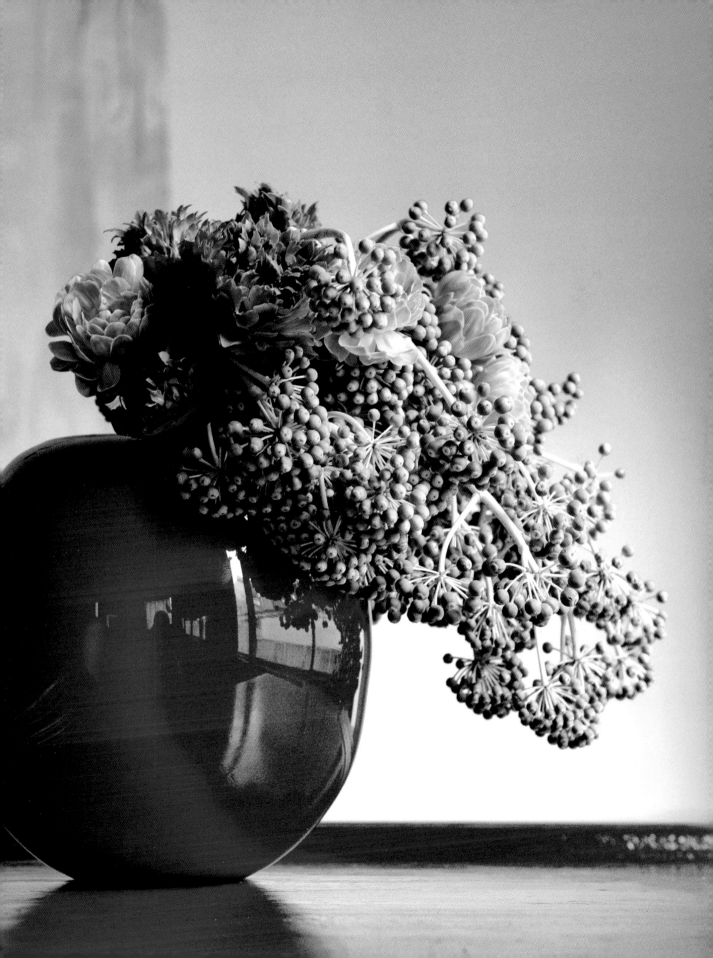

rustic simplicity
a rusted pipe with clematis

Using the idea of mitate—repurposing something that is considered useless or junk—a discarded (or forgotten) rusted pipe has been recycled here as a container for an innovative ikebana floral arrangement, fitted with a holder for water.

The rusted iron pipe is a symbol that all life eventually withers and loses purpose. But in spite of the rust, there is beauty to be found in such decay. A single clematis flower is inserted in the pipe, producing an electrifying contrast in the arrangement. The rusted iron pipe, in turn, highlights the elegance of this double petal clematis. There is only a pipe and a flower. This is the notion of reduction at its most extreme: everything that is not needed is subtracted to reach the purest form, and there the essence of the beauty is crystallized. This is the basis for the practice of the tea ceremony and Zen teachings.

Below left Hammer a nail or hook into a wall and hang an iron pipe on it. Insert a small glass test-tube as an inner container, or *otoshi*, for water (page 15).

Below right Double petal clematis flower.

MATERIAL
CLEMATIS

CONTAINER
RUSTED IRON PIPE

CHARACTERISTICS
SIMPLICITY, *MITATE*

TECHNIQUE, KNOW-HOW AND METHOD

The chosen rusted object, such as the pipe shown here, should be lightly brushed to remove rust residue. Insert a plastic or glass test-tube into the pipe and tape it in place, if necessary. Drill a small hole into the back of the pipe and hang it on a small hook or nail driven into the wall. If the pipe appears unstable, drill another hole and anchor it on two nails. Select a plain wall to showcase such a found object container.

Pay special attention to the flower's shape and color in order to enhance its contrast with the container. Keep in mind also that the expression of a flower sends a different message depending on the direction it is facing, so carefully consider what you want the flower to say to viewers. The clematis used in this arrangement can be substituted for other graceful flowers with contrasting texture, such as a lily, hibiscus or rose.

Using found objects or discarded utensils and similar rusted junk as containers requires a change in thinking and a bit of courage on the part of the arranger. But you will be amazed to find how dramatically such utensils come back to life once accompanied by a matching flower. Surprisingly, the warm and aged quality of rust goes well with both dried materials and fresh flowers. Using found objects as containers is becoming popular in Japan, especially with young ikebana artists. Try it in your living space as well.

a medley of branches
maple and loganberry

Japan is a country blessed with many deciduous and evergreen trees. In spring, the trees come into bud and shiny, crisp leaves flash around us. Branches have always been a basic component of Japanese ikebana and clearly evoke the seasons. This all-green arrangement on a table comprising a mix of early branches brings the freshness of spring indoors. The light green of the young leaves on the branches makes the viewer feel that spring is here even without the addition of colorful flowers.

Only a few branches of two kinds of trees are used in the arrangement. Two kinds of maple are placed near the bottom of the display so that they flow horizontally and give an impression of airiness. These branches alone in the pure white container are quite beautiful. By adding a loganberry branch, which stands vertically and then drifts sideways, the arrangement catches the light streaming through the window. It is a simple yet dramatic arrangement.

Here, the asymmetrically inserted branches create a dynamic structure with a wide-open space. The S-shaped flow of the branches expresses the movement of light and fresh air.

TECHNIQUE, KNOW-HOW AND METHOD

The beauty of fresh spring green cannot be fully expressed by leaves alone. The direction of the light and the surrounding space both help to project the beauty of fine leaves to a viewer. Keeping this in mind, pay attention to the density of the leaves and the amount of sunlight transmitted through them in the arrangement. If the leaves appear overly dense and piled up, cut away some of them to open up spaces and bring in more "air". As more light passes through the horizontal branches and their thin spring leaves, an impression will be created of warm air breezing gently through the arrangement.

A cross support is a necessity in this arrangement.

MATERIAL
MAPLE, LOGAN-
BERRY (BLUEBERRY)

CONTAINER
CERAMIC VASE

CHARACTERISTICS
ASYMMETRICAL
BALANCE, SINGLE
COLOR COORDINA-
TION

Left Use a cross-shaped support technique (page 12) to stabilize the branches. First, place the maple branches in a bold way. Then, insert a well-trimmed loganberry (blueberry) branch upright in the cross-shaped support. To maintain the vigor of the arrangement, be careful not to let the branches or leaves touch the table.

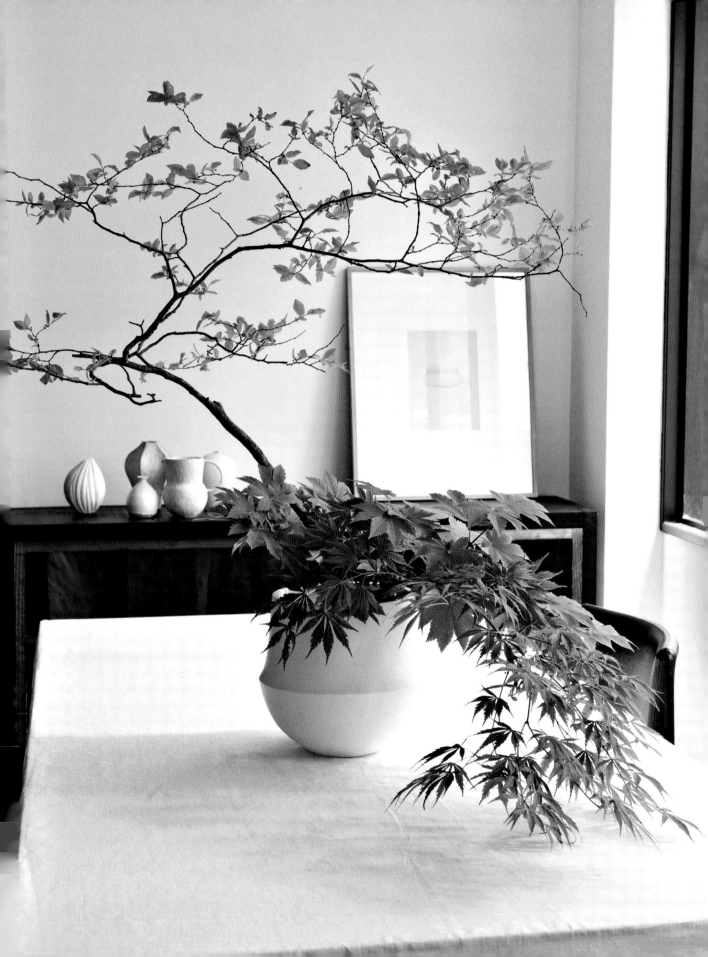

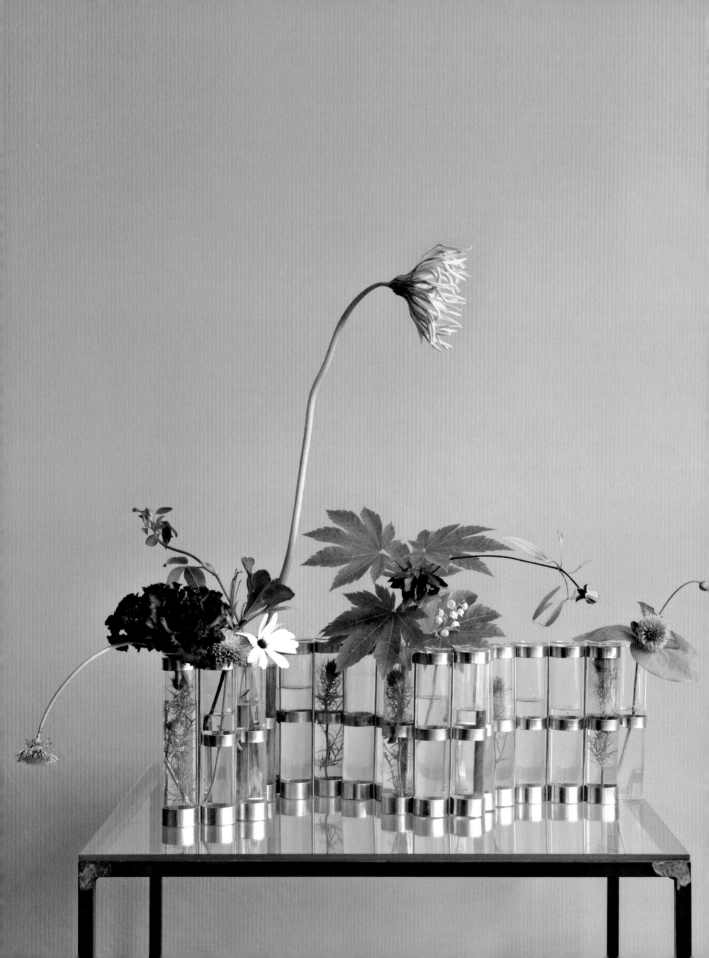

spring flows into summer
an ensemble of seasonal flowers

The four seasons change gradually but inevitably, each flowing seamlessly into the next. Just before spring is about to end, summer is already upon us in a game of hide-and-seek. It is even said that in Japan there is another transitional season between each of the four main seasons. Expressing this delicate transformation of seasons is at the heart of Japanese ikebana.

In both traditional and modern ikebana, flowers about to peak (*hashiri*), at their peak (*sakari*) and past their seasonal peak (*nagori*) are arranged together. In this arrangement, the blooming period of lilies-of-the-valley and dandelions is about to end, while hydrangea has just started to sprout. It is not just an ensemble of pretty seasonal flowers, though, but a subtle attempt to create awareness of time passing: a balance between the notions of birth, growth, decay and rebirth. We are made to feel, all in one arrangement, a sense of anticipation, enjoying the present moment, missing what has passed and having expectations of the future. That said, observing the present, the past and the future in one scene is very rare in the real world.

A container consisting of a sequence of glass tubes is used. Some of the tubes are intentionally devoid of flowers though filled with water. Remember that unbalanced balance, or imperfect perfect, is the keyword for a Japanese-style arrangement. Consider the balance of the height, density and rhythm, and enjoy creating an arrangement of flowers that implies the changing seasons. A combination of small pale spring flowers, full late blooms and buds about to open, can all create different moments. Soft green leaves and a dainty yellow gerbera can bridge the spring to summer. Flowers placed under water can give us a hint of the upcoming summer months.

TECHNIQUE, KNOW-HOW AND METHOD

Clear glass containers against a bright blue wall backdrop create a summer atmosphere. Mostly spring flowers are arranged to create a fusion of spring and summer. A gerbera looking at the incoming light appears to be longing for summer.

Consider each flower's features separately and also the overall balance and rhythm of the flowers together, particularly the height and density. As for the color scheme, mainly select flowers of pale pink to dark purple tones and add yellow flowers as a complementary color. The blue hue of the wall acts in an important supporting role of the triad color coordination.

MATERIAL
GERBERA, LILY OF THE VALLEY, DANDELION, AZALEA, MAPLE, CHOCO-LATE LILY, SCABIOUS (SCABIOSA), HYDRANGEA, CLOVER, CLEMATIS, AFRICAN DAISY (CAPE MARIGOLD), BLACK SARANA

CONTAINER
CONNECTED GLASS TUBES

CHARACTERISTICS
SEASONALITY, WATER AWARENESS

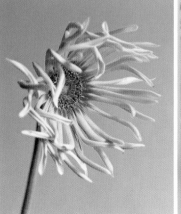

Left to right Lily of the valley, gerbera and scabiosa.

summer

In strong sunshine, light and shadow contrast more deeply. Foliage and flowers emerge richer and darker in color. Vegetation expands everywhere and grows densely in gardens and parks and along roads.

As Japan is situated in a temperate climate zone with a mild rainy season in early summer, there are more varieties of flowers in the season than just tropical ones. For example, typical summer flowers in Japan are hydrangeas, lilies and morning glories. But, undoubtedly, the prevailing color of summer is green and the beauty of the myriad leaves cannot be overlooked. How can we deal with the intense sunlight and find refreshment with floral materials?

It is essential in summer to make an arrangement that appears light and cool to counteract the heat. Arrangements using transparent water-filled containers or lush green leaves have a visually cooling effect. Exposing abundant water, with its clear and crisp nature, is a key component in creating a refreshing arrangement.

Clear or translucent colored glass containers and low basins that reveal a pool of water are deeply appreciated for their cooling and soothing impression. Alternatively, simple metal containers or metallic ones can be used effectively to produce the same results.

In summer, an arrangement should be simple and straightforward. A complex or messy arrangement may look too oppressive and may wear out the flowers as well. An arrangement delicately created with white or light-colored floral materials, such as lilies and grapes, may help you imagine being in the cool shade of a tree in the highlands even if you are actually living in a hot crowded city.

On the other hand, simple vigorous arrangements with verdant summer foliage, such as fatsia japonica, banana, aloe and other tropical succulent plants, may boost viewers' energy to enjoy the summer. Broad leaves reflect the light but also generate shade and a sense of relief from summer's heat. The sunlight transmitted through fine leaves feels gentle and uplifting.

Let your impressions of summer guide your creativity to make a simple ikebana that brings seasonal enjoyment into your home.

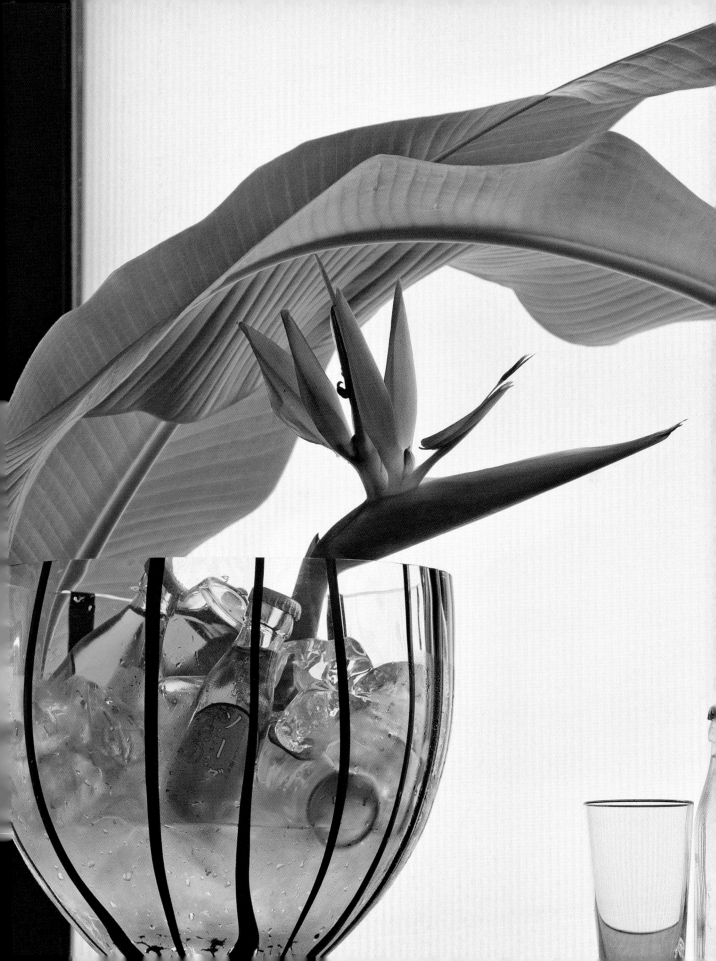

hosta and hibiscus
an eye-catching combination

This is a very refined arrangement that beautifully demonstrates an essential quality of Japanese-style arranging: the harmony of plant material and container. Here, the leaf of the hosta plant has a pattern of ribbed lines similar to the surface of the container. But the relation between the two goes much further. Not only do the outlines of the leaf and the vase reflect each other in form, the blue-green color and matte texture of the vase enhance the sheen of the verdant leaf and vice versa. The leaf also appears to be moving in the same direction as the vase; at the same time, it appears to be moving away. Although the vase appears modern and simple, its assertive and unusually sharp form makes it a challenging container.

A showy hibiscus peering over the leaf adds impact to the arrangement. The bright pink hibiscus is placed high and in the center to balance and softly accent the powerful form of the arrangement. A flower expresses various feelings with the direction it faces. Looking slightly downwards, this hibiscus appears to shyly blush.

Another striking feature is the contrast of the blue-green vase and emerald green leaf with the bright red flower and the deeper red of the table.

TECHNIQUE, KNOW-HOW AND METHOD

The vein pattern of the hosta leaf, the ribbed design of the container and the green color tones of both are beautifully coordinated in this simple arrangement. It is not always possible to encounter such an ideal union of materials and container, but you can always try to capture such a perfect moment by being senstive to the plant materials and potential containers around you.

The arranger neither created the hosta leaf nor the vase, but a true act of art is achieved at the point when the two elements are combined. Only one flower is added as a focal point and it has a calming affect on the dramatic placement of the leaf. Simplicity is successfully condensed in this arrangement.

The hosta leaf is obviously in complete harmony with the container. However, the impact of the arrangement depends largely on the direction and angle of the leaf. For maximum impact, the leaf is placed frontally so that it is completely visible to viewers. The flower is carefully set on the hosta leaf with the stem hidden behind it. For even more effect, the arrangement is placed against a plain wall.

The direction of the sunlight shining down on the arrangement causes the green to gradually change from light to dark. The red of the hibiscus complements the green tones and produces a strong contrast. The deep red table surface and the reflection of the vase on it further continue the color theme and the form.

The shape of the vase makes it difficult to place flowers firmly within. A Western-style arrangement with a large mass of flowers may not be difficult because the flowers will support each other. But if you want to put only one flower in a similar wide-mouthed container, some support structure must be utilized. A connected support (page 13) stabilization technique is used here.

 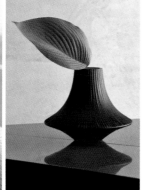

MATERIAL
HOSTA PLANT LEAF, CHINESE HIBISCUS (ROSE OF SHARON)

CONTAINER
GLASS VASE

CHARACTERISTICS
HARMONY OF ELEMENTS, SIMPLICITY, COLOR CONTRAST

Above left In this connected support, a twig is cut and one end is split part way. The stem of the hibiscus is slipped into the split and held tightly. The twig is then set into the bottom of the container and stabilized.

Above right As a final touch, spray water on the arrangement for a cool and refreshing look.

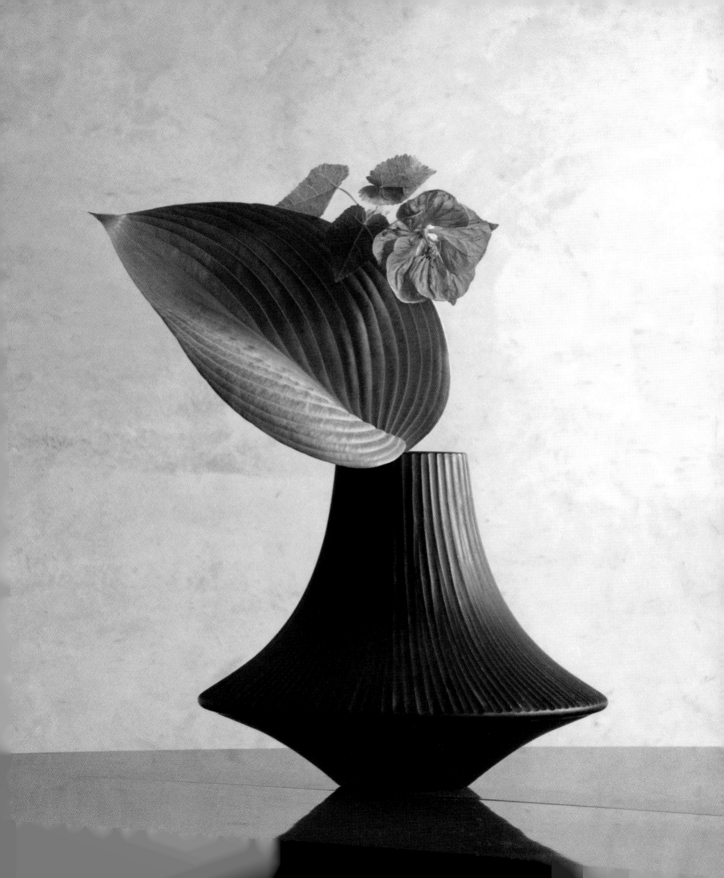

fruits from the garden
young green apricots

After the fragrant blossoms have withered, orchards of plum trees swell with hard green fruit in early summer that are, in reality, Japanese apricots. The unripe fruits are picked before the onset of the rainy season and steeped in distilled spirits with sugar for a few months to make a refreshing liqueur called *umeshu*. Fruits are a blessing from nature, but before eating them, include some in simple ikebana. The cut branches of fruit have a full volume and rhythm in their growth pattern that flowers and leaves do not possess. Making use of branches laden with fruit will allow you to enjoy creating a rhythmical arrangement and to experiment with balancing the uneven weight attractively.

The rolling form of this modern glass vase designed by Alvar Aalto complements the rhythm of the round apricots. By matching the characteristics of the container and the materials, the elements in the arrangement start to harmonize naturally.

In Japanese ikebana, the empty spaces in between the materials are of great importance for the balance and impact of an arrangement. The void where no materials are placed in the vase is intentionally left open to emphasize the areas that do hold materials.

The fresh green apricots match well with the white milky glass container and give an impression of coolness in early summer. When the characteristics of the materials and the container successfully match, you will be emotionally moved by the unexpected effects.

TECHNIQUE, KNOW-HOW AND METHOD

Carefully consider the curves of an irregularly shaped vase. Strong in–out curves, comparable to the contour of a Scandinavian lake, are emphasized in this *iittala* brand vase. Its artistic rhythm harmonizes with the natural form of the globular forms of the apricots. Moreover, in this arrangement, when you view the separated left and right masses of apricots, the silhouette of each looks similar to that of the container itself. Harmony or compatibility is a desired quality to attract people to objects and environments.

Branches with many fruit generate the rhythmical repetition of circles, while a few leaves add accents. Instead of apricots, you can use crab apples, oranges, limes, figs, olives, and even chestnuts and nuts. Most fruit, irrespective of the season, is usually round. The fundamental shape of a circle gives off an aura of stability. Enjoy creating various arrangements by matching the colors or shapes of different fruits with appropriate containers and backgrounds.

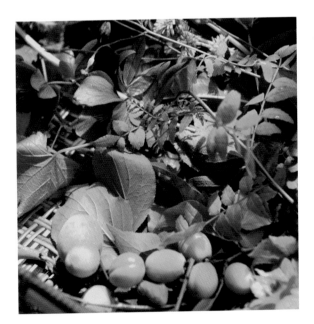

MATERIAL
JAPANESE APRICOT (PLUM)

CONTAINER
GLASS VASE

CHARACTERISTICS
RHYTHM, WEIGHT
BALANCE, SPACING

Left Green apricots, flowers and grasses gathered in baskets. Green leaves exude a feeling of freshness.

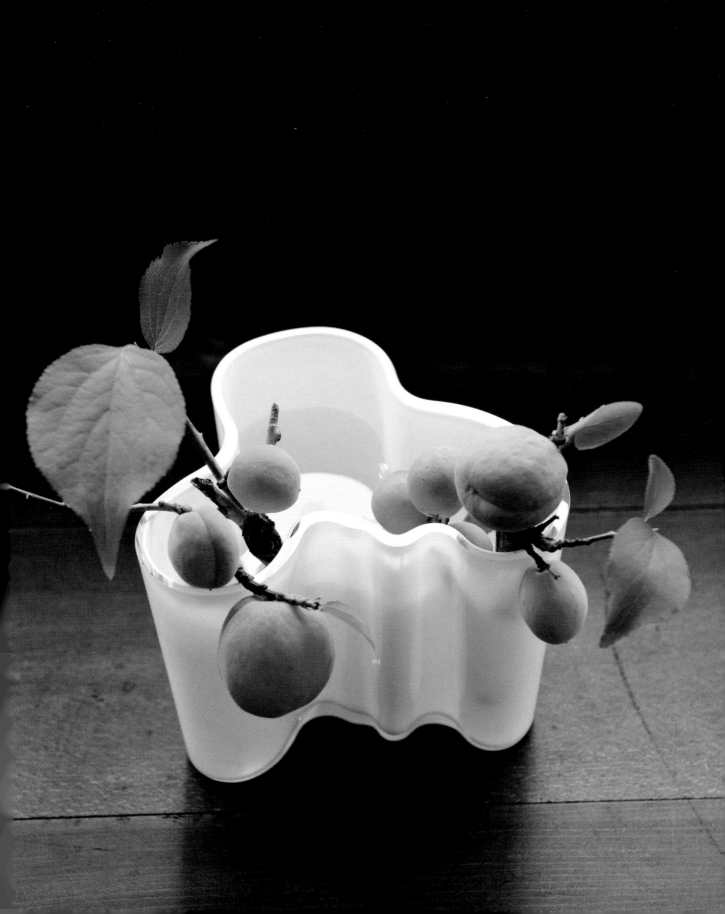

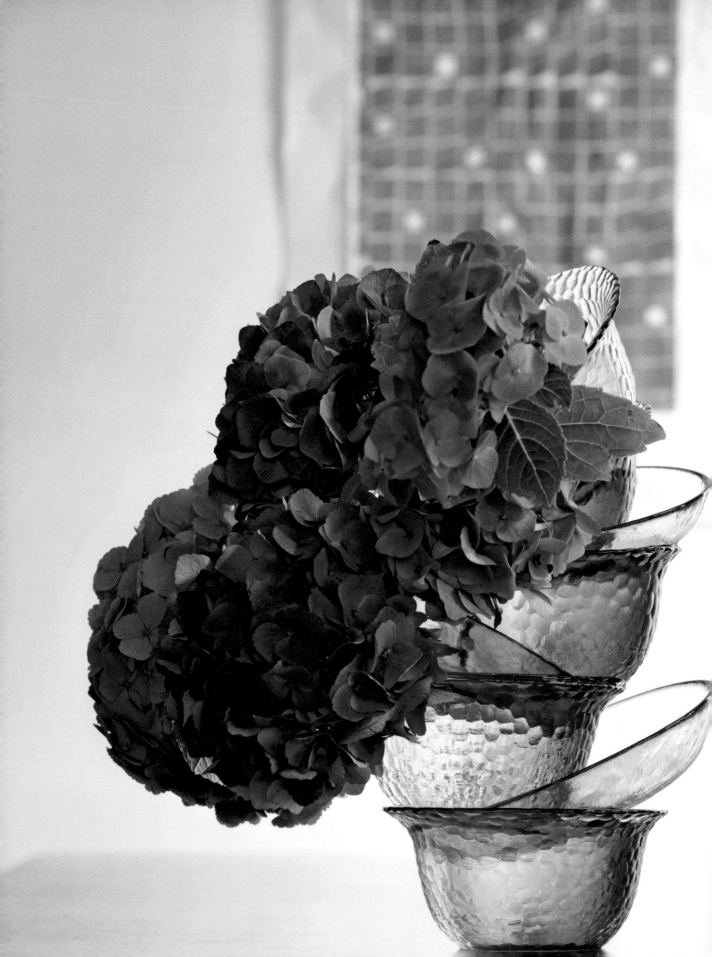

hydrangeas with matching glass
shimmer in the sunlight

Blue bowls and dishes randomly piled up and shimmering in the summer sunlight hold masses of matching blue flowers in their prime. The dimpled surface of the glass and the rounded forms mirror the texture and shape of the dense hydrangeas.

Pleasing proportion is sought in the unbalanced structure of the arrangement. Large flower heads are massed to one side while the stacked glass bowls seem about to topple over from the weight. There is a wonderful visual tension between the lucidity of the water-filled glass and the density of the hydrangea flowers, both united by color.

Besides the floral materials, the shape of the container, the season, the total form or design, color, light and the relation to the surrounding space all play a part in the success of an arrangement. A beautiful Japanese-style display is the result of the coordination of such factors in a carefully orchestrated way.

TECHNIQUE, KNOW-HOW AND METHOD

The containers used here are small glass bowls and plates designed for fruits and desserts. The dimples on their surface match the rhythm of the hydrangea petals. The subtle changes in color when they are piled up also mimic the delicate tones of hydrangeas. Using a single bowl as a container for a hydrangea bloom can produce a beautiful arrangement. But by stacking bowls, attention is focused on the shimmer of the water in the blue glass as it is pierced by sunlight.

Blue hydrangeas only are used in order to match the color of the glass bowls. Because of such a simple combination and uniform color tone, the impact of the arrangement rests on the encounter of the hydrangeas and the glass bowls and the effect it creates.

The glassware used here as containers is inexpensive and can be bought at any homeware shop. Most tableware can, in fact, be transformed into interesting containers for arrangements. It is necessary to be flexible in your thinking to get away from stereotyped ideas of what a container should be. Visit shops that sell a wide array of dishes and utensils to look for items that can be converted into unique containers, then coordinate them with matching floral materials.

MATERIAL
HYDRANGEA

CONTAINER
GLASS BOWLS AND DISHES

CHARACTERISTICS
UNBALANCED BALANCE, HARMONY OF ELEMENTS, COLOR COORDINATION

Above When piling up dishes, pay attention to the balance. It should be neither too methodical nor too haphazard.

a serene summer table
lacy flowers and green leaves

Here, different kinds of thin hydrangea branches with dainty flowers and verdant leaves are used in a spreading arrangement placed on a reflective dark wood table.

Some hydrangeas have large mophead flowers while others produce small flowers that blossom along the edge. These are known as lacecaps. When arranging hydrangeas, the blooms usually play a leading role. However, the subtle movement of the branches and the freshness of the leaves are also attractive elements of restrained beauty. Because hydrangeas require a lot of water to last well, the delicate material can denote refreshness and serenity in the summer heat.

Let a quiet arrangement like this decorate a table to accompany refreshing cool drinks on a lazy summer day and make guests feel relaxed and at home.

TECHNIQUE, KNOW-HOW AND METHOD

First, carefully observe the way each branch sprouts its flowers and leaves. Finding the natural direction of a branch is important to fully utilize its potential. In this arrangement, the branches are placed horizontally. A vase with a wide opening is selected accordingly. Using a cross support (page 13), three kinds of hydrangea branches are arranged to flow outward in all directions. Such a spacious arrangement should be set on a large table so that it can be appreciated from all sides.

MATERIAL
HYDRANGEA (LACECAP)

CONTAINER
CERAMIC VASE

CHARACTERISTICS
ASYMMETRICAL BALANCE,
FOUR-SIDED VIEW

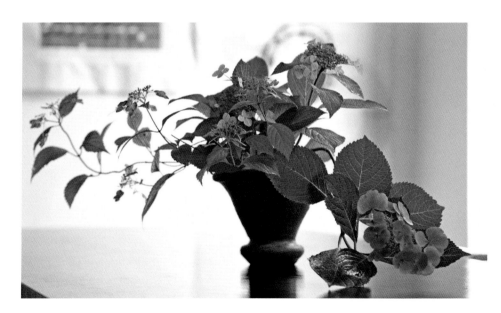

Above From the side, the arrangement is well coordinated with the picture on the wall. Arrangements should generally harmonize with their backdrop.

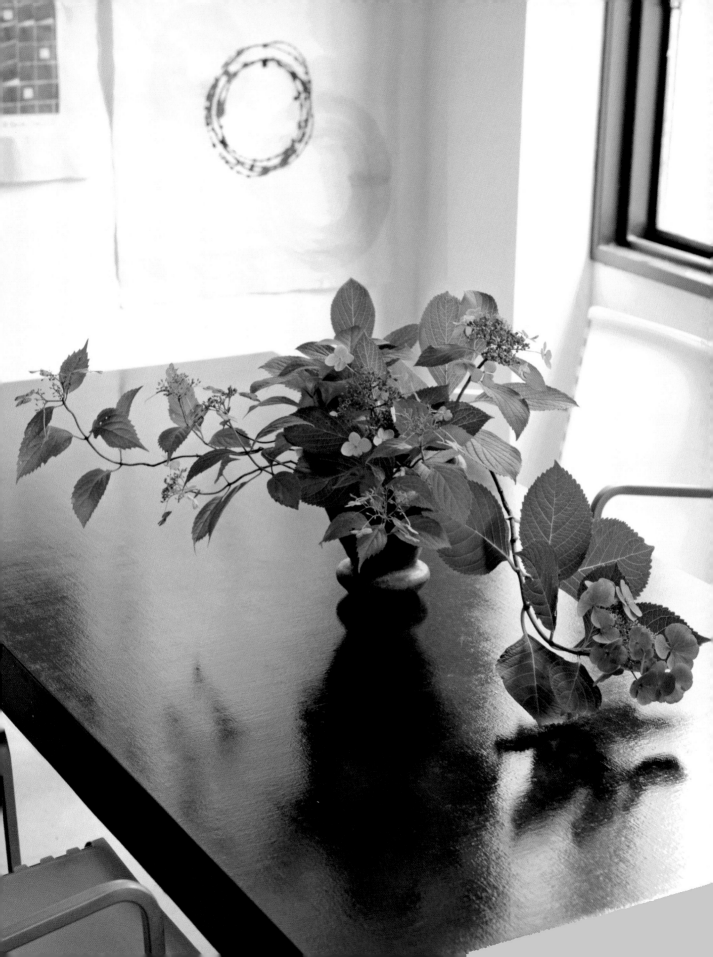

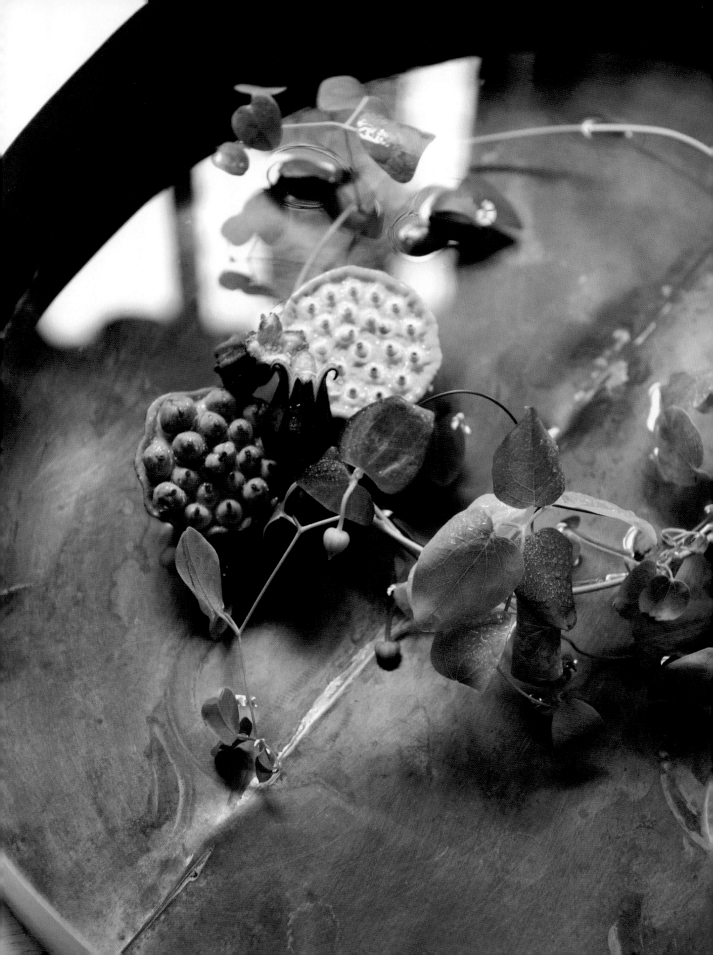

a miniature pond
lotus pods and clematis

As it is summer, let us create a story about aquatic life in a pond with an arrangement in a large, round basin. A wide, shallow container reveals all the water, which plays a visually important role. The water level over the plants is just enough to look tranquil. Two clematis flowers appear to be swimming in a reflecting pool of water. Using the clematis vines as a stabilizer, two lotus pods are placed at one point in the basin as an accent. The soft reflection of the surroundings on the water's surface is part of the story.

Below Vines are used as the stabilizer in the arrangement.

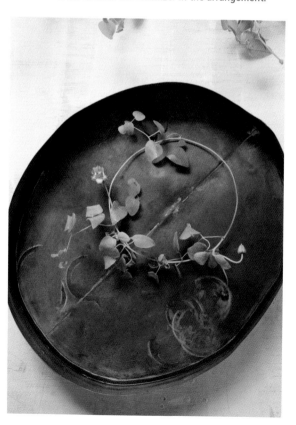

TECHNIQUE, KNOW-HOW AND METHOD

The deep color of the clematis flowers needs to be clearly displayed. A tarnished, discolored metallic container is used so that the rhythmical movement of the stems and leaves of the clematis stands out. An eye-catching lotus seedpod placed in the basin acts as a focal point in the water.

How high the water level should be is carefully considered; too little water feels inadequate and too much is overpowering. The clematis stems are adjusted so that in some areas they sink under the water and in others the leaves float above. The two flowers and tiny buds peek above the water.

Creating a shallow floral arrangement and positioning it low to be seen from above presents a new and interesting perspective to viewers. This low arrangement can be seen from every direction and the reflections will change at each angle. This inviting arrangement is well suited to be placed on the floor at an entrance or on a low table in a living room.

MATERIAL
CLEMATIS (CLEMATIS INTEGRIFOLIA), LOTUS POD

CONTAINER
SHALLOW ROUND METAL BASIN

CHARACTERISTICS
SEASONALITY, ABOVE VIEW, WATER AWARENESS

glory lilies immersed
in a glass cylinder

Glory lilies, like bright fantail goldfish in an aquarium, swirl around in an eddy of water in a cylinder-like glass container. Such containers produce interesting and unexpected effects because water acts like a large lens and dynamically enlarges the form of the flowers. The beauty of the wavy glory lily petals is thus heightened when placed under water.

A few long stems of glory lilies are carefully submerged in the water. Some blooms are placed deep into the container and rest against the glass, using the tension of their stems. As some flowers float upward, a few petals spill out above the lip of the glass. The arrangement looks fresh and lively.

Behind the glass container are more whirlpools printed on beautiful Japanese *washi* paper on sliding *fusuma* doors, a perfect background for the live swirling flowers and stems.

TECHNIQUE, KNOW-HOW AND METHOD

Usually flowers will not stay submerged in water unless anchored inside. Glory lilies normally float up, but here the resilient stems act as a spring and push against the inside of the container and hold the flowers in place. This technique of using natural tension to keep materials fixed is similar to the horizontal support stabilizing technique (page 12). Make sure that the length of each stem is longer than the inside diameter of the container so that the bended stem produces enough tension to press against the inside of the glass cylinder and holds the flower stationary. Other sturdy flowers with springy stems that can withstand being under water, such as anthurium or calla lily, may be used.

This is also an arrangement to show off water. Do not put in too many materials, as the balance of the water and the flowers is important. Place the flowers in a pleasing position without bunching them. Consider also the setting where the arrangement is to be placed. The brilliant red of the glory lilies will stand out and the water will look even more attractive in front of a green or blue wall.

Left Beyond a *fusuma* sliding door, the arrangement is set against a solid blue background.

Right Water on water motif. This *fusuma* sliding door is from a well-established Japanese *Edo-karakami* paper shop. Its classic water swirl pattern is a perfect background for the flowers under water.

MATERIAL
GLORY LILY

CONTAINER
CYLINDER-SHAPED GLASS VASE

CHARACTERISTICS
UNBALANCED BALANCE, HARMONY OF ELEMENTS, WATER AWARENESS

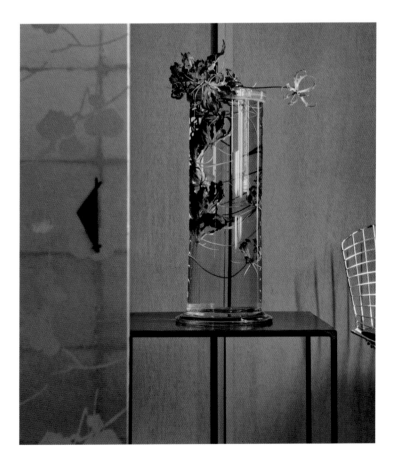

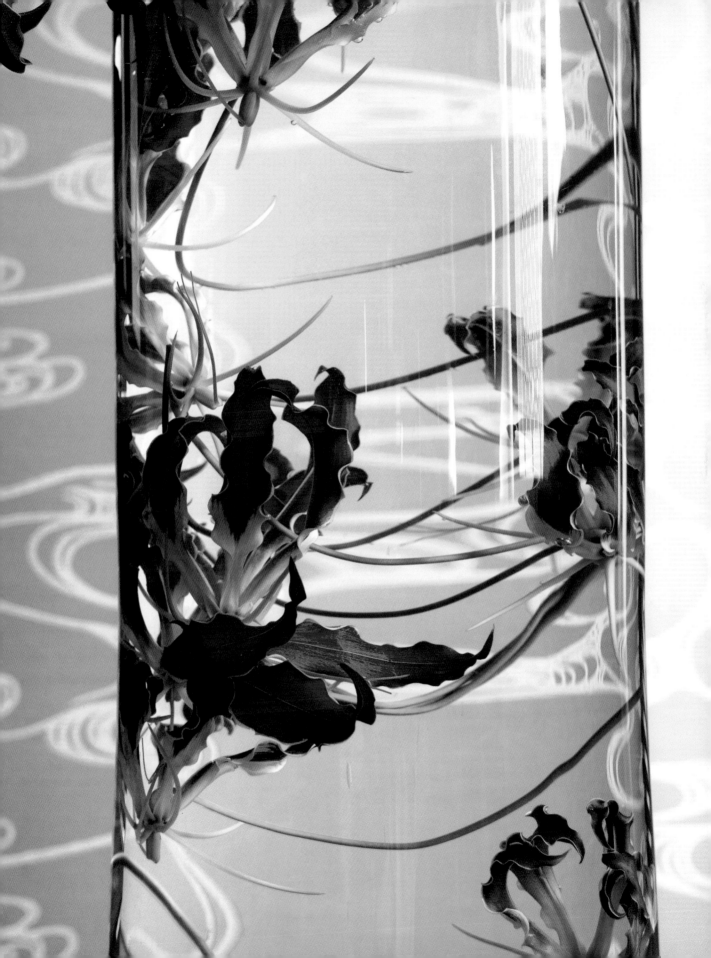

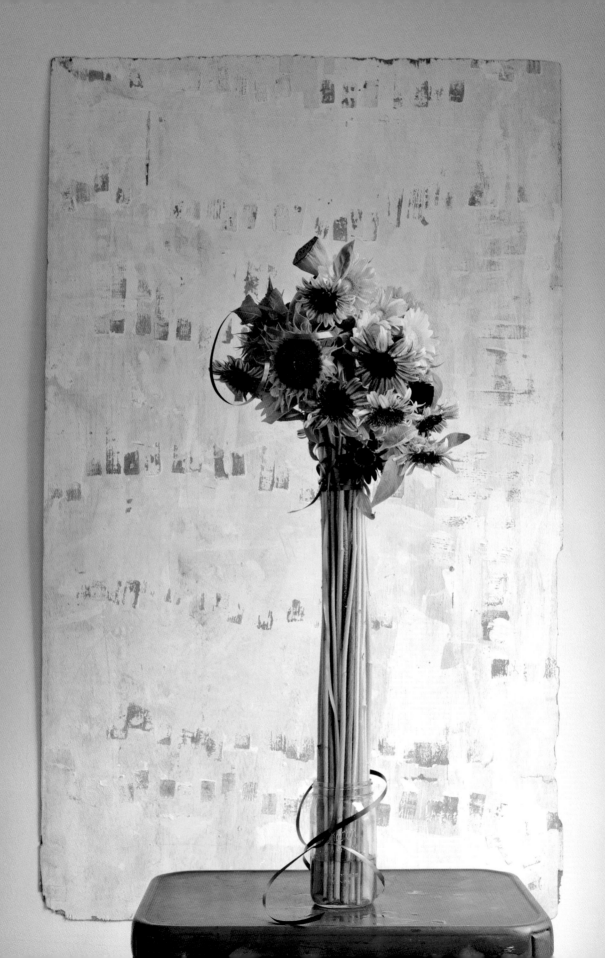

sunflowers and lotus pods
posing in the artist's studio

An artist must work quickly to capture the faces of the sunflowers posing in the natural light streaming through the studio. If only we could go back in time to visit Van Gogh and present him with this arrangement.

An icon of summer, the sunflower's name is derived from the flower's shape and image, which is often used to depict the sun. Unlike the large flower heads that produce seeds and oil, these sunflowers are perky cultivars in varying colors, from lemon yellow to burnt amber. The arrangement very simply emphasizes the vertical nature of the sunflower's long stems.

The vertical posture represents a strong and steadfast will and the bundled stems a commitment to cooperate as they stand close together. The flowers look in various directions and their faces display individual traits, just like people gathered to see an event. The neat bundle of stems looks sturdy, fresh and lively. The viewer will find this arrangement invigorating in the hot summer.

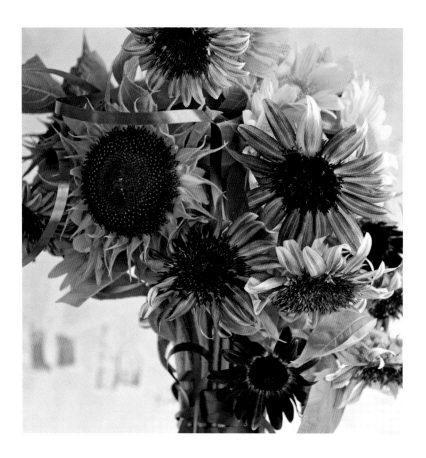

TECHNIQUE, KNOW-HOW AND METHOD

Bundled firmly together, the long stems of a bunch of bright sunflowers are casually placed in a simple, slim, transparent jar. The sunflowers appear to stand in the tight-fitting jar without support. For a successful arrangement, it is important to make the bundle of stems fit the diameter of the container. It is also important to achieve balance at the top of this tall arrangement, otherwise the jar may topple.

Purple is a complementary color to yellow, so a strip of light purple ribbon is used to tie the stems together and swirl through the flowers. Another strip of ribbon runs down the stems, gently curling around the container before falling freely around the base. The ribbon visually connects the compact top of the arrangement with the narrow bottom.

Occasionally, adding other materials, such as ribbon, paper, fabric or metal, makes for an arrangement with a twist, and at the same time can accentuate the characteristics of the plants.

Opposite No complicated techniques are required to create this arrangement, only imagination in the choice of flowers and colors.

Left A close-up of the compact top of the arrangement.

MATERIAL
SUNFLOWER, LOTUS SEEDPOD, SMILAX CHINA

CONTAINER
GLASS JAR

CHARACTERISTICS
VERTICALITY, COLOR COORDINATION (COMPLEMENTARY)

glossy green leaves
gathered indoors

In their natural environment, fatsia leaves absorb a great deal of the sun's light and turn a deep glossy green. The name of the plant in Japanese, *yatsude*, is the image of an eight-fingered hand. Here, a mass of broad fatsia leaves are gathered in a container set against a wall, face forward, showing off the shapes of their strong, flat leaves. By contrast, a few vividly colored clematis flowers are gently cradled in the center of the hand-like leaves. Smaller and lighter colored raspberry leaves poke through from behind the rich mass of fatsia. The balance of the delicate flowers nestled in the strong leaves creates a distinct contrast in terms of volume and color.

The single leaf arrangement shown below highlights the unique shape of the fatsia leaf. Both arrangements make the most of the vivid color contrast between the flowers and leaves. They show how you can emphasize the flowers even though their size is small.

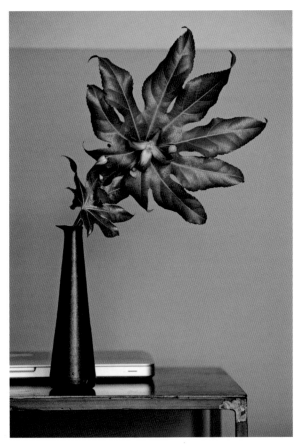

MATERIAL
FATSIA JAPONICA, RASPBERRY, CLEMATIS

CONTAINER
ANTIQUE WINE COOLER

CHARACTERISTICS
FRONTAL VIEW, COLOR COODINATION (CONTRAST), MASS

TECHNIQUE, KNOW-HOW AND METHOD

In the large arrangement on the right, the branches are set in a wine cooler. No stabilizer is used. Instead, the branches are supported due to the friction created by the crossing, massing and interlocking of the leaves. As both fatsia and raspberry have similar palm-shaped leaves, combining them does not affect the overall rhythm. Nonetheless, the difference between their colors provides the arrangement with attractive color gradation. The clematis was selected for its pinwheel face and innocent charm.

In the small arrangement on the left, the interesting shape of a single fatsia leaf is emphasized. If positioned upright, the leaf would look too stiff and serious. Therefore, a curving leaf is selected. A flower is inserted in a natural hole on the leaf.

These examples show how it is possible to create two completely different arrangements using the same materials: a large mass arrangement to decorate a living room or hall, and a small simple Japanese ikebana to place in a bedroom or corner of a room.

Left In this small arrangement, the unique shape of the fatsia leaf is emphasized. At the same time, we can appreciate the contrast with the lovely small clematis flower.

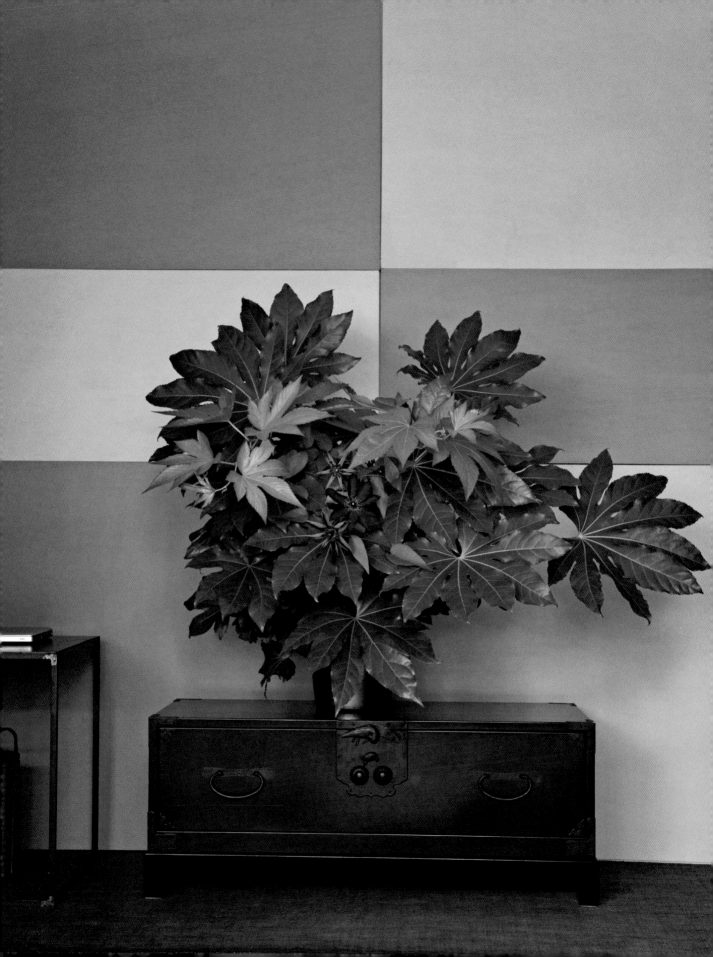

a creature from the wild
aloe stretches out its tentacles

Wild aloe, with its thick fleshy leaves, looks like some extraterrestrial creature. But this saw-toothed succulent provides very interesting material for floral arrangements because of its fast growing, powerful and spontaneous vitality.

Lance-shaped leaves spring from a central rosette in random directions as if about to stretch forward and grasp. The arrangement, arranged simply in a clear glass container, successfully expresses the aloe's dynamism and strength. It is a muscular arrangement, one that leaves an unforgettable impression on a hot summer day.

MATERIAL
ALOE

CONTAINER
GLASS VASE

CHARACTERISTICS
UNBALANCED BALANCE,
WATER AWARENESS

Left Aloe cut from the garden.
Below The same material in a bulbous glass container.

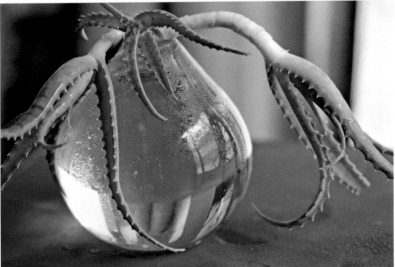

TECHNIQUE, KNOW-HOW AND METHOD

Aloe is almost always overlooked as material for a Japanese-style flower arrangement. But when you examine it closely, it is an interesting material. Think about what kind of design you could create with such a wild and heavy plant. Before cutting the leaves, carefully examine the plant from the center to the tips to figure out the direction and movement of each leaf. Trim unwanted leaves toward the bottom to expose more of the stem's line. The rolling back movement emphasizes aloe's vigorous nature. Select stems and place them so that most of the tips of the leaves are pointing upward. Because of the plant's weight and growth pattern, some stems will naturally face downward, but the ascending motion of the tips will appear uplifting to viewers.

By using a glass container or laboratory beaker, the full force of the succulent leaves will be magnified. Place the stems in the container asymmetrically to give the impression of a wondrous creature just about to lunge forward with its feelers.

Use abundant water and arrange boldly while paying attention to the details of the stems dipping down into the water. It is visually interesting when some portion of aloe is submerged in the water. The enlarged image, with only a few stems draped over a glass ball-shaped vase, gives us a truly cool and quenching feeling. By putting a few tips of leaves under water, the container and the foliage become unified.

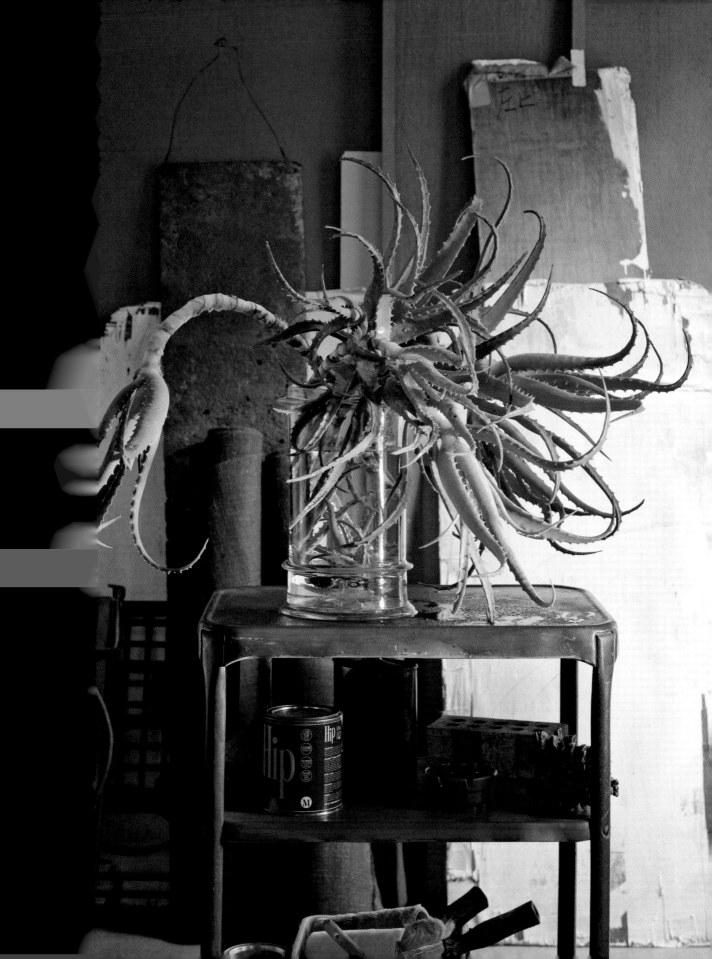

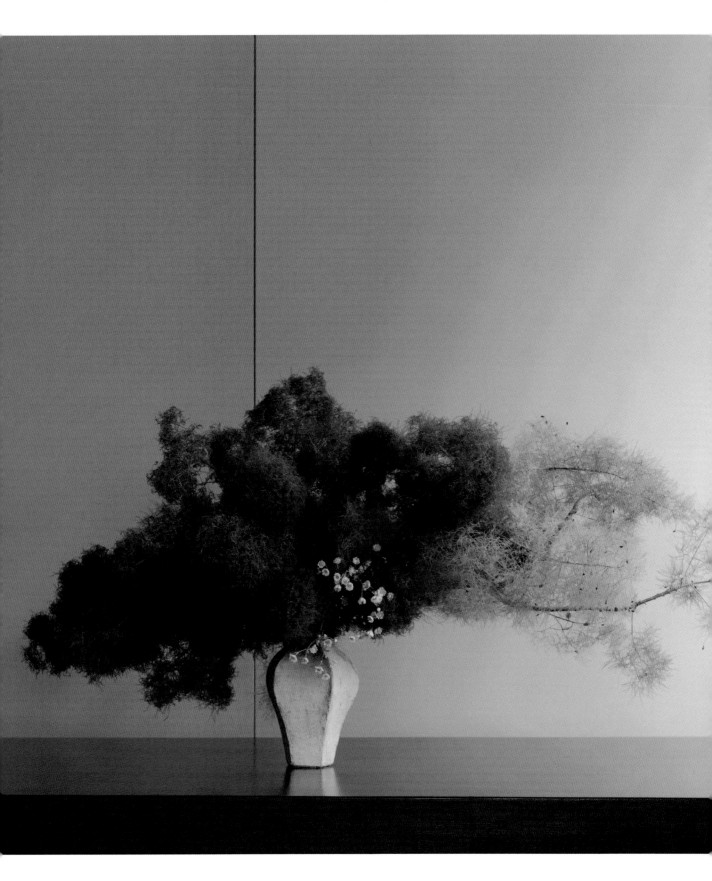

summer clouds drifting by
smoke tree and fleabane

Imagine puffy clouds drifting by on a lazy summer afternoon. A mass of smoke tree looks much like a fluffy summer cloud. The soft red mass atop a still white vase appears to gently float in front of a striking green wall.

The charm of the smoke tree is its vaporous form and sense of ambiguity. The branches are trying to extend toward the light cast from the right. The highlight of this arrangement is the gradation of the colors that are slowly diluted as the branch approaches the light. The end tip seems as if transformed into light itself. Two different qualities of the same material are mixed and integrated to create a beautifully harmonious arrangement of depth and impact. This spacious eye-opening early summer arrangement seems plucked from the skies.

MATERIAL
SMOKE TREE, FLEABANE

CONTAINER
CERAMIC VASE

CHARACTERISTICS
ASYMMETRICAL BALANCE, COLOR GRADATION, LIGHT DIRECTION

TECHNIQUE, KNOW-HOW AND METHOD

This arrangement is asymmetrically balanced, with longer branches on the right, but it is the combination of various lengths of branches arranged asymmetrically that gives the entire arrangement its dynamism.

First, a cross support (page 13) is set into the vase. Proper positioning of the cross stay allows the long smoke tree branches to be stabilized firmly in the vase.

This vase is selected because its many-sided coarse surface interestingly reflects the light from the side, and its size, which is relatively small, creates a striking contrast to the large mass of the smoke tree. The small vase suits the arrangement because, despite the volume, the branches of a smoke tree are thin and light. The contrast of size between the container and the arrangement casts a mystery over the structure that arouses the viewer's curiosity.

Along with the bold display of smoke tree, the humble fleabane is used in the arrangement. Its color tone is resonant with the white ceramic vase. There is a stark difference between the feeling of the vase and that of the smoke tree and so the dainty fleabane works to make a connection between the two. The simple color of the flowers and the amount used are synchronized with the white vase and create a rhythmical accent to the smoke tree.

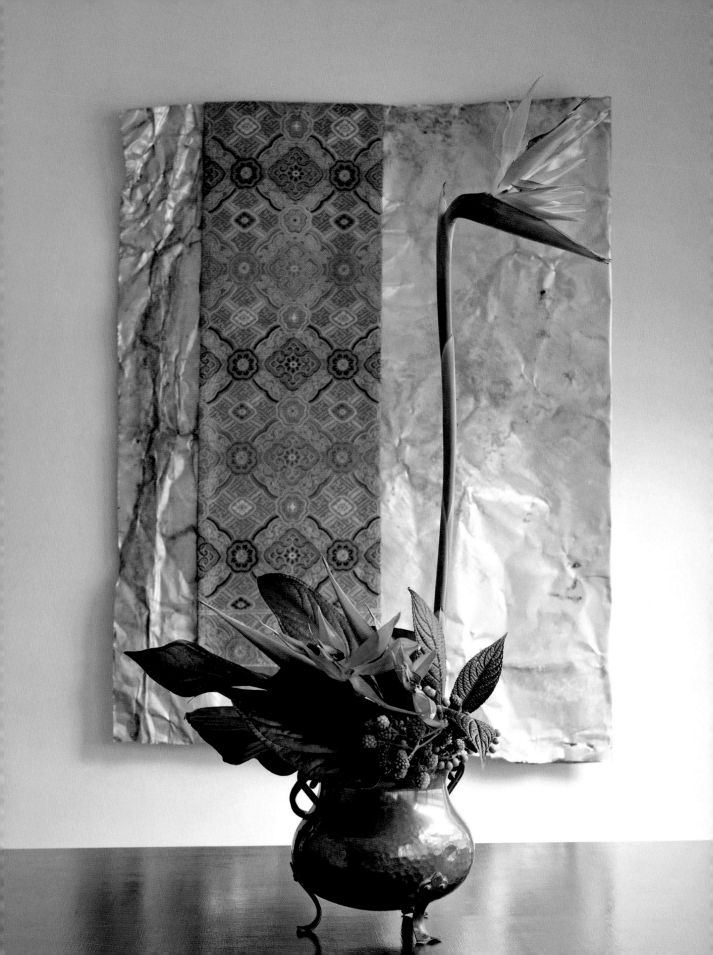

a bird ascending to the heavens
strelitzia with berries

This arrangement has a somewhat tropical flavor by using floral materials from a warm climate. The long-stemmed flower looks like a bird stretching its wings and getting ready to fly up to the heavens. Strelitzia's long, vertical stalk and vivid orange colored flowers are displayed to the fullest. By placing the leafless stalk vertically, an image of a bird's long graceful neck is created. Arranging branches with imposing verticality is one feature of the upright *rikka* form in classical ikebana. A strong vertical line continues to be a basic form even in modern styles of ikebana.

Large bronze-toned anthurium leaves are coordinated with a similar colored copper pot, a good example of the union or harmony between material and container. The short curving legs on the pot lift the arrangement off the table and give more upward movement to the ascending bird-of-paradise flower. The whole arrangement seems about to take off.

A Japanese kimono sash, or *obi*, in the background bears a motif that is associated with the image of Heaven (Paradise) in Buddhist scripture. Here, the *obi* has been used in a work of art and serves as an eye-catching background for the arrangement. The position and colors of the *obi* visually balance the strong right-sided placement of the flower. The vertical repetition of the pattern adds another element of upward movement.

TECHNIQUE, KNOW-HOW AND METHOD

This arrangement was conceived and coordinated specifically for a "bird-of-paradise" theme. All the components—floral materials, container and background—were carefully selected to achieve the desired mood. The arrangement is intended to elicit the viewer's surprise at "a bird made of plants!" It is important, however, to not use techniques that form a realistic image of a bird. Too much control over an arrangement will only show off craft skills and detract from the characteristics and beauty of the floral interpretation.

To start with, a bittersweet vine is coiled up and put into the container to act as a support for the materials. The stems and leaves are then inserted one by one. No *kenzan* pin holder or other artificial means have been used to stabilize the tall strelitzia stem. The natural vine support is a component of the entire arrangement and has been deliberately left visible to viewers.

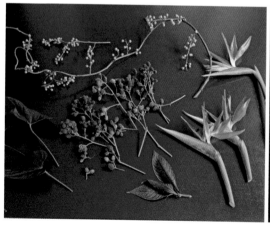

Above left Materials follow a triad color scheme and harmonize in proportion.

Above right Sturdy flexible vines, such as bittersweet, can be used to support other materials. Natural stabilizers are gentle and friendly to plants.

MATERIAL
STRELITZIA, ANTHURIUM LEAVES, BLACKBERRY, BITTERSWEET, STROBILANTHES (PERSIAN SHIELD)

CONTAINER
ANTIQUE COPPER VASE

CHARACTERISTICS
VERTICALITY, HARMONY OF ELEMENTS, COLOR GRADATION

lily, diane and veronica
maidens in the shadows

Young maidens in green garments seem to be peeking out from the shadows. Only the pure white faces of the flowers and tendrils of green stand out from the dark background. White flowers are often more eloquent than colorful ones because of the purity and restraint they emanate. These gentle and tranquil white flowers arranged simply attract us just as much as any flashy arrangement would.

On a hot summer day, time seems to stop in the cool quiet space where this arrangement is set. How inviting it would be to gaze at this simple ladylike ikebana relaxing in the corner of a room.

Generally, rooms in traditional Japanese houses were dark. In small spaces with few lights, white flowers like these stand out and radiate a feeling of purity. This is exactly the feeling we can enjoy in the *chashitsu* (tea ceremony room). In any home there might be a small dark corner that would profit from a simple Japanese-style arrangement to light it up with pleasing flowers.

Below left Pliable wire netting is used as the stabilizer. The wire is exposed and forms part of the arrangement.

Below right In a different situation, familiar flowers often show unexpectedly different expressions.

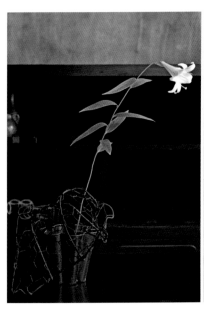
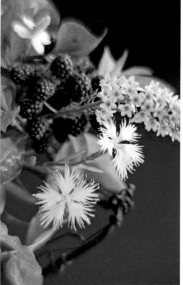

TECHNIQUE, KNOW-HOW AND METHOD

Only two colors, white and green, are used in this arrangement with a small touch of red. A limited color palette is subdued and relaxing to the viewer, much like looking at a nostalgic monochrome photograph.

Of course, light is essential for us to see objects. But just how much and what type of light and how much darkness or shadow is needed to enhance an arrangement is an artistic choice. The amount of either will effect the arrangement greatly, so it is necessary to experiment with different placements and positions to find what works best. In the case of this arrangement, the darkness and lack of strong light are what make the beauty of the flowers stand out. The technique of utilizing the impact of the light and shadow helps you create stimulating scenes with your arrangements.

A piece of rusted wire netting that fits over the Western-style container is used as the stabilizer. The netting allows you to control the position of each flower. You can create an airy arrangement by using only a few materials. This stabilizing method is intended to be seen, and is actually interesting to look at because of its shape.

MATERIAL
LILY, PINK (DIANTHUS), SPEEDWELL (VERONICA), BLACKBERRY, HOUTTUYNIA CORDATA (CHAMELEON PLANT), VINE

CONTAINER
FLOWERPOT, RUSTED WIRE NETTING

CHARACTERISTICS
LIGHT AND SHADOW, NATURALNESS

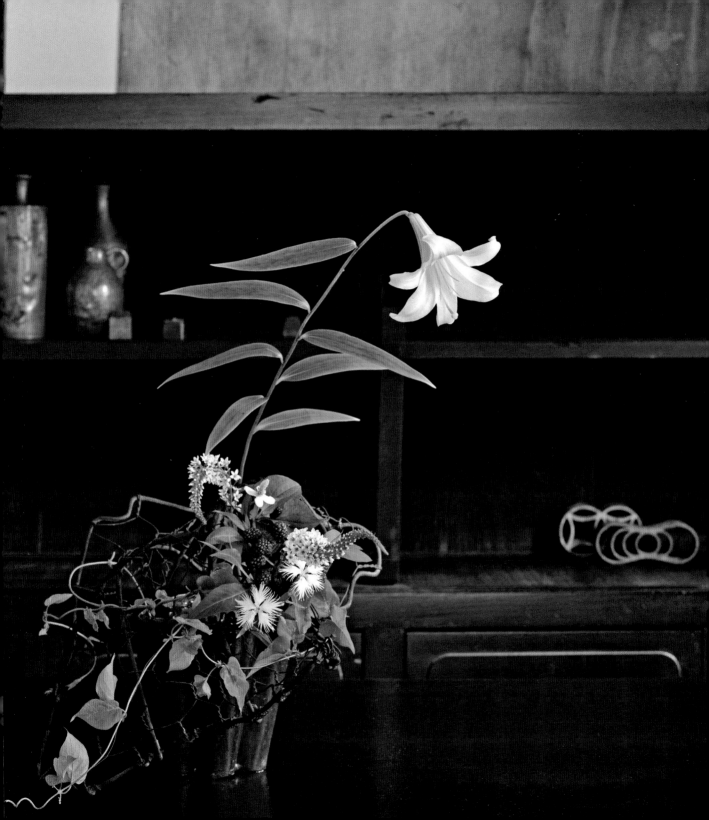

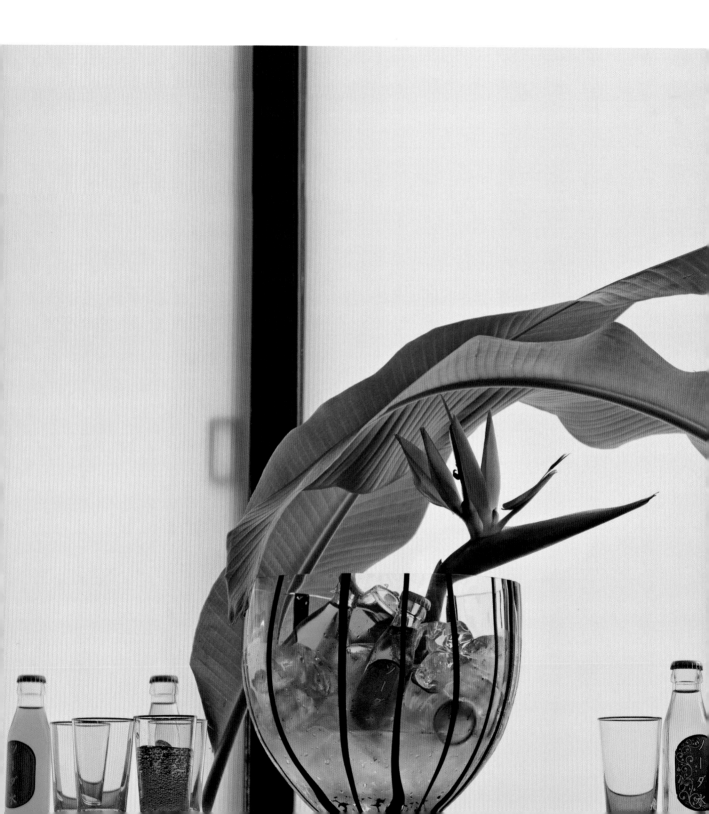

a cool summer party
flowers and leaves on ice

Large flowing banana leaves arching over soda pop and ice cubes are the center of attention at a cool tropical party in the summer season. A beautiful flower and matching colorful drinks on ice beckon viewers to the table.

Banana leaves supported by two glass vases extend over the table and slightly touch as if communicating with each other. The strelitzia seems to be wearing a party hat and joining in the lively conversation.

Bottles of colored soda water are arranged rhythmically in the vase-cum-ice bucket and on the table to add fun to the scene. The soft sunlight cast onto the leaves through an opaque glass window forms reflections and shadows on the leaves. Guests at a summer party are sure to be delighted by the cool feeling emanating from this arrangement and will drink to its charm.

Left Various colored soda bottles form part of the overall arrangement.

Right The banana leaves form the basic structure.

TECHNIQUE, KNOW-HOW AND METHOD

The backlight from the window makes us aware of silhouettes and shadows rather than the colors of the objects. The transmitted light strengthens the presence of the object by giving the viewer the illusion of the object emitting light itself. Large, extended banana leaves are ideal materials to realize the effects of light. Try to bring out the individual characteristics of each leaf through its placement without using too many at once. Horizontally extended and over-lapping lines are emphasized and show off the flexibility of the material.

MATERIAL
BANANA LEAF, STRELITZIA

CONTAINER
GLASS VASES

CHARACTERISTICS
HORIZONTAL BALANCE, COLOR COORDINATION, LIGHT AND SHADOW

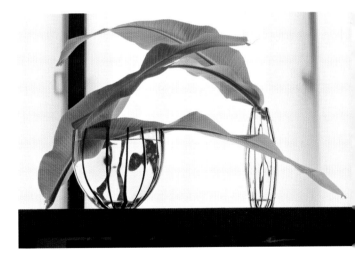

a contrasting pair
fresh peonies on a dried branch

This simple and moving arrangement embodies so many of the rich contrasts that give Japanese ikebana its beauty: light and dark, line and mass, fresh and dry, vertical and horizontal, movement and stillness. The wild movement of the barren branch combined with the brilliant pink peonies stir dramatic feelings in our hearts. To add to the sensation, large peony flowers shine in full bloom. The withered branch, by contrast, accentuates the beauty of the flowers at their peak.

The fossilized branch acts as a support for the flowers. In spite of its simple structure, this is a very impressive arrangement. A kimono with a similar flower pattern, hanging on the wall, forms a quiet backdrop.

TECHNIQUE, KNOW-HOW AND METHOD

In Western-style arrangements, gorgeous flowers such as peonies are often used in a voluminous way that calls attention to their color and massing. But without using a lot of flowers, you can make an arrangement that is just as appealing and effective. Because of the limited use of materials, the unique color and shape of each flower can be emphasized.

The color of the container harmonizes with the withered branch and has the earthy texture of tree bark. A dark and restrained container is selected so that the vivid color of the peonies stands out.

Dried branches can be used over and over again in many arrangements and appear completely different depending on the coordination of the other components. If kept dry and carefully stored, the branches will last a long time and give you a wide variety of arrangement options. Look for interesting naturally discarded branches while walking in the mountains or fields or along the beach.

MATERIAL
PEONY, DRIED BRANCH

CONTAINER
CERAMIC VASE

CHARACTERISTICS
COLOR CONTRAST,
CONTRAST OF
MATERIALS

From left The container, putting the withered branch in place, then adding the flowers.

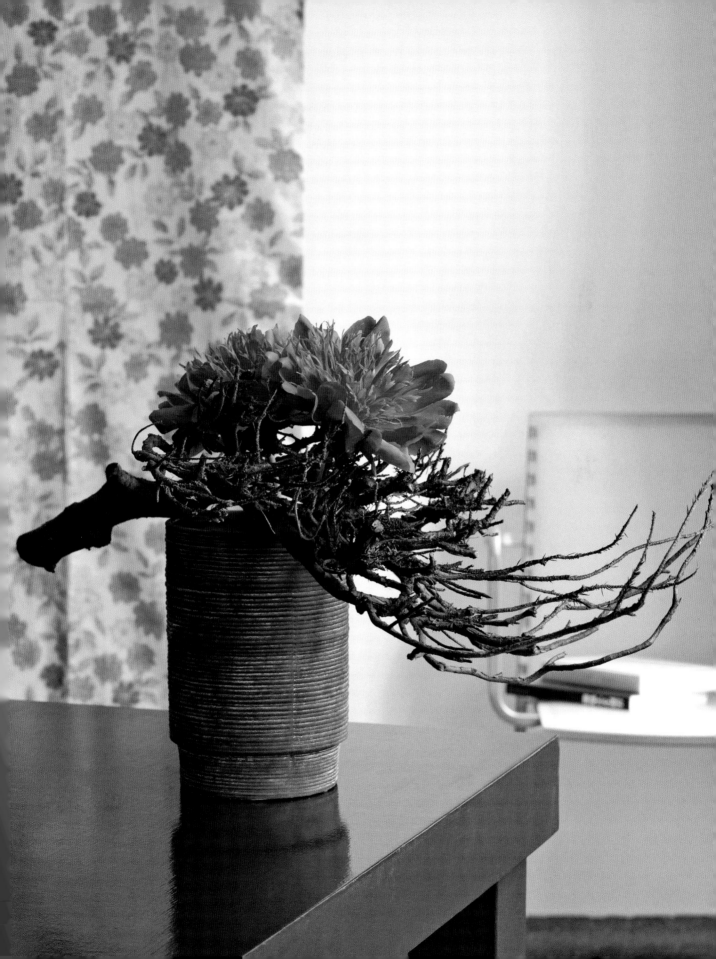

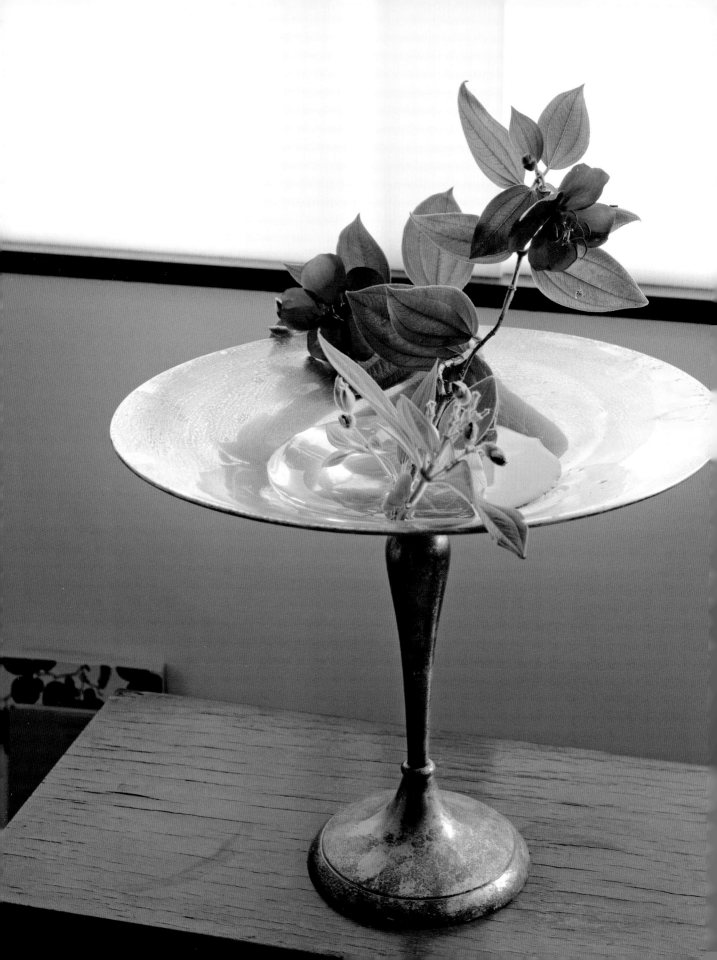

a daydreaming princess
behind a curtain

Soft sunlight streams through a curtain onto a silver compote. A single lovely princess floats on the capacious dish and tilts toward the light. The backlight softens the flower's bright color and gives a dreamy aura to the arrangement. The subdued tone harmonizes nicely with the slightly tarnished silver dish and creates a refined arrangement fit for a real princess.

MATERIAL
PRINCESS FLOWER

CONTAINER
SILVER COMPOTE

CHARACTERISTICS
BALANCE OF LIGHT
AND MATERIALS,
WATER AWARENESS

TECHNIQUE, KNOW-HOW AND METHOD

A few flowers placed on a shallow, flat container without the use of any complex devices becomes a truly memorable Japanese ikebana. The only technique necessary here is to set and support the flowers using the floral material itself.

Pay attention to the quantity of water you pour into the container. How much water is needed to bring out the best in the arrangement? Sometimes water up to the top of the container will seem perfect, sometimes the minimum amount will look better. The water quantity will also differ according to the season. In this particular arrangement, only a small amount of water is used since it occupies one small shape and creates a nice balance between the flower, the container and the sunlight. Moreover, as princess flowers bloom from the end of summer until early winter, you can demonstrate an autumn feeling with a smaller quantity of water. In an autumn arrangement, you can avoid a chilly impression in your ikebana by adjusting the water quantity.

Above This self-stabilization technique shows how the stems are interconnected.

grape vines on the wall
like a living sculpture

A simple Japanese ikebana becomes a wall hanging to decorate any space. Hanging flowers on the wall is a common practice in a *chashitsu*, a room for the tea ceremony in Japan. In this simple room, there is a special alcove or *tokonoma* where seasonal ikebana is placed and a relevant scroll, called *kakejiku*, is hung on the wall. It is a small unique display of seasonal items that sets the tone for the enjoyment of drinking tea in a relaxing atmosphere. A similar idea can be used for decorating a wall in a Western home.

Below A bunch of grapes on a vine.

Opposite Not only are green grapes refreshing but the cascading movement of the vine generates an image of a soft summer breeze.

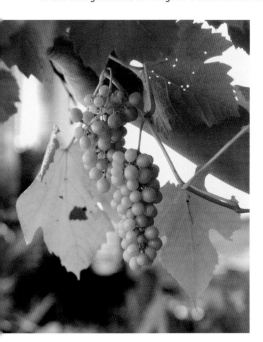

MATERIAL
GRAPE, SMILAX CHINA

CONTAINER
GLASS VASE, SHEET OF RUSTED IRON

CHARACTERISTICS
DIRECTION, MOVEMENT

TECHNIQUE, KNOW-HOW AND METHOD

In this arrangement, a rusted and pitted sheet of iron is hung along a stairwell and a slim glass flower vase attached to it by a hook. The iron sheet is a truly original container created from imagination yet with awareness of its beautifully harmonizing textures and colors.

The elongated shape of the iron sheet resembles a Japanese scroll (*kakejiku*) with its subtle and restrained colors that are so much a part of Japanese aesthetic taste. Fresh, juicy green grape vines are placed in the translucent glass container and extend gracefully downward. The cascading movement of the vines is so natural, it gives the impression of vines swinging freely in a summer breeze.

Vines such as grape and ivy are ideal materials for a hanging ikebana as they are light and have interesting movement. When you make your arrangement, take into account that the materials will extend down to the surrounding space.

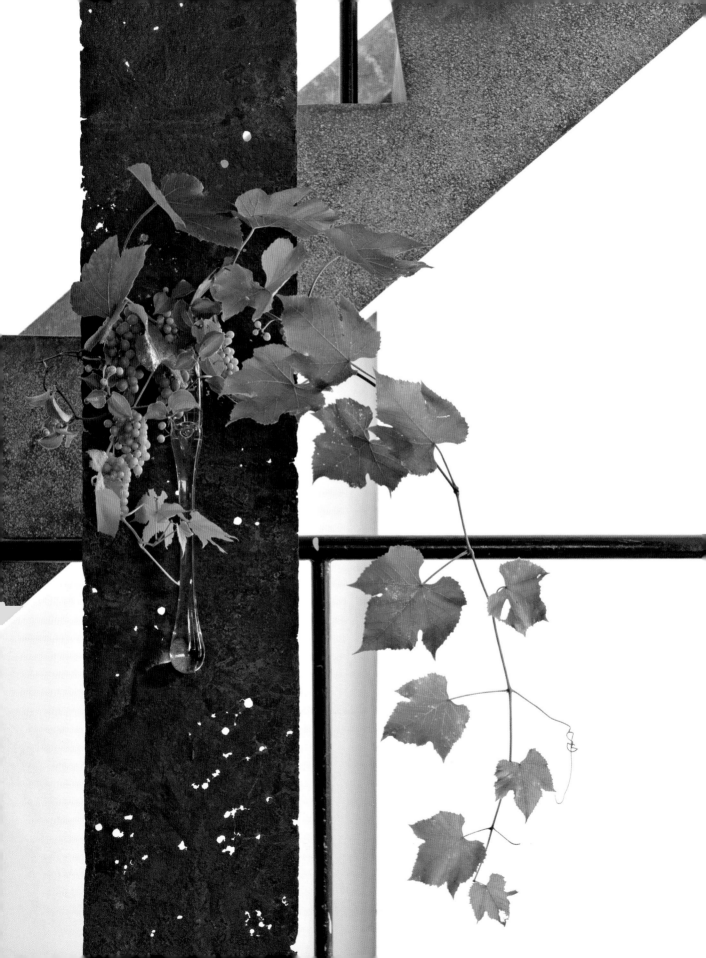

autumn

After the hot and often humid summer, when plants spend all their energy growing, autumn offers respite from the heat and supplies abundant fruits to savor. The sun's glare slowly softens to a honey-colored light and shadows grow longer and longer. A change of radiance causes the color tones we see in the moderate autumn sunlight to appear deeper and more muted.

Autumn is the season to enjoy a feast of color. Mountains flare with turning red and yellow leaves and orchards and fields bear fruits and vegetables of multiple colors. In Japan, we pray for a fertile harvest and offer flowers to the gods that are believed to exist in all living things. People appreciate the plentiful gifts from nature with a thanksgiving celebration meal, a common event all over the world.

Create simple modern ikebana using the floral materials of the harvest time. Autumn colors of red, orange and yellow express warmth and comfort as the season cools. Your home interior will be enriched with Japanese-style arrangements to accompany feelings of gratitude. Flexible and less restrained flower arrangements are more suited to this season. Cascading or hanging arrangements, rather than vertical ones, may be appreciated in terms of their structure. Typical materials used in this season include branches heavy with berries or fruit, wispy flowers and tinted leaves that can be found in gardens and woodlands.

Ceramic or clay vases have an earthy texture and a more comforting aura than hard porcelain china or transparent glass. Autumn is a good time to experiment with flower-friendly baskets. The cooling effect of seeing water in an arrangement is no longer needed; less water in open containers is more appropriate. But the dryness of the season also conjures up a desire for water and therefore deep containers like buckets and pitchers suit autumn arrangements too.

Quietly but steadily, a cycle of life is coming to an end and winter is slowing creeping upon us.

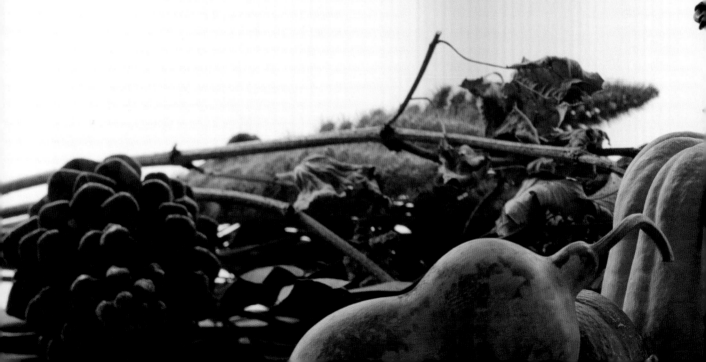

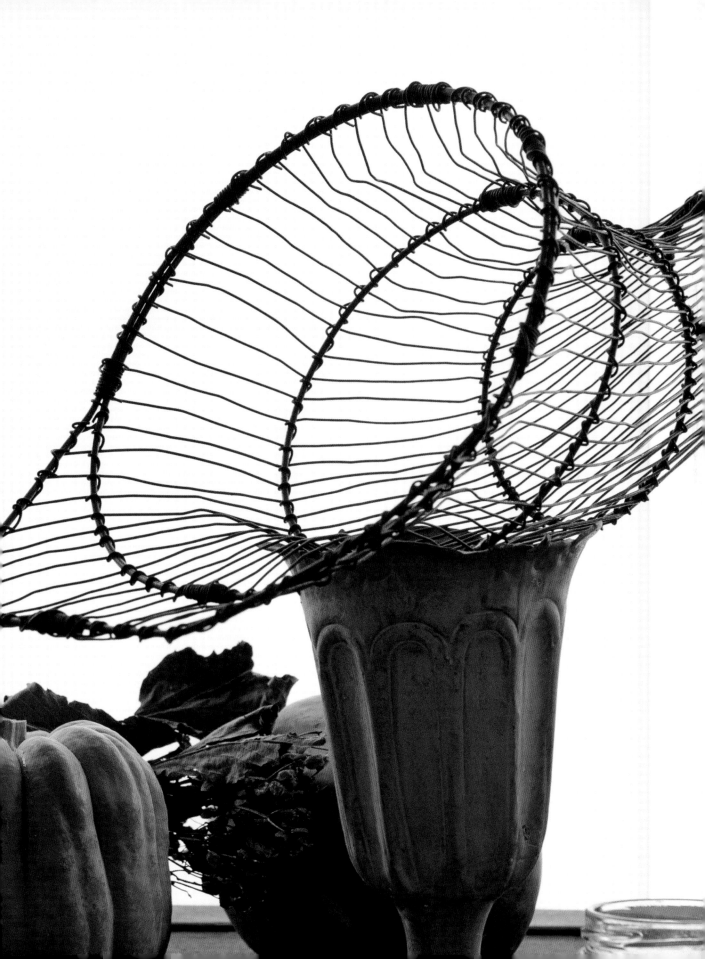

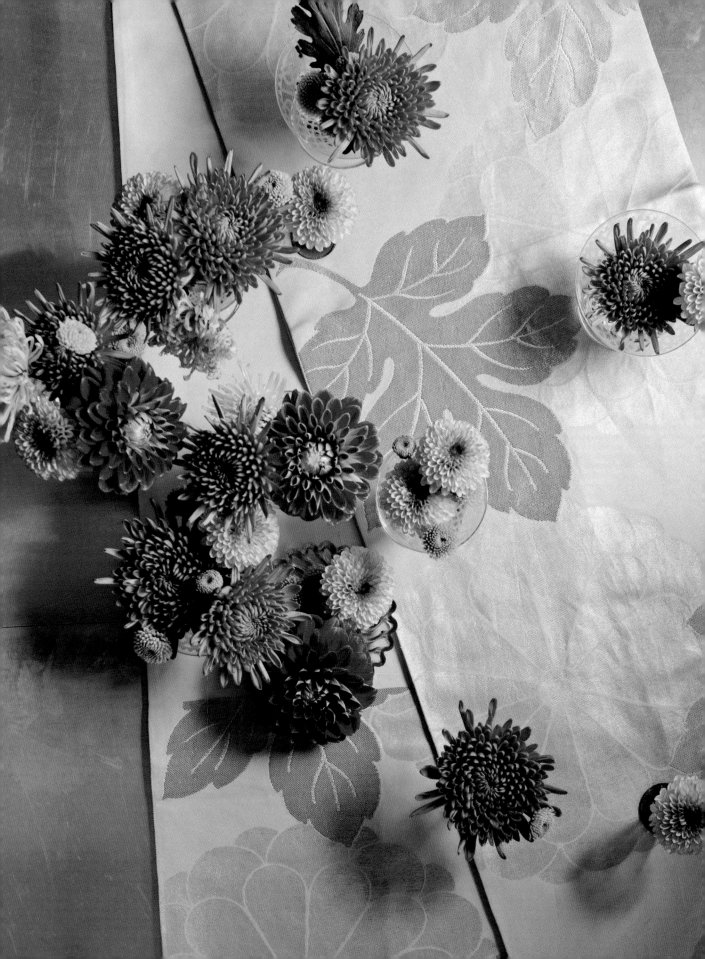

mums and dahlias
beautiful from every angle

This simple ikebana is inspired by the chrysanthemum-patterned Japanese *obi*, or sash for a kimono, laid across the table. The chrysanthemum is one of the flowers that typify Japan because it is a symbol of the Japanese royal family and the flower's design is their family crest.

Japanese traditional clothing, such as kimono and *obi*, have a strong affinity with the seasons through their patterns, colors, designs, weaves and dyes. The chrysanthemum is a typical and popular motif for autumn in other Japanese arts as well.

In this table decoration, real chrysanthemums are randomly and playfully set on a pale blue *obi* decorated with the ubiquitous chrysanthemum pattern. The difference in scale between the flower and leaf pattern of the fabric and the live flowers is an interesting contrast. So too is the vivid color of the fresh flowers against the soft blue-green tone of the *obi*. Unity of theme and contrast of color have produced a simple, pleasing arrangement. Antique Baccarat wine glasses are used here as containers but any simple glass containers will do just as well. Although *obi* are often used as table runners in interior decor and ikebana, it is unusual to match real flowers with the pattern of an *obi* in creating a floral arrangement. As such, this arrangement may inspire you to seek out other matching fabric motifs and flowers.

TECHNIQUE, KNOW-HOW AND METHOD

Old used Japanese *obi* can be found in many flea markets in Japan and even outside the country. Old ones tend to have bold patterns that may provide inspiration for a seasonal arrangement. If you cannot find a satisfactory one for your idea, this simple ikebana can be re-created using different types of printed placemats, table runners, tablecloths or even unsewn fabric that you may have at home.

Lay out the flowers so that they are well coordinated with the rhythm of colors or patterns of the *obi* or other fabric. Pay attention to the color contrast and try not to arrange too haphazardly. This idea can be applied to many situations with various flowers to enrich your daily life at the table. It is particularly suitable when entertaining and serving guests.

MATERIAL
CHRYSANTHEMUM, DAHLIA

CONTAINER
WINE GLASS, GLASS PLATE

CHARACTERISTICS
COLOR COORDINATION, HARMONY OF ELEMENTS, MATERIAL AND BACKGROUND

Left Flower-filled glasses of various shapes and heights, set on a Japanese *obi*, can be enjoyed from all angles.

wild grasses and flowers
a gentle autumn breeze

A breath of crisp autumn wind flows through the living room. The unrestrained stems of the floral arrangement catch the breeze, giving the impression that nature has been transplanted to a corner of the room.

Delicate grass-like plants may lose their beauty and character when cut, so it is best to bring flowers and grasses from the fields into your home with the soil and roots intact. Besides, it is pleasant to experience such naturalness in daily life indoors.

Since ancient times in Japan, the patrinia, also aptly called Golden Lace, has been recognized as one of the seven autumn flowers. The warm patina and tone of a tarnished wine cooler fit well with the patrinia and also match the low chest used to display this simple ikebana. Taking into account the height of the flowers and the best angle for viewing, the arrangement has been placed on a small low table. It is a quiet arrangement, one that contributes to a calm and peaceful atmosphere.

Below A close-up of patrinia stems.

TECHNIQUE, KNOW-HOW AND METHOD

Great attention is paid to preserving a natural look in the arrangement, even though some floral techniques are applied, such as twisting, tangling, rolling and squeezing (*tame*, page 16) the leaves and stems. In its natural environment, the patrinia grows upright, but here the stems are purposely tilted in the direction of the window to take advantage of the light. The slanted arrangement not only makes us conscious of the source of light but suggests a breeze is blowing the fronds to one side.

Gentle manipulation of the stems and leaves is applied in order to achieve a look of perfect balance in the arrangement. Handling and maintenance techniques are valuable skills for putting your ideas into arrangements. Attention to small details is necessary to imbue an arrangement with the feelings you wish to express. Feeling the wind or the light in ikebana is another important nuance that reflects the Japanese aesthetic spirit.

MATERIAL
PATRINIA (GOLDEN LACE)

CONTAINER
ANTIQUE WINE COOLER

CHARACTERISTICS
NATURALNESS, SEASONALITY

a single cosmos blossom
greets the arriving guests

A single cosmos flower stands upright in a shallow dish, ready to greet guests. An ikebana arrangement like this, placed at the entrance of a house to welcome guests, is known in Japan as *mukae-bana*, or welcome flowers. Guests can admire the arrangement as soon as they enter the front door. They will have to look carefully at this ikebana to understand the interesting posture of the almost smiling cosmos. This is a very simple arrangement and shows the arranger's daring originality in placing a single flower upright in such a broad container.

Below A beautiful entwined kiwi fruit vine is used as a natural stabilizer. The small amount of water in the dish balances the delicacy of the vine's stems.

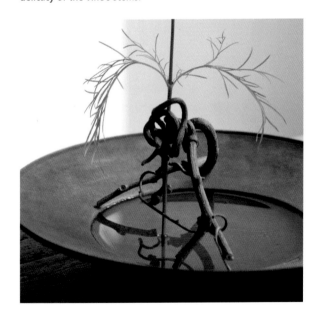

MATERIAL
COSMOS

CONTAINER
SHALLOW DISH, DRIED KIWI FRUIT VINE

CHARACTERISTICS
VERTICALITY, SIMPLICITY, BALANCE

TECHNIQUE, KNOW-HOW AND METHOD

The arrangement uses a naturally dried kiwi fruit vine as a support for the flower rather than any artificial stabilizer, such as floral foam or *kenzan* pin holder. The vine is placed firmly in the shallow dish and the thin cosmos stem is inserted into a small loop of the vine. For material such as a twisted vine to work as a stabilizer, it is essential that there are two stabilizing points, top and bottom. This means, the flower stem, which must touch the bottom of the dish, is supported by a loop of the vine at a higher point and against a crossing vine stem at a lower point. The vine stabilizer is fully exposed, thus becoming an integral and captivating element of the arrangement.

The form of the naturally shaped kiwi vine is both interesting and charming. In this case, the harmony of the arrangement is achieved by using a dried vine with a little more thickness than the stem of the cosmos and with a similar color. The simple container with its dark tone also makes the upright cosmos more striking.

Cosmos is a good material for flower arrangements because each flower has a unique expression. The flowers and leaves also move in many directions. Cosmos can be enjoyed as a mass of flowers or as a lone bloom.

Discovering the beauty in a single flower and deciding which part of that beauty should be the focus in an arrangement is a challenge for any creator striving to express a personal statement. Closely study the individual features of floral materials and become familiar with the qualities that make each one unique.

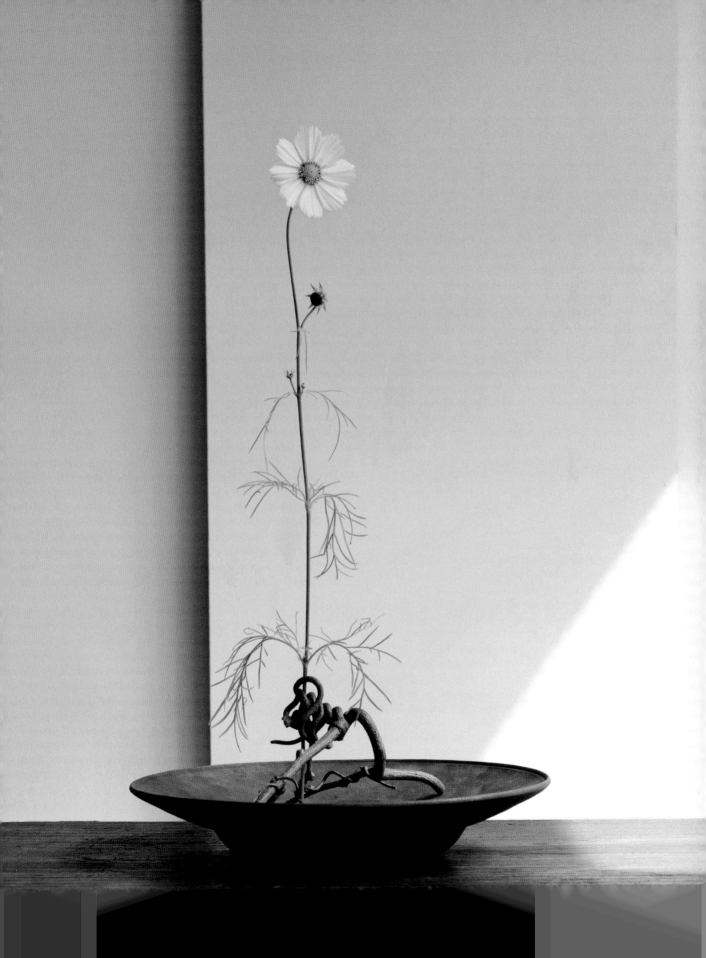

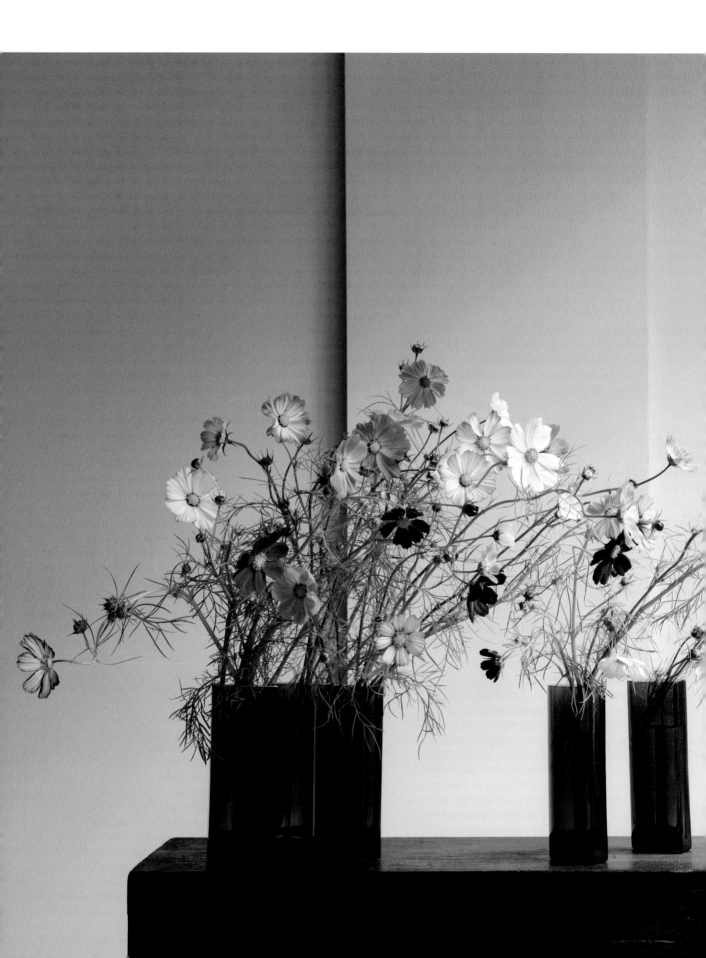

swimming in the wind
cosmos in glass vases

A profusion of cosmos swaying and bobbing in the fields is re-created in this arrangement. Each flower seems to sing and dance in the soft autumn light and breeze. In a popular Japanese song, cosmos is called "autumn cherry" after the spectacular view of the flowers growing in the fields, every bit as lovely as cherry blossoms in spring. Here, the cosmos blooms are held aloft by their stems wedged against the sides of semi-transparent glass vases in a harmonizing green.

MATERIAL
COSMOS

CONTAINER
GLASS VASES

CHARACTERISTICS
NATURALNESS, MOVEMENT, ASYMMETRICAL BALANCE

Left The flowers move in harmony, like a school of fish.

TECHNIQUE, KNOW-HOW AND METHOD

Multiple containers of the same design bring out the charm of cosmos. The use of smoky, semi-transparent glass here allows the flowers to be camouflaged as they float up the sides rather than be anchored to the bottom. The mass of flowers at the top is light and flowing, yet conveys a sense of volume.

Regardless of where you obtain cosmos, picked in the field or bought in the market, the water absorption technique of *mizukiri* is very important to keep the fragile flowers fresh and strong. When arranging, examine each cosmos intently for the direction of the flower face or movement of the stem before placing it in a vase. The end result should express one complete, orchestrated movement of cosmos.

When you have multiple containers of the same type, you can enjoy a variety of arrangements by changing their position, sometimes setting them close together, at other times widely apart. A random, unbalanced placement of vases allows an arrangement to change to suit the space where it will be displayed.

The setting of containers needs to be balanced in the total arrangement in terms of how much floral material will be used and where the arrangement will be placed. The gaps between multiple containers become negative space and an integral part of the overall composition. Generous spacing is very effective for creating ikebana for a wide or deep space or for producing an airy feeling. The wide gap between containers on the left and right sides of this arrangement adds dramatic impact.

amaranthus on fire
flaming crimson creates drama

Blooms of bright red amaranthus conjure up an image of a blazing fire, the dramatic light from its flames casting shadows on the leaves and flowers. Also known as tampala, the plant has multicolored bushy leaves with dangling, beadlike flowers. Three shiny bright red cylinder-shaped containers provide the height needed to lift up the amaranthus and allow the plant's unique beaded flowers to cascade down like chains.

The varying reds of all the components—leaves, flowers, containers and table—combine to produce a dynamic, energetic, uplifting experience for the viewer.

TECHNIQUE, KNOW-HOW AND METHOD

Multiple containers of the same design produce a sense of drama that cannot be achieved with a single vase. Here, three simple red cylinder-shaped vases are used to create one harmonious arrangement. The containers are not used independently but relate to the others to create the desired unity. They are intentionally not set in a parallel line or at regular intervals. Their positions can be easily adjusted after arranging. Placing one container slightly forward injects more depth in the arrangement and adds excitement and movement. This concept of unbalanced balance is a basic tenet of ikebana and is illustrated in several floral works in the book.

When you come across a simple and pleasing container, purchase several in the same color and size. Red, white and black containers are particularly useful and will allow you many options in making your own creative arrangements. For example, these red containers can be used for arrangements in autumn, for Christmas (see page 130) and at New Year.

MATERIAL
AMARANTHUS TRICOLOR
(TAMPALA)

CONTAINER
CYLINDER-SHAPED GLASS
VASES

CHARACTERISTICS
COLOR GRADATION, RHYTHM,
UNBALANCED BALANCE

Above left A random placement of three bright red containers.

Above right Reflected light on the amaranthus produces a fascinating gradation of reds.

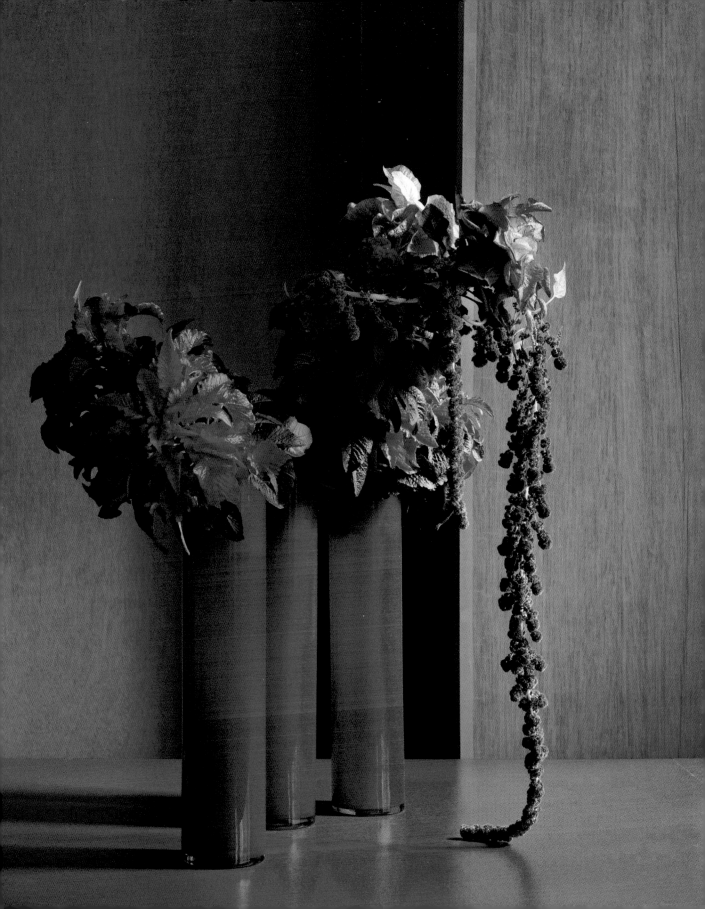

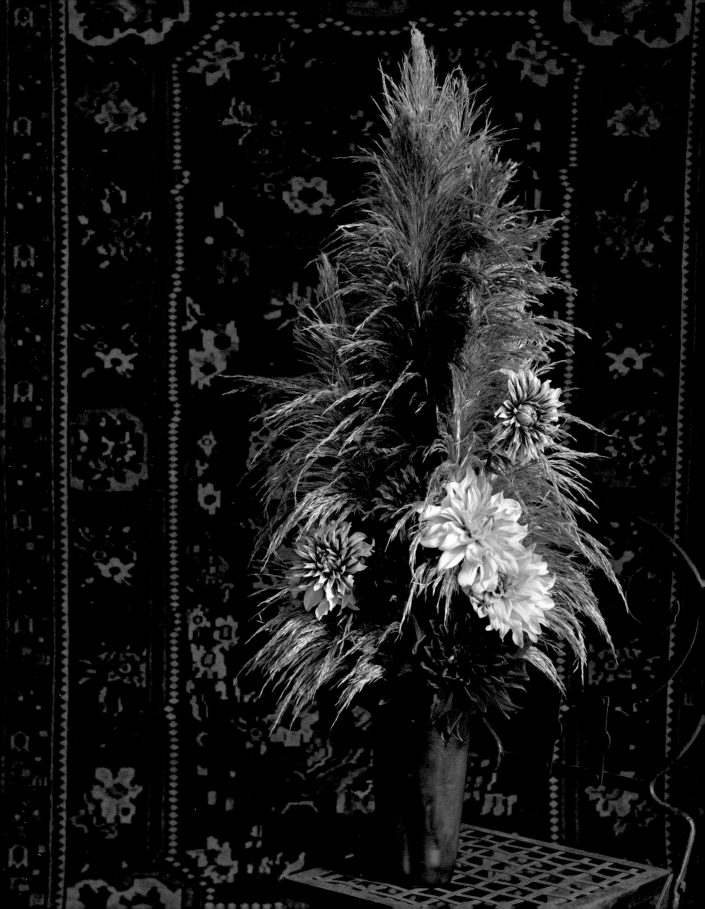

pampas and dahlias
dressed up for a night out

This arrangement evokes an image of a lady wearing a fur stole over her kimono. Perhaps she is going to a concert or a play. With their long, feathery, silver-white plumes, pampas grasses always look rich and elegant, making them ideal for a stunning arrangement in a theater lobby or as a centerpiece in a large room.

In Japan, there is a long history of wearing kimono, although today it is worn more on special occasions than for daily wear. Over a century ago, a new culture of European dress was introduced to Japan, and Western clothes are now standard dress for modern Japanese. But a combination of fashions, such as a fluffy fur wrap over a kimono, is considered stylish in Japan and is particularly popular with twenty-year-old women who dress in traditional kimono to celebrate their coming-of-age.

This floral arrangement borrows two glamorous images—a kimono and a stole—from two different cultures and combines them in a gorgeous arrangement that exudes prosperity and abundance befitting the autumn season.

TECHNIQUE, KNOW-HOW AND METHOD

One of the characteristics of pampas grass is its erect form. As its fronds cannot be bent or shaped, they have to be arranged in a way that makes the most of their inherent straight line. In this arrangement, the stalks are cut short and only the tufts are used. Large, elegant dahlias in shades of red, pink and white are placed asymmetrically among the pinkish-cream pampas fronds, with more flowers inserted near the base just above the lip of the container. A spotlight on the flowers heightens the drama of the overall arrangement.

The subtle color gradation of the flowers, wine cooler and background tapestry has been skillfully calculated and coordinated to create a magical and memorable arrangement.

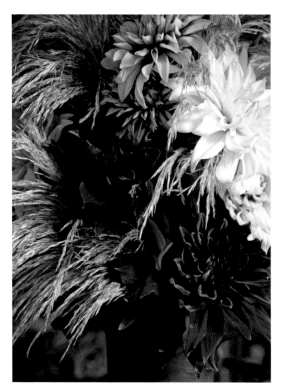

MATERIAL
PAMPAS GRASS, DAHLIA

CONTAINER
WINE COOLER

CHARACTERISTICS
VERTICALITY, ASYMMETRICAL BALANCE, LIGHT AND SHADOW

Left The color combination of the floral materials is both exquisite and sophisticated. Dahlias are placed in and out of the shadows for dramatic effect.

turning autumn leaves
placed naturally in a basket

The panoramic turning of the leaves to the autumn color spectrum fascinates us and fills our hearts with wonder. Here, all the tones of autumn are condensed into one arrangement to bring the seasonal phenomenon into our homes. Various colors of autumn leaves and fruits are gathered to create a seasonal palette arranged in a basket. Even the leaves of grape and raspberry vines change their colors as their shiny fruits grow plump and ripen. Floral materials such as these can be picked in the garden or collected in the fields in a big basket and then casually arranged in a natural manner.

A basket arrangement of seasonal materials can be enjoyed outdoors at a picnic or during a tea break on the patio in the garden. A handled basket can easily be carried indoors and set on a bench in the foyer or placed on a side table as a pleasant reminder of the vast autumn landscape.

MATERIAL
GRAPE, RASPBERRY, WILD
GRAPE, COCKSCOMB, SAGE

CONTAINER
BASKET

CHARACTERISTICS
COLOR COORDINATION,
MOVEMENT

TECHNIQUE, KNOW-HOW AND METHOD

When many kinds of floral materials are used, first decide the leading or prominent color for the arrangement, in this case, red. The point is to arrange the gradation of the leaves, starting from green, turning to yellow, and finally to red. Here, the color red represents the climax and is allocated to the center of the arrangement. However, do not let the leading color be too distinct or dominant, as this arrangement should exude a natural taste.

You should also be conscious of the role of other materials. Consider how each material has naturally grown toward the light and arrange it while paying attention to the direction of the stems and leaves.

A basket needs an inner container to hold water. As this basket has a wide opening, it is difficult to make an arrangement using few materials. Placing another container in the basket as *otoshi* (page 14) is recommended. In a Western-style arrangement, arrangers tend to fill a basket with too many floral materials. By using a smaller inner container, a more roomy and airy Japanese-style arrangement with fewer materials can be created that focuses on the sensitive movement of each stem. Arranging twisted vines in the basket first acts as a support for the other flower materials and creates additional movement in the arrangement. Utilizing natural stabilizers that are also a part of the arrangement is a common and useful technique in Japanese ikebana.

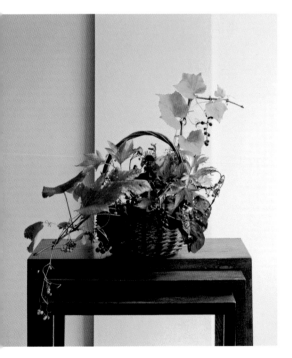

Above Wild grape resembles an emerald necklace.

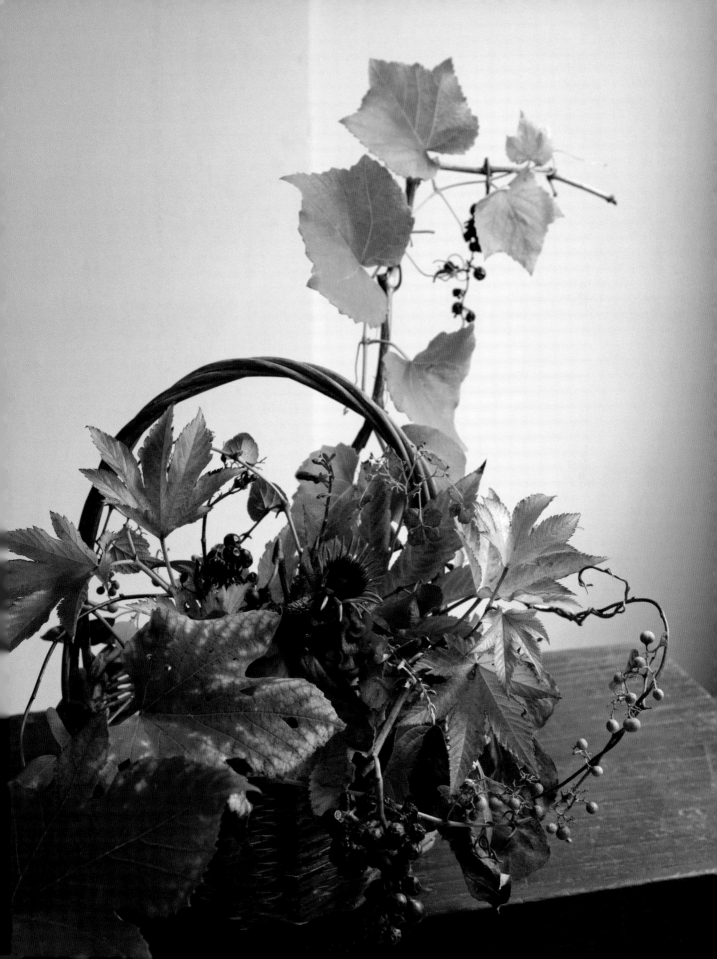

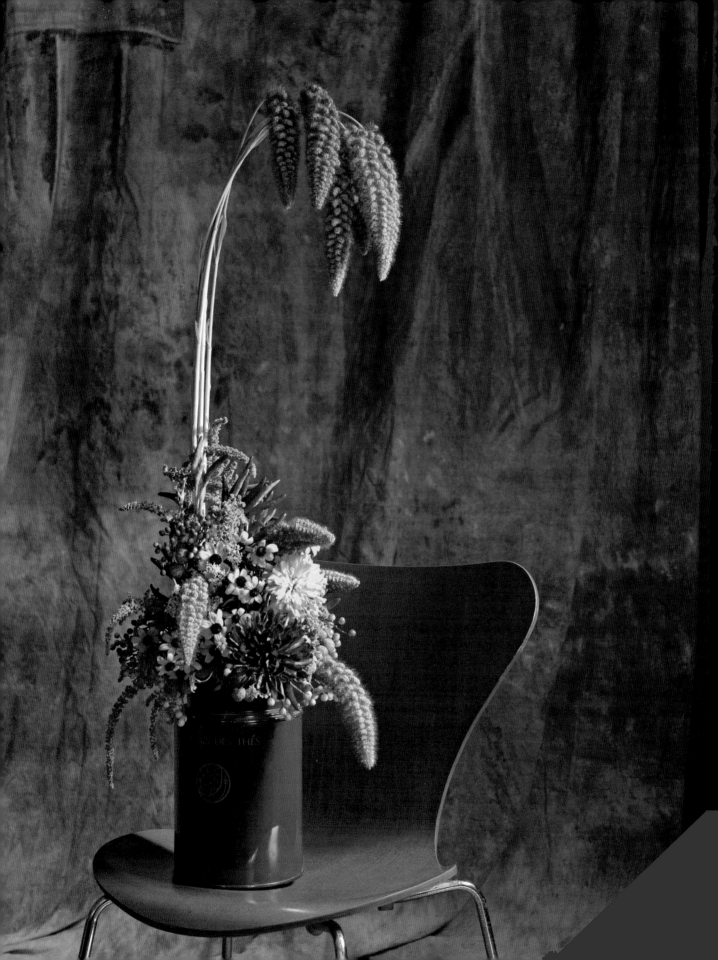

a collage of cozy colors
like an old family album

The gathering of crops in autumn brings people together in work and celebration. This bountiful fruit-and-flower arrangement, placed on a chair, expresses a time to share and give thanks. It is filled with a sense of nostalgia for collective memories, much like a photograph of a family sitting down together and reminiscing. Autumn is the season that generates such warm sentimentality.

A deep red zinnia, toning with the bright red chair, is the focus of the arrangement. Surrounding it are other vividly colored flowers that exude the energy of autumn. The tall, drooping foxtail millet, dramatically showing off its full complement of seeds, is a symbol of the harvest.

The colors of the flowers and fruits in the arrangement also harmonize beautifully with the richly woven curtain behind, a warm and inviting background. The texture of the fabric is denser and more tactile than a glass window or a plain wall, allowing the same qualities in the floral arrangement to stand out and be noticed.

A basic feature of the art of ikebana is considering the entire atmosphere of an arrangement and its placement. That is why this display makes us feel as though we are looking at an old picture of family members taken at an early photo studio.

TECHNIQUE, KNOW-HOW AND METHOD

Full seed tips of foxtail millet epitomize autumn. The plant has abundant ears that naturally bend over with their own weight and symbolize fertility. In this season in Japan, on the evening of a full moon, silver grasses (*miscanthus sinensis*) are arranged in place of stalks of ripe grains to express thanksgiving for autumn crops.

To start the arrangement, vines of berries of various colors are placed in a large tea caddy to act as the support for other floral materials. The berries flow out and above the can to also become a noticeable part of the arrangement. Flowers are then inserted one by one into the spaces between the berries, and the volume and height are gradually built up. Finally, long stalks of foxtail millet are inserted, higher than the main grouping of flowers, while the heads of shorter stalks are allowed to protrude amidst the flowers or dangle over the sides. The entire arrangement is then checked for overall balance.

MATERIAL
ZINNIA, FOXTAIL MILLET, RUDBECKIA (CONEFLOWER), RED PEPPER, BITTERSWEET, VIBURNUM COMPACTUM

CONTAINER
TEA CADDY

CHARACTERISTICS
COLOR GRADATION, SEASONALITY

From left to right The container set on a chair. A large mass of bittersweet placed in the tea caddy acts as a stabilizer. Flowers are inserted all around, evenly balanced but not monotonous.

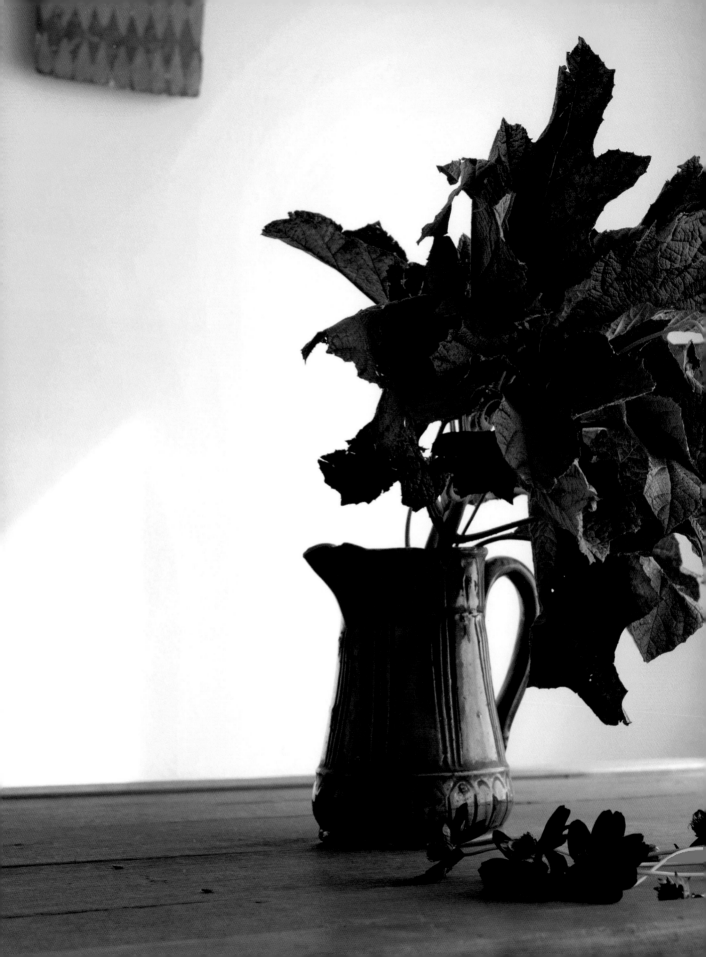

chocolate and red
french provençal chic

The leaves of the chocolate-colored oakleaf hydrangea have a robust, powerful form. In the center of the leaf display is a cosmos of the same color, seemingly crawling out like a tiny, curious creature, perhaps to join its companions strewn below.

Hydrangea bushes are prolific in Japan and have a strong seasonal image in the culture. Their flowers, after enjoying lush growth in the rainy season at the onset of summer, continue to grow and change color until they slowly dry out on the branches. Here, in tranquil contrast to an exuberant expression of autumn using hydrangea flowers, oakleaf hydrangea leaves are placed in a French Provençal glazed vase. It is a very simple but chic and modern ikebana.

Below The powerful form of oakleaf hydrangea leaves contrasts with the slim, flat wooden trestle.

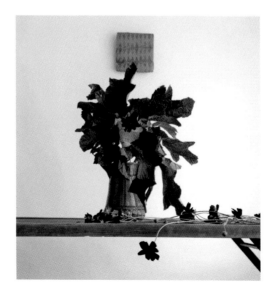

TECHNIQUE, KNOW-HOW AND METHOD

The color palette of the oakleaf hydrangea leaves and chocolate cosmos are so harmonized that it may be difficult at first to realize the tiny cosmos is there. But when spotted, the quality of the cosmos captures our attention and is recognized as being quite different from the leaves. By controlling the color tones, the arranger communicates a sophisticated, picture-like autumn.

A single flower by nature has the power to attract attention and to become symbolic. Like this arrangement, once the flower is camouflaged by controlling the entire color palette, the surprise is amplified when the flower is finally discovered. Arranged in an antique jug, without too many other materials, the distinctive display leaves a lasting impression.

MATERIAL
OAKLEAF HYDRANGEA (HYDRANGEA QUERCIFOLIA), CHOCOLATE COSMOS

CONTAINER
FRENCH ANTIQUE JUG

CHARACTERISTICS
COLOR TONE

autumn cornucopia
still life in a vase

A cornucopia is a container shaped like a horn. Originating in classical antiquity as a symbol of abundant harvest and prosperity, it has continued as such in Western art and is particularly associated with the Thanksgiving holiday in North America. The horn-shaped basket is often decorated with produce, flowers and nuts. In this simple Japanese ikebana, a pedestal vase topped by a wire cornucopia and filled with delicate floral materials forms the central element of an autumn still life of harvested fruits and vegetables placed on a table.

The arrangement of fruit and vegetables with floral materials in ikebana is called *morimono*. The produce forms an integral part of the arrangement and careful consideration is given to the color, position and balance of the flowers and branches in relation to it. A cornucopia motif is seldom found in Japan and does not carry any particular meaning. In fact, the wire cornucopia used here was purchased on the west coast of the United States. Its nearest companion is a Japanese basket. But with typical Japanese sensibility, instead of being used as a container, the wire cornucopia here functions as a stabilizer for the flowers, and thus becomes a part of the materials of the arrangement.

The horns of most animals extend upward, their shape and direction giving them an air of strength and bravery. This cornucopia also moves upward and symbolizes the hope for growth and plentitude.

TECHNIQUE, KNOW-HOW AND METHOD

Because a cornucopia expresses abundance in life, even the simplest arrangement will impress if the container is well utilized. In this arrangement, what is important is that the shape of the cornucopia is not hidden and, at the same time, its airy, basket-like form is effectively exploited.

In creating ikebana, it is always important to pay attention to the relationship between the arrangement and the space it occupies and thus decorates. Here, the entire table comprises the stage for the still life. All materials on the table, from a pumpkin to an apple to a nut, constitute a part of the entire ensemble and attention should be given to the position and balance of each as it relates to the whole.

MATERIAL
HYDRANGEA, POKEWEED, SPRAY MUM

CONTAINER
IRON VASE, WIRE CORNUCOPIA BASKET

CHARACTERISTICS
HARMONY OF ELEMENTS, BALANCE

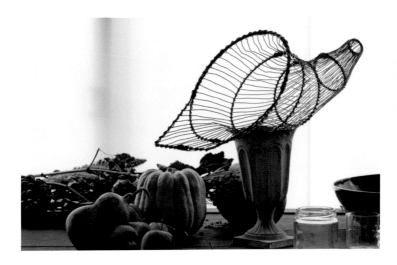

Left To gain height, a wire cornucopia is set on a pedestal container filled with water.

Right A delicate mum protrudes from the display, a typical and effective Japanese touch.

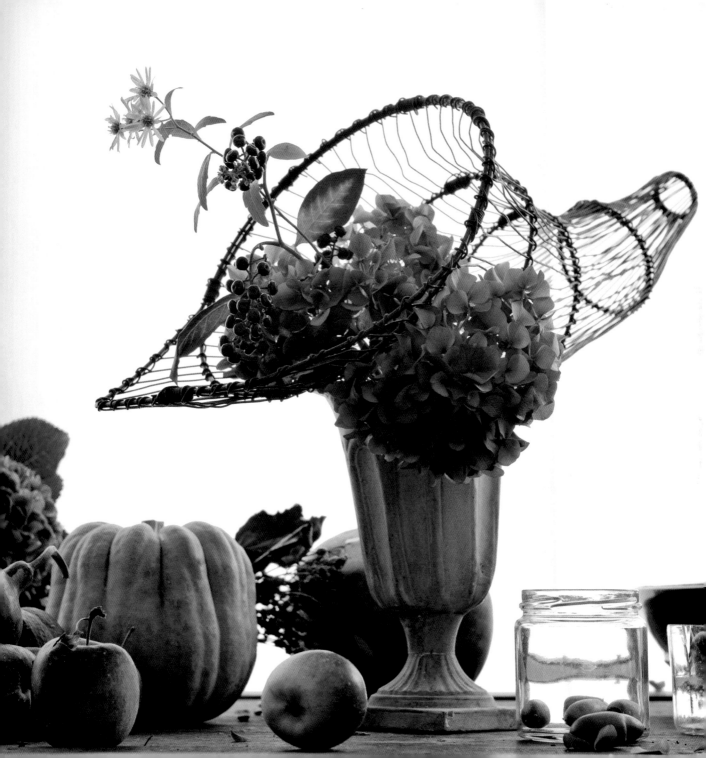

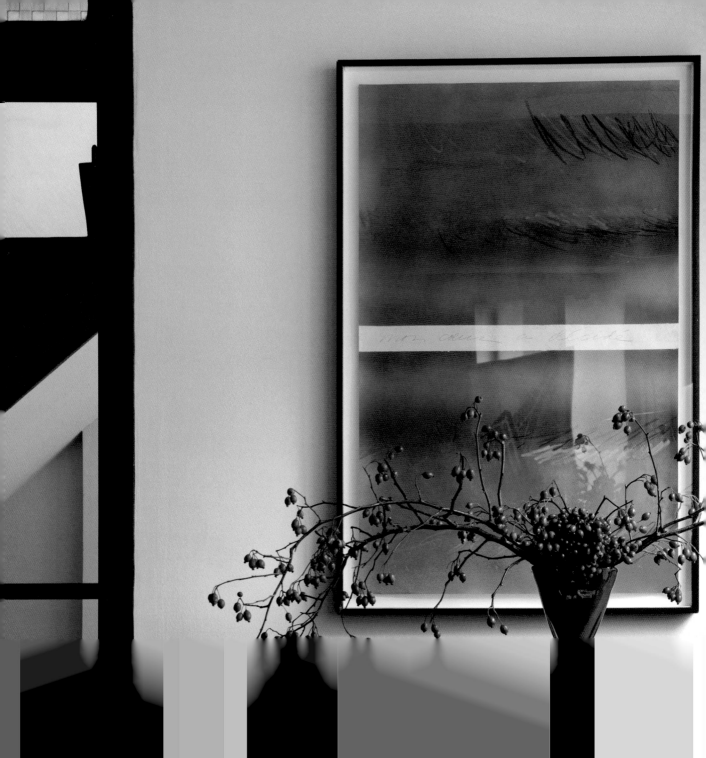

dancing red berries
on a bright and lively stage

Branches reach out from a small red vase. Overflowing red berries pop out in all directions, seeming to dance on the cabinet. In the picture behind, mountains blazing with the color of autumn foliage appear to mimic the rhythmical movement of the arrangement. Together they appear like a scene on a stage and resonate deeply with the audience. The fiery autumn orange-red can be enjoyed for only a short period of the year. Feelings of joy and thanks to the season, however short, are put into this lighthearted yet sophisticated arrangement.

Below The tips of the branches are reflected in the glass of the picture, unifying the arrangement with the backdrop.

TECHNIQUE, KNOW-HOW AND METHOD

To emphasize the pretty red rose hips, the whole arrangement is coordinated with the same orange-red colors, from the materials to the vase to the backdrop. In echoing each other, the components are able to convey a simple yet strong message. Being able to create displays that appeal to viewers and elicit a positive response is an important aspect of ikebana.

The branches of the rose hip have gentle curves. Sub-branches protrude from the sides, with fruits on the tips where the roses bloom. Here, two sets of branches are arranged side by side left and right of the central vase. In this way, the characteristics of the floral materials and the expansive space are fully utilized. The glass container is so small you can hold it in your hand, yet a large horizontal arrangement has been created with the help of a horizontal support (page 12).

Other trees with light branches that bear shapely berries or fruits can be used for a similar arrangement.

MATERIAL
ROSE HIP, VIBURNUM COMPACTUM

CONTAINER
GLASS VASE

CHARACTERISTICS
COLOR COORDINATION, FRONTAL VIEW, HORIZONTAL BALANCE

a hanging branch of ripe fruit
casts long shadows on the wall

Autumn is the season of bunches of ripened fruits hanging proudly in orchards. As winter approaches and the fallen leaves from the trees have been swept away, interesting bare branches remain silhouetted against the sky. Unlike most fruiting trees, however, the persimmon holds on to its fruit long after its leaves have fallen, inviting us to look up at the bright orange globular shapes dangling from the branches.

When persimmon branches laden with fruit decorate a wall, they present a very different aspect from their natural growth on a tree. The upside-down placement of the branches shown here allows the various sized fruit to be concentrated at the top, forming a mass of color in contrast to the jagged lines of the brown branches cascading below. A spotlight from above casts dramatic shadows on the wall. This is a very natural and simple ikebana with great impact.

TECHNIQUE, KNOW-HOW AND METHOD

No container of water is used in this arrangement. Instead, an attractive piece of weathered wood is attached to a wall and the persimmon branches are hooked over the top. Hanging persimmon fruits keep their shiny appearance without any water intake. The cascading leafless branches creates a striking balance in the arrangement.

Sometimes an unrealistic or unusual approach is required to realize a dramatic arrangement. However, the balance of reality and unreality is important in avoiding artificiality in ikebana. The right balance depends on the materials and how you choose to arrange them. The key is whether or not the intrinsic beauty of the plants in an arrangement can speak to the soul of the viewer.

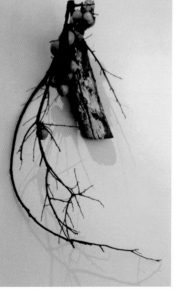

MATERIAL
PERSIMMON

CONTAINER
WEATHERED WOOD

CHARACTERISTICS
MOVEMENT, WEIGHT
BALANCE

Far left Make a hole in a piece of weathered wood collected in the garden or forest and attach it to a hook on the wall.

Left Place the persimmon branches and fruits upside down near the top of the wood. The branches will cascade down while the fruits will remain at the top. Adjust the branches until they are stable and balanced.

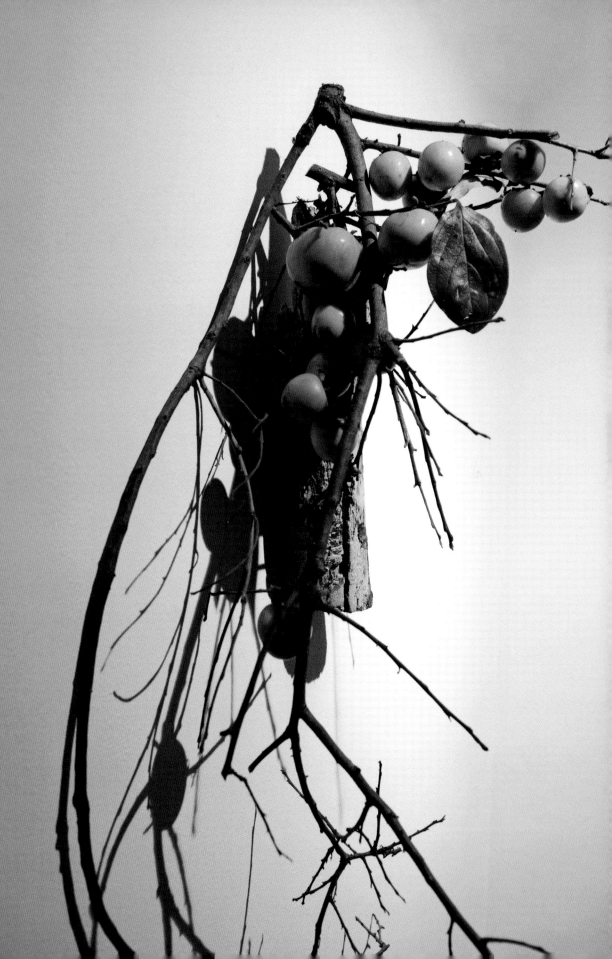

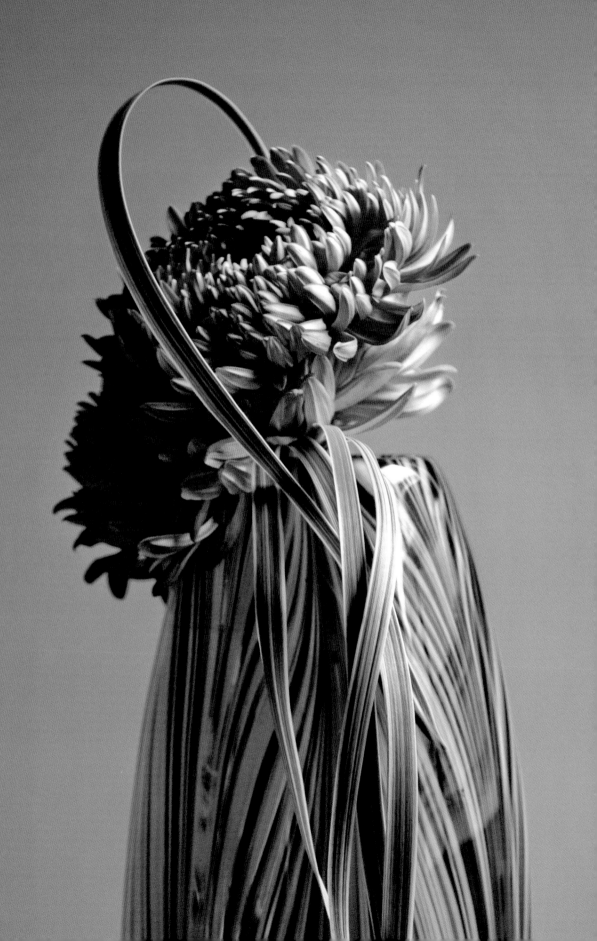

a tangle of leaves
in a camouflage vase

Slender leaves appear to spring from the leaf pattern on the surface of the glass vase. Real leaves tangle with the swirling glass "camouflage" leaves while one twirls up over two fully opened blooms. The lovely form of the container and the rich color of the flowers make a sensual statement in this simple modern ikebana.

The glass vase, with its unique leaf motif, creates the illusion of many leaves in the arrangement when actually only are few are used. It is a good example of materials harmonizing with the container. It also demonstrates that with only a few materials, it is possible to make an arrangement with dramatic impact.

Although the container is a modern Western-style one, a simple Japanese-style ikebana is successfully created. The color combination also plays a role, with the green container and background setting off the golden flowers.

Below left First, a handful of leaves are placed in one side of the vase.

Below right Two chrysanthemum stems are then added, with their heads resting on the rim.

Left Finally, one of the leaves is looped over the flowers for artistic effect.

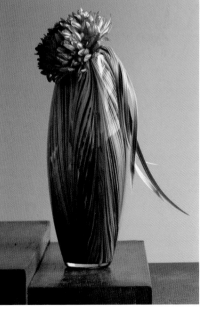

TECHNIQUE, KNOW-HOW AND METHOD

Inspired by the pattern and color of the container, the arrangement consists of matching miscanthus leaves and two large chrysanthemums whose long curling petals coordinate with the swirls on the leaves and glass vase.

Only a few leaves and flowers are needed to create such a dramatic arrangement. The volume or size of the materials does not matter. The key is to study the container carefully and to select floral materials that will harmonize with its shape, color and pattern and the lighting conditions.

By looping one leaf over the flower, the arrangement as a whole forms a unity without disrupting the placement of the flower and leaves. Autumn sunlight entering from the right casts a beautiful glow on the arrangement.

MATERIAL
CHRYSANTHEMUM, MISCANTHUS LEAF

CONTAINER
GLASS VASE

CHARACTERISTICS
HARMONY OF ELEMENTS

winter

After the harvest is over, flowers wither and broad-leaved branches become bare. Plants hibernate and spend the winter lying dormant. But there is still enough green amid the stark surroundings to attract our attention. Hardy evergreens show off their glossy leaves and firm needles retain their deep color. It is a season of bold contrasts and dramatic statements that can be captured in simple Japanese-style arrangements.

Winter is also the season of joyful festivities, such as Christmas and New Year, when there are opportunities to invite guests into your home. It is a perfect time to enjoy ikebana using natural winter materials to create a warm, welcoming ambience.

We are all familiar with large decorations of evergreens and seasonal objects in public places. In Japan, large Western-style displays of seasonal floral materials are common in hotel lobbies and department stores. Big arrangements, with lots of flowers in large containers are seen as appropriate to bring cheer during the holidays. However, winter, with its colder temperatures and shorter daylight, is also a time when people become more introspective. Now is the time to make a simpler Japanese-style flower arrangement with only a few floral materials that captures the spirit of the winter landscape.

You may wonder how ikebana can be created in the harsh winter season. But it is possible to find many attractive materials if you look for them. Leafless branches allow us to appreciate their true form and vines curl and dry naturally into interesting shapes. Some berries, ignored by birds, remain firm through the cold and a few very early bulbs blossom. Although materials that can be arranged in a mass are gone, bare branches are often used in winter arrangements to emphasize a strong linear shape.

In ikebana culture, the withering and dying stage of a plant is recognized and accepted. This is linked to the concept of the impermanence of worldly things derived from Buddhism. A winter arrangement with dried branches, accented by fresh flower materials available from florists, can describe a story on a brighter note that foresees a breath of new life in the coming spring.

Bringing evergreen plant material indoors is an age-old tradition at Christmas. Green is a symbol of the continuity of life, a celebration of a new cycle of growth and fertility. In Japan, as in many places elsewhere, red and white are congratulatory colors for the New Year and express the joy of life. This triad of colors is rich in opportunities for creating evocative displays with dramatic texture and splashes of brilliant color.

Containers with a warm color or texture and a closed form or small mouth are most suitable for the winter season. Darker colors may be preferred, and clay pottery rather than hard porcelain may also be appreciated. On the other hand, it can be interesting to intentionally use ice-like glass containers to recall a freezing winter. The coordination and decoration are really up to your imagination and will depend on where you live and how you experience winter.

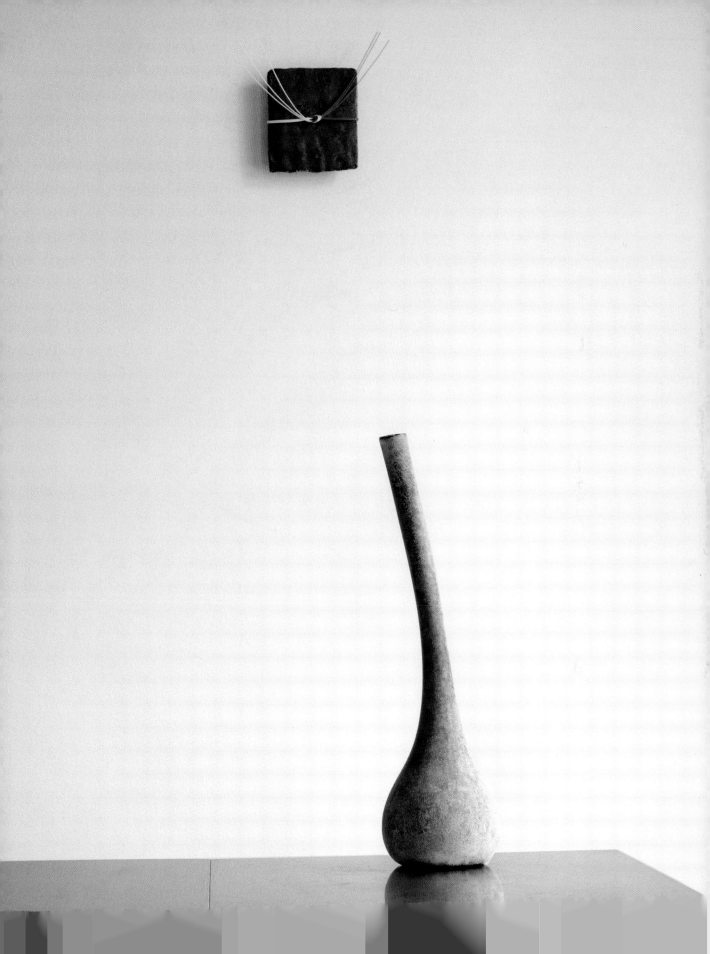

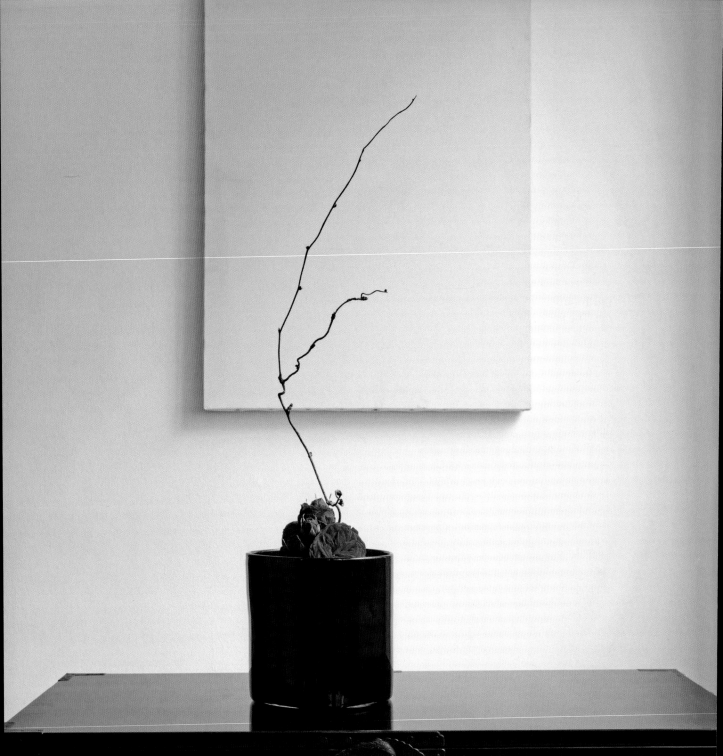

a wispy vine and red roses
peek out from a black vase

Red roses huddle and peek out curiously over the edge of a sturdy black container. The half faces of the flowers seem shy and reserved. A single black vine, shooting upward, appears like a piece of Japanese calligraphy drawn on the white canvas behind. This combination of black, red and white represents one of the most dramatic color contrasts in ikebana.

A Japanese-style flower arrangement is never complete merely with arranging the flowers. The harmony between the container, backdrop and surrounding space are valued every bit as much as the floral materials. This arrangement is a good example of achieving such harmony, which is what makes it both suggestive and successful.

Below left A small container with flowers is placed inside a larger one.
Below right The two containers used in the arrangement.

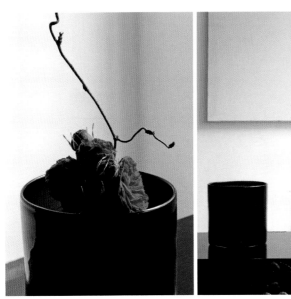

TECHNIQUE, KNOW-HOW AND METHOD

It is only natural to want to fill a wide-mouthed container with many flowers and make a Western-style arrangement. In contrast, a simple modern ikebana can be created by placing a smaller vase inside a bigger vessel. This produces a tighter, sharper arrangement and also uses fewer flowers.

The technique of setting a smaller vessel into a larger one is widely practiced in ikebana. It is particularly useful when the larger container cannot hold water, such as a basket, a container with holes or a porous clay pot.

It is not necessarily true that the more flowers in an arrangement, the more it stands out. In Japanese ikebana, the design edict "less is more" applies, as shown in this simple arrangement. Its few red flowers enveloped in a strong black container evocatively convey the joy of life.

MATERIAL
DRIED VINE, ROSE

CONTAINER
LARGE GLASS VASE, SMALL CERAMIC VASE

CHARACTERISTICS
SIMPLICITY, COLOR CONTRAST, VERTICALITY

a red christmas table setting
brings good tidings and good cheer

How about giving a sophisticated Japanese touch to a Christmas Day party table? Most Japanese consider themselves Buddhist, and Christmas as a religious event is celebrated by only a few Christian groups. But as the lifestyle in Japan has become more Westernized, it is common for many Japanese to enjoy some Christmas celebration in their homes.

This large two-color arrangement is designed for a party table for adults. Several cylinder-shaped red vases and candles of different heights are grouped on the table. Branches laden with small, hard red berries and a few sprigs of soft green fern, placed in the vases, hover over the arrangement. A warm glow from the candles reflects off the glass containers and lights the stylish arrangement from below.

MATERIAL
FIRE THORN (PYRACANTHA),
ASPARAGUS FERN

CONTAINER
CYLINDER-SHAPED GLASS VASES

CHARACTERISTICS
COLOR COORDINATION,
UNBALANCED BALANCE,
HARMONY OF ELEMENTS

TECHNIQUE, KNOW-HOW AND METHOD

Appropriately for Christmas, bold red is the color of choice for the floral materials, containers, candles and bottom tablecloth in this arrangement. The secondary color, green, is used sparingly in the arrangement and for the top tablecloth to offset the dominant red. Fire thorn branches stretch over the table, maintaining their balance in spite of the weight of the berries. Delicate green sprigs of asparagus fern appear to float among the branches.

Hamonizing with the cylinder-shaped vases, candles of identical shape and color are interspersed on the table. These combine with the vases to emphasize the arrangement's vertical line and increase the impact of the red. Bottles of red wine placed near the display, together with long-stemmed crystal glasses contribute to the verticality and play an important supporting and coordinating role.

The generous spacing of the containers sets the tone for this expansive arrangement. The flowing branches and delicate ferns are arranged sparingly and do not completely fill the mouths of the containers. A luxuriant arrangement is successfully achieved with only a few materials and two colors.

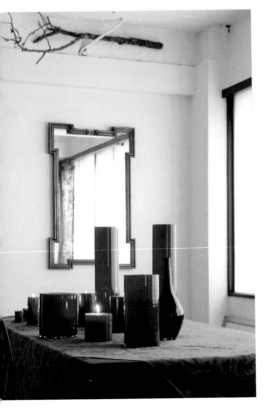

Left The table with the vases and candles in place.
Right Fire thorn branches hover above but do not touch the table.

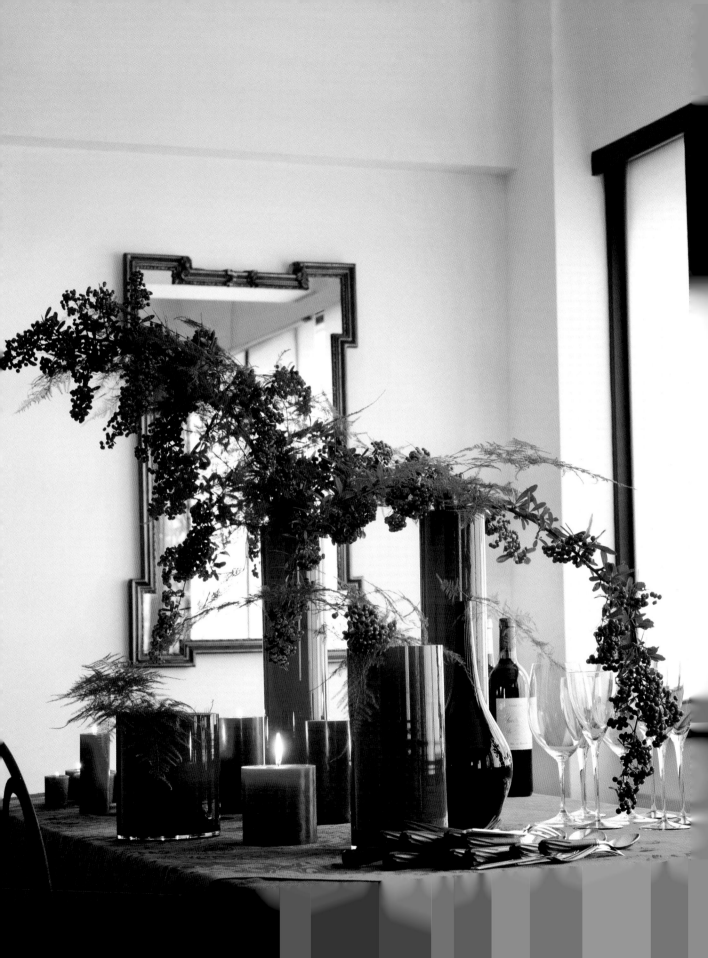

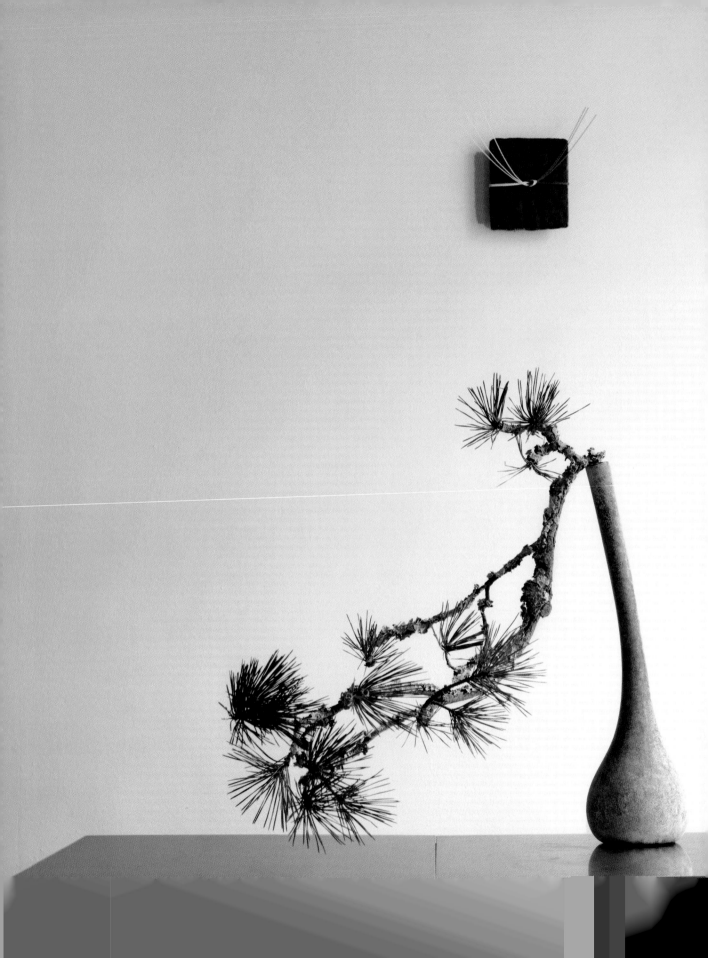

the noble pine branch
is perfect for the new year

Pine trees are evergreens that have existed in Japan for thousands of years. They stand tall in many coastline areas and can withstand harsh winter conditions. An image of the pine is represented in every aspect of Japanese culture. The revered pine is considered a symbol of luck and longevity.

Pine trees endure nature's severity yet grow strong. The Japanese feel great empathy with the tree's strong will to live, and to arrange pine is to make that emotion apparent in an evocative way. Pine is treated as a noble tree and is therefore typical material for a New Year arrangement.

This pine branch was found on the seashore. It suggests that the tree was continuously blown by strong, cold winter winds. The small bunches of needles twist as they try to reach for sunlight. The rough mossy surface of the bark harmonizes perfectly with the frosty look of the vase. There is something very soothing about the arrangement.

TECHNIQUE, KNOW-HOW AND METHOD

A single branch cascades down from the container yet maintains tension in the balance, while the back-looking pine needles visually help lift the branch up off the table. From this arrangement, you can feel the pine's strong will to survive.

In putting together the arrangement, think about the direction of the light source. In this case, the arrangement is carefully set to receive light coming from the right. Although the cascading flow of the branch is emotionally moving, be careful that it does not touch the table in order to maintain the dramatic tension in the arrangement. Note the wonderful union of material and container and the architectural quality of the whole arrangement.

MATERIAL
PINE

CONTAINER
CERAMIC CONTAINER

CHARACTERISTICS
LIGHT DIRECTION, HARMONY OF ELEMENTS

Right The position of the container is important. Consider the balance of the entire space. In order to invite the incoming light to the arrangement and fully accommodate the extending branches, the container is placed not in the center but toward the right of the table.

a sculptural air plant
the icy tone of winter

The color tones of icy winter permeate this arrangement. Air plants, despite their wintery appearance, contain a watery green color inside. They grow and thrive without soil. This lively, sculptural plant is arranged in a tall, sleek glass vase and accented with eye-catching red berries and a black lotus pod.

A seasonal arrangement like this, with its cold aura, can be captivating in a warm living room in winter, especicially if placed in front of a white wall between windows without curtains.

TECHNIQUE, KNOW-HOW AND METHOD

Air plants require no water and thrive by taking in moisture and nutrients from the air. As the other materials are dry, this arrangement will last for a long time in winter provided the air plants are occasionally misted with water to offset the dryness of indoor heating. The air plants are arranged asymmetrically to suggest their vigorous and fighting spirit in the icy grip of winter. Although the lotus pod is dried, it still shoots upward, demonstrating its will to survive. There is much to ponder in the arrangement.

MATERIAL
AIR PLANT (TILLANDSIA), DRIED RED BERRY, DRIED LOTUS POD

CONTAINER
LONG-STEMMED GLASS VASE

CHARACTERISTICS
VERTICALITY, UNBALANCED BALANCE, HARMONY OF ELEMENTS

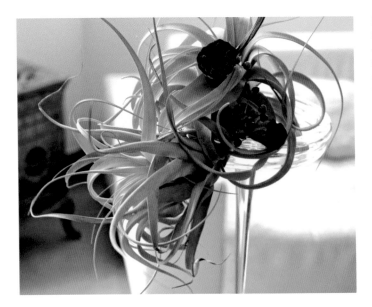

Left Two air plants are suspended near the side of a shallow glass stem vase, seemingly about to fall over the side. At the same time, the air plants are used as stabilizers for the upward facing dried lotus pod. The red of the dried berries makes a striking contrast.

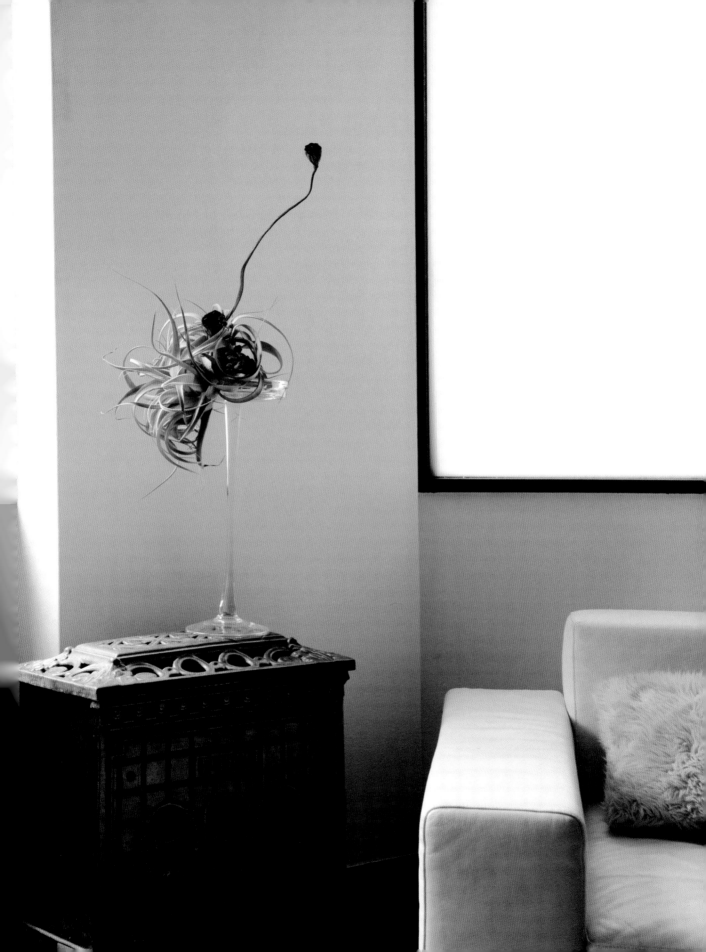

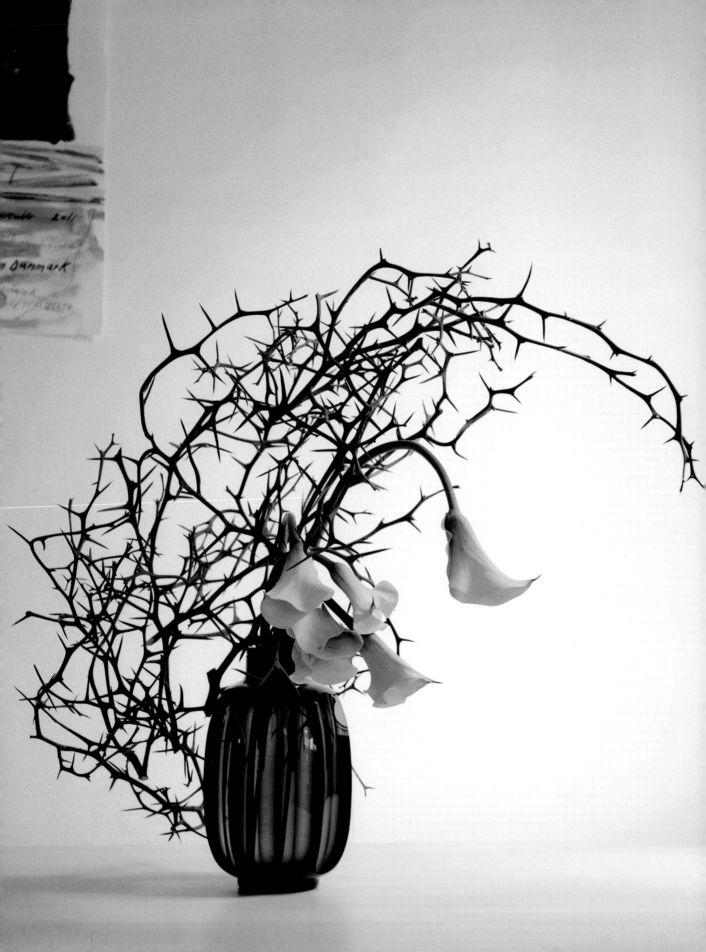

trifoliate orange bares itself
long thorns come alive

Except for evergreens, most trees lose their leaves in winter. Devoid of leaves, the skeletal forms of trees and bushes are revealed, providing an opportunity to consider just how they grow. For people who practice ikebana, it is an exciting time for pondering the distinctive features of trees—their shape, the movement of their branches and the color and texture of their bark.

In Japan, there are many citrus trees that remain green in winter and hold on to their fruit, some too sour to eat fresh and usually made into jam. Although the trifoliate orange produces downy, bitter, citrus-like fruit, it is a deciduous shrub and sheds its leaves to reveal long, sharp thorns. The sharpness of the prickly branches makes it a challenging material to arrange. In this ikebana, the ferocity of the thorns is softened by the use of a smooth, rounded vase and lilting flowers. The contrast of stiff and fluid lines is particularly effective.

TECHNIQUE, KNOW-HOW AND METHOD

At first glance, the materials in this arrangement appear incompatible. The bare, contorted branches of the trifoliate orange look frighteningly stark against the brilliant yellow flowers and soft, slender stalks of the calla lilies. But the green of the stems turns out to be a unifying factor, as is the movement of both materials. In the end, opposites attract and the qualities of each are highlighted.

The modern bluish-black container holds the materials firmly. The color of the flowers, the yellow tabletop and the picture in the background are harmonized and condensed into one coordinated display.

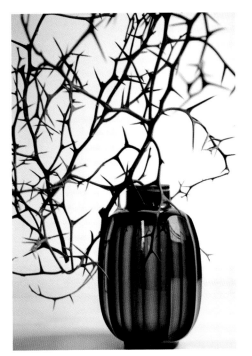

MATERIAL
TRIFOLIATE ORANGE, CALLA LILY

CONTAINER
GLASS VASE

CHARACTERISTICS
COLOR COORDINATION, CONTRAST OF MATERIALS

Left Branches of trifoliate orange hooked onto the container do double duty as floral element and stabilizer for the flowers.

a regal amaryllis
with a royal blue stripe

The amaryllis has a thick, straight stem topped by large, dramatic blooms. This arrangement emphasizes the straight line of the amaryllis stalk and its simple placement in a container. In order to enhance the verticality of the stem, a Japanese sash for kimono, or *obi*, with a royal blue line on gold is hung behind. The relationship between the arrangement and the backdrop is well conceived and defined using a simple color scheme.

A silver-colored oval container and a flower support of the same tone are used in the arrangement. The metal support is a traditional Japanese one called *shippo* composed of interlocking circles. It is available outside Japan in some shops that sell floral design equipment. You can use a different support device as long as it looks neat and has enough weight to hold the top-heavy amaryllis firmly.

The cool, straight blue line of the *obi* accents the softer curving green line of the flower stalk. The fully opened pink flowers, with their bright yellow stamens, make a striking statement against the subdued gold background.

TECHNIQUE, KNOW-HOW AND METHOD

Although a metal *kenzan* pin holder is a popular floral support in Japanese ikebana, it is not used in this book: a *kenzan* is neither a beautiful device nor a natural one, and the way it holds floral materials is very cruel. In contrast, a *shippo* is beautiful even when it is visible in an arrangement and it does not damage plants. If a *shippo* is not available, you might try using some stones or twisted vine to hold the stem upright.

Although this arrangement consists of only one stalk of amaryllis, another option is to add a leaf at the base of the stem. But without extra garnish, the simplicity of the arrangement is emphasized and the flowers at the top immediately catch the eye.

Calla lily and strelitzia may also be used to create an arrangement that emphasizes the beauty of a single glorious bloom.

MATERIAL
AMARYLLIS

CONTAINER
ROUND BAKING PAN

CHARACTERISTICS
VERTICALITY

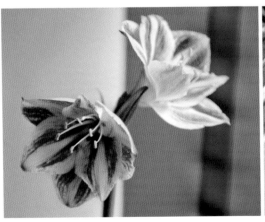

Above left Note the beautiful contrast between the amaryllis and the royal blue line on the Japanese *obi*.

Above right The weighted *shippo* is steady in the container. Although the support is a tool for the arrangement, it is simple and beautiful and need not be hidden from view. The matching tones of the container and support device create a sense of unity.

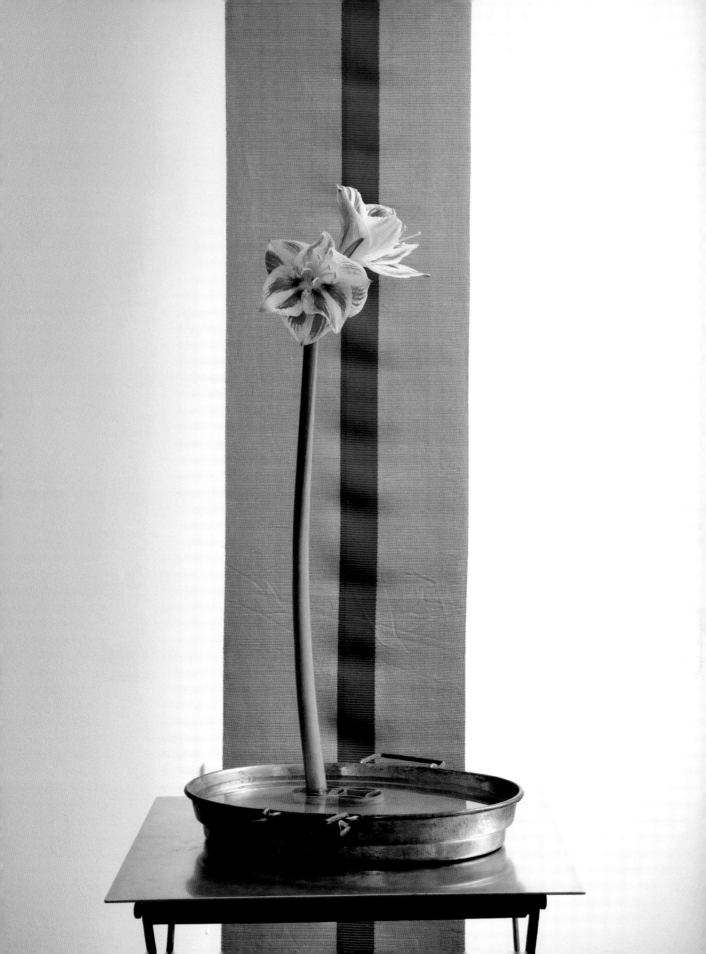

moss breathes quietly
the sound of silence

Moss and lichen breathe quietly on the branches of ancient trees deep in the damp forests of Japan. Moss is regarded as a symbol of longevity and is used in elegant classical ikebana to express nobility. Traditionally, it exudes a sense of celebration.

In Kyoto, the ancient capital of Japan, there is a temple called Saihoji, a Unesco World Heritage Site. This temple is also known as Koke-dera or Moss Temple in acknowledgment of the temple garden's estimated 120 species of moss.

The Japanese appreciate the beauty of moss, and a ball of gently breathing moss set on a table or hung outdoors is a popular item in garden cafes and shops for soothing the mind.

This arrangement succeeds in turning a corner of a room into a miniature forest, bringing silent nature into the house. It may not appear to be a Japanese-style arrangement but it truly conveys the essence of an expression of natural beauty captured in Japanese traditional ikebana.

MATERIAL
MOSS

CONTAINER
WOOD BRANCHES

CHARACTERISTICS
NATURALNESS

TECHNIQUE, KNOW-HOW AND METHOD

Dried and decaying branches have a sort of curious charm that attracts a viewer's attention. In this intriguing arrangement, a few branches selected from the forest floor are used as both base and container. The branches are bundled together and positioned upright, and a cluster of moss is casually placed on top. Although the arrangement looks simple, the moss is treated symbolically and spiritually. It is as though it is being nobly carried in the air, far from its usual habitat on the surface of stones or wood.

It is rare to have moss as the main material in Western-style arrangements. Moss is mostly used to cover floral foam or hide an unsightly base or device. By letting it play a leading role, the delicate beauty of moss can be visible to all.

In Japan, moss is often used as the base for small garden trees and bonsai. A large ball of moss with other sprouting plants embedded in it can be hung from the eaves of a roof.

It is a good idea to look at the materials you use from a different perspective. By taking a different approach to familiar floral materials, you can discover new ways to express their beauty in simple modern ikebana.

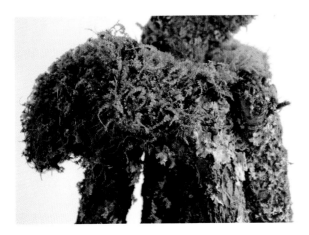

Above A close-up of the moss. It needs to be misted occasionally to keep it moist. Moss that contains water flourishes.

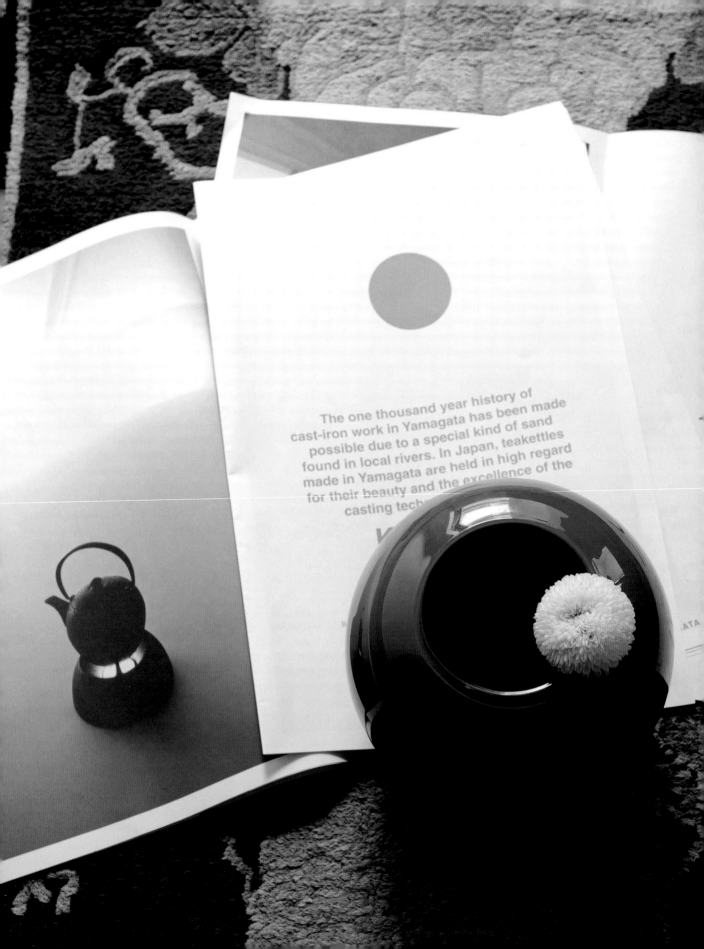

The one thousand year history of cast-iron work in Yamagata has been made possible due to a special kind of sand found in local rivers. In Japan, teakettles made in Yamagata are held in high regard for their beauty and the excellence of the casting tech...

moss breathes quietly
the sound of silence

Moss and lichen breathe quietly on the branches of ancient trees deep in the damp forests of Japan. Moss is regarded as a symbol of longevity and is used in elegant classical ikebana to express nobility. Traditionally, it exudes a sense of celebration.

In Kyoto, the ancient capital of Japan, there is a temple called Saihoji, a Unesco World Heritage Site. This temple is also known as Koke-dera or Moss Temple in acknowledgment of the temple garden's estimated 120 species of moss.

The Japanese appreciate the beauty of moss, and a ball of gently breathing moss set on a table or hung outdoors is a popular item in garden cafes and shops for soothing the mind.

This arrangement succeeds in turning a corner of a room into a miniature forest, bringing silent nature into the house. It may not appear to be a Japanese-style arrangement but it truly conveys the essence of an expression of natural beauty captured in Japanese traditional ikebana.

TECHNIQUE, KNOW-HOW AND METHOD

Dried and decaying branches have a sort of curious charm that attracts a viewer's attention. In this intriguing arrangement, a few branches selected from the forest floor are used as both base and container. The branches are bundled together and positioned upright, and a cluster of moss is casually placed on top. Although the arrangement looks simple, the moss is treated symbolically and spiritually. It is as though it is being nobly carried in the air, far from its usual habitat on the surface of stones or wood.

It is rare to have moss as the main material in Western-style arrangements. Moss is mostly used to cover floral foam or hide an unsightly base or device. By letting it play a leading role, the delicate beauty of moss can be visible to all.

In Japan, moss is often used as the base for small garden trees and bonsai. A large ball of moss with other sprouting plants embedded in it can be hung from the eaves of a roof.

It is a good idea to look at the materials you use from a different perspective. By taking a different approach to familiar floral materials, you can discover new ways to express their beauty in simple modern ikebana.

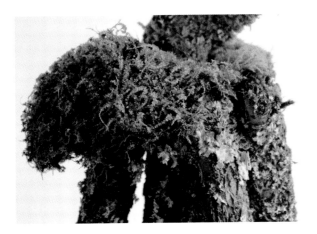

MATERIAL
MOSS

CONTAINER
WOOD BRANCHES

CHARACTERISTICS
NATURALNESS

Above A close-up of the moss. It needs to be misted occasionally to keep it moist. Moss that contains water flourishes.

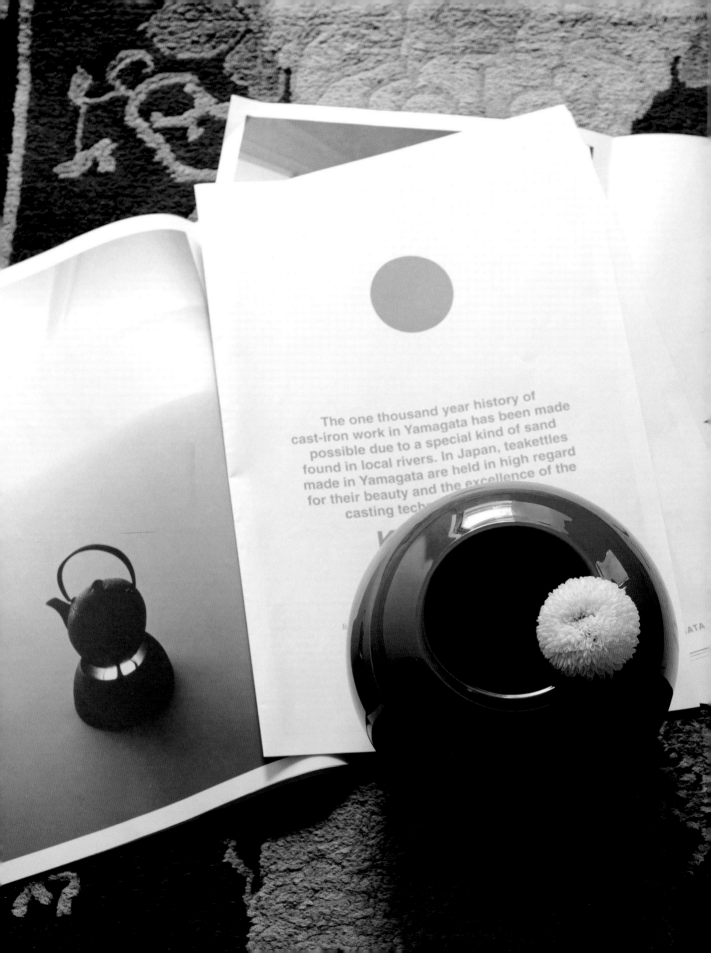

The one thousand year history of cast-iron work in Yamagata has been made possible due to a special kind of sand found in local rivers. In Japan, teakettles made in Yamagata are held in high regard for their beauty and the excellence of the casting tech...

a red round vase
is the rising sun

A red round vase is set on papers laid out on a richly woven Oriental rug. Perched on the edge of the container's mouth is one small, white, round chrysanthemum flower. When viewed from above, the continuous circular rhythm of the arrangement grabs the viewer's attention.

The powerful red and white combination reminds us of the "rising sun" or the national flag of Japan.

MATERIAL
CHRYSANTHEMUM

CONTAINER
GLASS VASE

CHARACTERISTICS
CONTINUITY, RHYTHM

TECHNIQUE, KNOW-HOW AND METHOD

The concept behind this arrangement is repetition of a motif, in this case a circular form. The circular flower is resting on the edge of the circular opening of the circular container, but is not supported by it. The stem touches the bottom of the container and is standing steadily upright. Only one flower is arranged and it can be viewed from all directions.

Arranging a single flower alludes to the simple seasonal ikebana for the tea ceremony known as *chabana*. Tea ceremony aesthetics prescribe that *chabana* be composed of bare essentials, and the viewer may react freely and spontaneously, sharing the inner joy of the poetic experience of the arranger.

A circle relates to the image of a celestial object, and in this arrangement, the sun is symbolized. The sun is essential for all living things to survive. The printed papers opened up on the rug also have circles on them. The Chinese character contained here means sky, or the heavens where the sun is the center.

By arranging one symbolic flower, the creator wishes to send a special message to the viewers on the meaning of life. Yuji Ueno believes that arranging flowers leads to the secrets of life and hopes you recognize his message from this arrangement. You should also put your own messages into your arrangements for viewers to contemplate.

afterword

A few years ago, I rediscovered the charm of ikebana when I stumbled across a flower arrangement in a small gallery in Tokyo. The arrangement, graceful and dignified, simple but strong, made a huge impression on me and has stayed in my mind ever since. The arrangement did not use any special devices or complicated techniques. The flowers were not special or rare, and the container was not one that was typically used in ikebana. But I felt a connection with the arrangement that transcended its beauty and power to encompass a much larger existence—the whole universe and the world of nature.

This was my first electrifying encounter with the work of Yuji Ueno, a flower artist living in Tokyo. When he was in his twenties, Yuji practiced ikebana at an established school and mastered the conventional techniques. But in a radical departure from his training in traditional ikebana, he now expresses contemporary trends in Japan through his inventive and original floral displays. My encounter with Yuji's ikebana in the small gallery in Tokyo was undoubtedly the starting point for this book. It is what motivated me to convey my delightful experience and admiration for his work to a much wider audience, both at home and abroad.

Yuji's floral arrangements, all specially created for this book, are enhanced by the outstanding photographs of "magical" master photographer Noboru Murata. All taken in natural light, the photographs capture the full impact and spirit of Yuji's distinctive creations. The collaboration between Yuji Ueno and Noboru Murata has resulted in a publication on modern Japanese-style flower arranging that is sure to delight and inspire readers to replicate the arrangements or to use them as a springboard for their own creations. The arrangements are within the reach of everyone and will not fail to impress whoever sees them.

In March 2011, the Great East Japan Earthquake and tsunami hit Japan. The horrific events and subsequent efforts to recover from them demonstrated the tenacity, resilience and spirituality of the Japanese people. The floral works displayed in this book were all made after these tragic events and during the ongoing recovery. They, too, reflect the Japanese mentality, the strong spirituality that is at the heart of ikebana, whether consciously or not. It is hoped that ikebana, which is not merely a simple flower decoration technique, will inspire people in Japan and in other countries to take an interest in this new, fresh type of ikebana and make it a satisfying and integral part of their lives. **Rie Imai**

acknowledgments

For copyediting and English support, we received tremendous assistance from Kathleen Adair. She is a Master instructor of modern ikebana and the founding member of an independent group that studies with various ikebana artists and head-masters.

We would also like to extend our heartfelt thanks to the following people without whom this book could not have been realized.

PUBLISHING
Eric Oey, June Chong and Chan Sow Yun (all from Tuttle Publishing)

DESIGN
Masakazu Fujii (F Design Office), Natsuho Sugawa

PHOTOGRAPHS
Tomoko Osada

ARTISTIC ADVICE
Kaoru Yamamoto

OTHERS WHO HAVE PROVIDED ASSISTANCE, SUPPORT AND INSPIRATION
Miki Arai, Seika Adachi, Naoko Fujimura, Kaori Imaizumi, Serge Coing, Kazuyo Omata, Etsuko Nagasawa, Kaz Imai

PROCUREMENT OF MATERIALS AND FACILITIES FOR PHOTO SHOOTING
Tokyomatsuya Inc. (Tokyo)
Ozuwashi (Tokyo)
Benandsebastian (Copenhagen)
Tistou Co., Ltd (Tokyo)
Jikonka (Tokyo)
Studio R (Tokyo)

the team

This book was made possible through the collaboration of three talents: **Rie Imai**, an interior decorator and lifestyle coordinator with international experience; **Yuji Ueno**, a master of contemporary ikebana floral art with a strong passion and commitment, and **Noboru Murata**, one of Japan's most accomplished photographers with a wide range of experience with Japanese arts and culture.

Published by Tuttle Publishing, an imprint of Periplus Editions (HK) Ltd

www.tuttlepublishing.com

Copyright © 2013 Periplus Editions (HK) Ltd

ISBN 978-4-8053-1212-4

Distributed by

North America, Latin America & Europe
Tuttle Publishing
364 Innovation Drive, North Clarendon, VT 05759-9436 USA
Tel: 1 (802) 773-8930; Fax: 1 (802) 773-6993
info@tuttlepublishing.com
www.tuttlepublishing.com

Japan
Tuttle Publishing
Yaekari Building, 3rd Floor
5-4-12 Osaki, Shinagawa-ku, Tokyo 141 0032
Tel: (81) 3 5437-0171; Fax: (81) 3 5437-0755
sales@tuttle.co.jp
www.tuttle.co.jp

Asia Pacific
Berkeley Books Pte Ltd
61 Tai Seng Avenue #02-12, Singapore 534167
Tel: (65) 6280-1330; Fax: (65) 6280-6290
inquiries@periplus.com.sg
www.periplus.com

15 14 13 10 9 8 7 6 5 4 3 2 1

Printed in Singapore 1310CP

the tuttle story

Many people are surprised to learn that the world's largest publisher of books on Asia had its humble beginnings in the tiny American state of Vermont. The company's founder, Charles Tuttle, came from a New England family steeped in publishing.

Tuttle's father was a noted antiquarian dealer in Rutland, Vermont. Young Charles honed his knowledge of the trade working in the family bookstore, and later in the rare books section of Columbia University Library. His passion for beautiful books—old and new—never wavered throughout his long career as a bookseller and publisher.

After graduating from Harvard, Tuttle enlisted in the military and in 1945 was sent to Tokyo to work on General Douglas MacArthur's staff. He was tasked with helping to revive the Japanese publishing industry, which had been utterly devastated by the war. When his tour of duty was completed, he left the military, married a talented and beautiful singer, Reiko Chiba, and in 1948 began several successful business ventures.

To his astonishment, Tuttle discovered that postwar Tokyo was actually a book-lover's paradise. He befriended dealers in the Kanda district and began supplying rare Japanese editions to American libraries. He also imported American books to sell to the thousands of GIs stationed in Japan. By 1949, Tuttle's business was thriving, and he opened Tokyo's very first English-language bookstore in the Takashimaya Department Store in Ginza, to great success. Two years later, he began publishing books to fulfill the growing interest of foreigners in all things Asian.

Though a Westerner, Tuttle was hugely instrumental in bringing a knowledge of Japan and Asia to a world hungry for information about the East. By the time of his death in 1993, he had published over 6,000 books on Asian culture, history and art—a legacy honored by Emperor Hirohito in 1983 with the "Order of the Sacred Treasure," the highest honor Japan bestows upon a non-Japanese.

The Tuttle company today maintains an active backlist of some 1,500 titles, many of which have been continuously in print since the 1950s and 1960s—a great testament to Charles Tuttle's skill as a publisher. More than 60 years after its founding, Tuttle Publishing is more active today than at any time in its history, still inspired by Charles Tuttle's core mission—to publish fine books to span the East and West and provide a greater understanding of each.